HOW TO DRAW AND PAINT SCIENCE FICTION ART

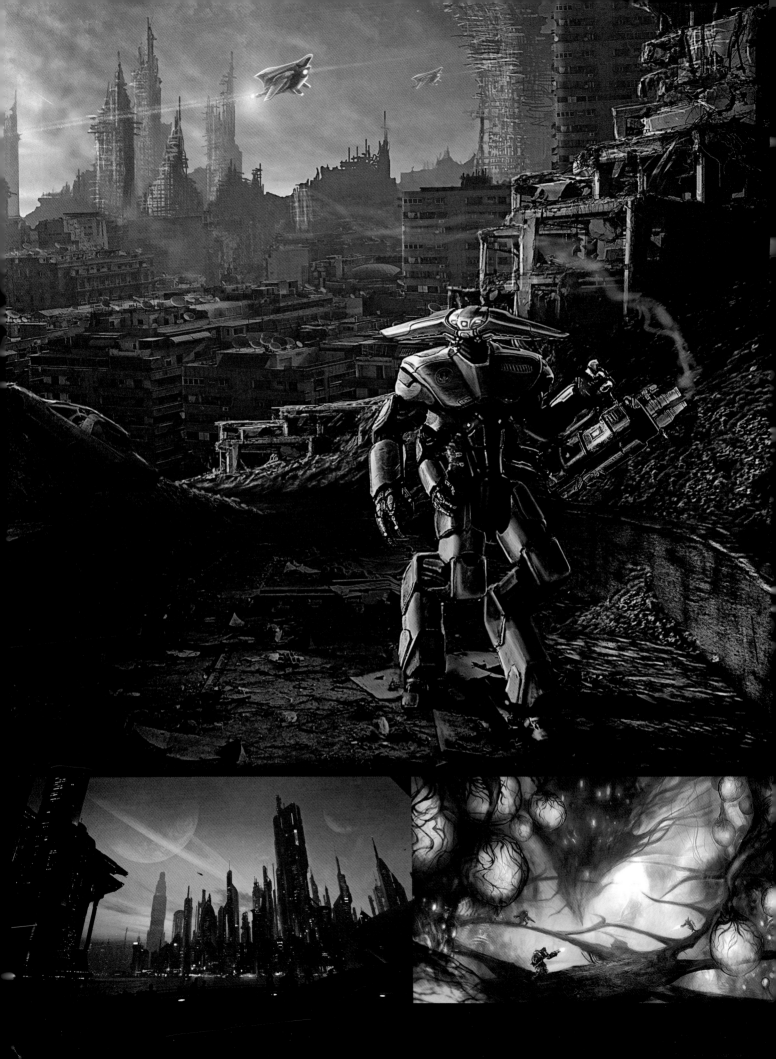

futurescapes and characters, from
scientific marvels to dark, dystopian visions

Geoff Taylor

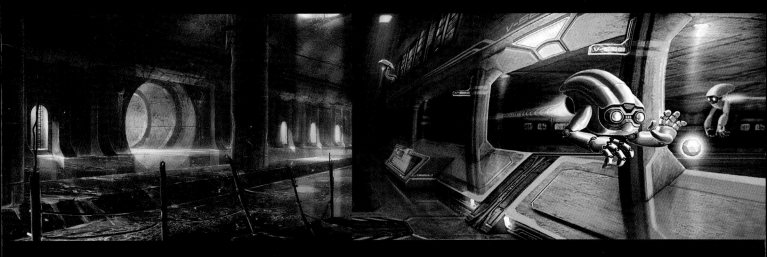

First edition for North America
Published in 2011 by
Barron's Educational Series, Inc.

A QUARTO BOOK

All inquiries should be addressed to:
Barron's Educational Series, Inc.
250 Wireless Boulevard
Hauppauge, New York 11788
www.barronseduc.com

Library of Congress Control No.: 2010939627
ISBN: 978-0-7641-4689-3

QUAR.DPSF

Conceived, designed, and produced by
Quarto Publishing plc
The Old Brewery
6 Blundell Street
London N7 9BH

Senior Editor: Ruth Patrick
Art Editor: Jacqueline Palmer
Designer: John Grain
Copyeditor: Ruth Patrick
Proofreader: Sally MacEachern
Indexer: Helen Snaith
Picture Researcher: Sarah Bell
Art Director: Caroline Guest
Creative Director: Moira Clinch
Publisher: Paul Carslake

Color separation in Singapore by
PICA Digital Pte Ltd
Printed in Singapore by Star Standard Pte Ltd

10 9 8 7 6 5 4 3 2 1

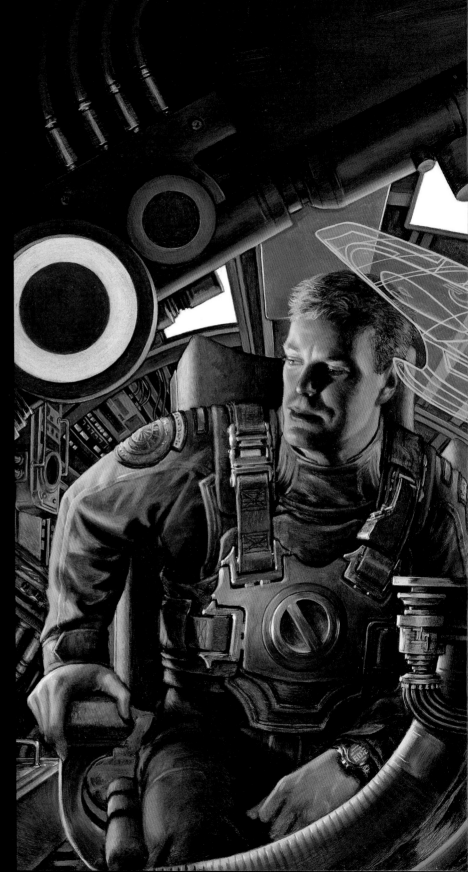

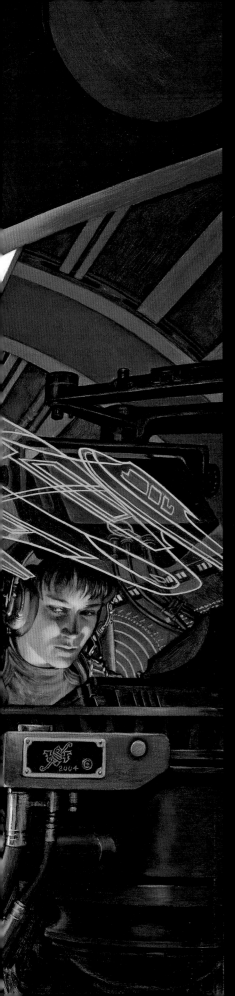

Contents

Foreword

Science fiction offers visual artists a chance to create something truly unique. As artists working in the realm of science fiction, we get to explore a variety of roles: storyteller, architect, industrial designer, futurist, and inventor. The genre is challenging, yet extremely inspiring.

This balance allows artists the opportunity to sharpen technical skills while expanding their design sense. This book will help you to develop fundamental drawing and painting skills, and offers a step-by-step explanation of how to take an idea from the written word to a finished painting. The roots and trends within the genre will be discussed, as well as some insight into the overall creative process.

I've had the chance to work on several sci-fi titles over the years, and the content of this book is largely inspired by my experience working on those projects. I've been lucky enough to have some amazing mentors who have passed a great deal of guidance, theory, and insight my way, and I'm thrilled to be able to share some of that with you in the pages of this book.

Geoff Taylor

About this book

The information in this book is organized into four chapters:

Text and images explore the subject.

In this section, a timeline tracks the development of the sci-fi genre.

Chapter 1: Inspiration (pages 16–27)

Sci-fi art is all about letting your imagination run wild. This chapter shows you how to gather reference material and draw inspiration from everyday sources such as magazines, films, books, and movie posters, which you can then adapt to suit your own individual style.

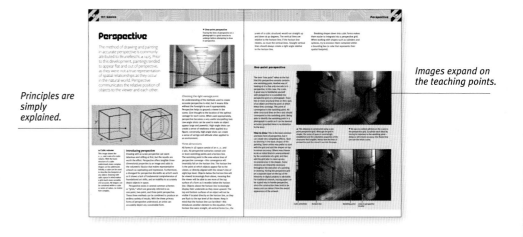

Principles are simply explained.

Images expand on the teaching points.

Chapter 2: Art basics (pages 28–53)

Traditional materials as well as the latest digital tools, hardware, and techniques are all covered. Learn the principles of composition, anatomy, and perspective to give your characters and futurescapes a sense sci-fi realism.

Chapter 3: Creating new worlds
(pages 54–111)

This chapter focuses on five different sci-fi worlds, with the aim of introducing a wider range of imagery and concepts. Various popular science fiction themes are included, along with a number of inspirational works of art by accomplished artists in the field.

Organization of chapter 3

Different artists offer their interpretation of each featured world, while author Geoff Taylor shows how to create a range of subjects for each world.

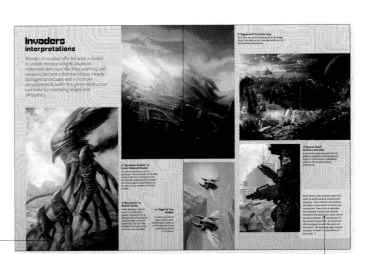

Artists offer a range of interpretations.

Author Geoff Taylor describes his own vision for each sci-fi world.

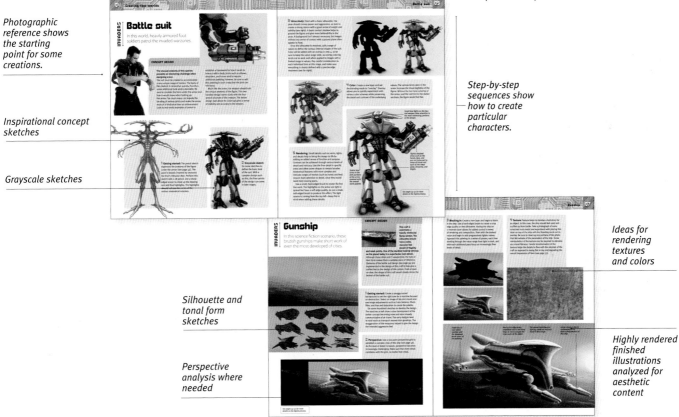

Photographic reference shows the starting point for some creations.

Inspirational concept sketches

Grayscale sketches

Step-by-step sequences show how to create particular characters.

Silhouette and tonal form sketches

Perspective analysis where needed

Ideas for rendering textures and colors

Highly rendered finished illustrations analyzed for aesthetic content

Chapter 4: Picture making
(pages 112–125)

Learn to assimilate the elements acquired from the previous chapters to create a cohesive world in which your characters seamlessly integrate with the landscape, and see the work of other sci-fi artists, architecture, vehicles, and creatures.

Subjects shown as how-tos in the previous chapter are here shown integrated into finished art.

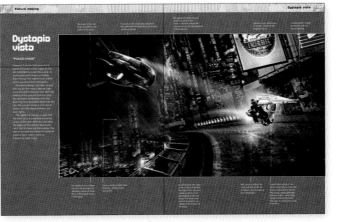

Defining the genre

In a broad sense, science fiction themes have existed in the human mythos for eons. A fascination with the unknown has steered our collective minds into these realms for centuries.

Any story where the author takes the liberty of scientific invention or exaggeration could be termed science fiction. As society's collective scientific understanding grew, so too did its desire to speculate upon possibilities and embellish and elaborate upon the existing models. By the 1750s modern themes of science fiction began to emerge. Fiction has a habit of coevolving with society, and the genre of science fiction is no exception.

The characteristics of science fiction

The works are often didactic in nature—this genre allows writers and artists to criticize society by presenting potential future scenarios that could arise as a result of our current lifestyles, technology, and political systems. On the flip side, the genre can also offer solutions by presenting creative alternatives to the current paradigm. Sci-fi also has the possibility to take the viewer or reader on a journey deep into the unknown. Science fiction is often set in the future, but it can also propose deviations from our known historical time line. Time itself can play an active role in the fiction when themes of time travel are addressed. The genre also has the potential to explore the vastness of space so deeply that time becomes irrelevant. The settings are endless in range—sometimes it can be as simple

as an unknown invader or visitor getting mixed up in the world we are familiar with, or as foreign and unfathomable as an alien world completely unlike our own.

Providing a precise definition for the genre is difficult, as it is too wide in range and too limitless in possibility. Lester Del Rey stated that the lack of a concrete definition for the genre is due to the fact that "there are no easily delineated limits to science fiction." Part of the problem with pinning down the genre stems from the metamorphosis that it has undergone in the past century. An already elusive

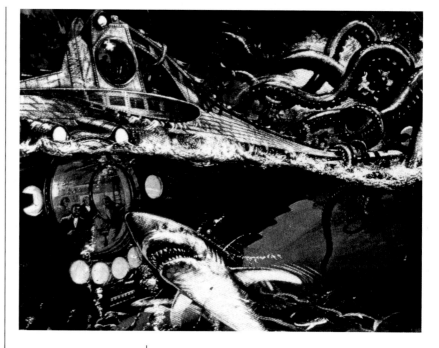

▲ **An early classic**
Jules Verne was one of the first authors to entice readers with science fiction themes. His books have stood the test of time and continue to inspire contemporary sci-fi artists. This is a detail from an old film poster for *20,000 Leagues Under the Sea*.

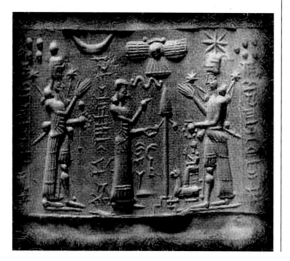

◀ **Ancient visions**
This image shows early evidence of man's fascination with the cosmos. Some myths can be interpreted as a precursor to modern science fiction themes.

genre has branched out into a variety of sub-genres; each one complex and full of its own lore and invention.

Hard and soft science fiction

Categorization of the genre is complex, since there are a great deal of overlaps, and sub-genres within sub-genres. To keep things relatively simple there are two broad headings that the other sub-genres fall into: hard science fiction and soft science fiction. Hard science fiction deals with themes surrounding what we refer to in current-day society as "hard science": physics, biology, chemistry, and branches within those disciplines. This arm of science fiction often attempts to offer some prophecy of the future of science, and in some cases is quite successful. Often the attempts at foreseeing future technologies fail miserably. Careful attention is paid to what is potentially possible, or what could eventually be possible, given our consensus of knowledge. Work within this genre is intended to offer a glimpse at

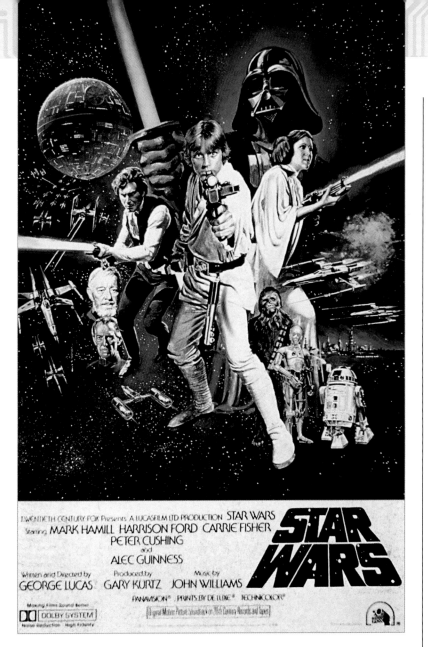

STAR WARS

TWENTIETH CENTURY FOX Presents A LUCASFILM LTD PRODUCTION STAR WARS
Starring MARK HAMILL HARRISON FORD CARRIE FISHER
PETER CUSHING
and
ALEC GUINNESS

Written and Directed by Produced by Music by
GEORGE LUCAS GARY KURTZ JOHN WILLIAMS

PANAVISION® · PRINTS BY DE LUXE® · TECHNICOLOR®

DOLBY SYSTEM

what is attainable without giving in to pure fantasy or exotic technology that falls drastically outside of the current scope of understanding.

Soft science fiction tends to deal predominantly with what we term the "soft sciences," or social sciences. Themes of economics, politics, sociology, ecology, and parapsychology are common within this sub-genre.

Science fiction sub-genres

The following is a summary of some of the major sci-fi sub-genres. Keep in mind there are no rules—there is nothing to keep an artist from mixing, overlapping, and redefining these sub-genres.

Space epic, or space opera

- Set in the far reaches of space and tends to be so grand in scope that it covers both hard and soft science fiction themes.

▲ **Star Wars**

This franchise still remains a benchmark in science fiction storytelling and design. *Star Wars* is an endless source of inspiration for artists working in this genre.

- Sometimes explores a great stretch of a planet's, solar system's, galaxy's, or even the universe's history.
- Epics tend to span multiple generations of characters and tend to culminate with a large-scale battle or revolution.
- Imagery can be endlessly diverse.

Given the extensive nature of the settings and the potential diversity of the characters, the possibilities are infinite. Consider the level of diversity seen on our planet alone; imagine how varied the imagery could become when dealing with multiple planets or even multiple star systems. While there is no formula for a space epic, one can typically expect to see a large-scale conflict between good and evil and an exploration of themes of government and society as a whole.

EXAMPLES

Novel and movie: *Dune* (novel by Frank Herbert: 1965; movie: 1984)
Movie: *Star Wars* (1977, 1980, 1983, 1999, 2002, 2005, and 2008)

Post-apocalyptic

- Some great conflict or cataclysm has drastically degraded society and the ecosphere.
- No distinct time line for this genre.
- The apocalypse can be set in the distant future.
- Could speculate on a different outcome to World War II or the possibility of a third world war in the near future.
- A severely damaged and polluted landscape.
- Cities reduced to rubble with small pockets of high-tech civilization surviving in exile, and remote locations.

It is expected that some level of technology has survived the apocalypse; however some aspects of society may be seen to have reverted to more tribal or nomadic lifestyles. Typically the world is in a state of chaos; a lack of centralized authority leaves the world in a state of unchecked anarchy. Sometimes harsh authoritative government regimes are shown within this lore, but typically we see a world void of any real leadership be it benevolent or malevolent. Themes of plague and disease are frequently addressed. Zombies are a frequent theme. This genre offers a critique of scientific arrogance and an examination of human behavior in the aftermath of destruction.

EXAMPLES

Video game/movie: *Resident Evil* (video game: 1996; movie: 2002)
Movie: *Mad Max* (1979, 1981, and 1985)

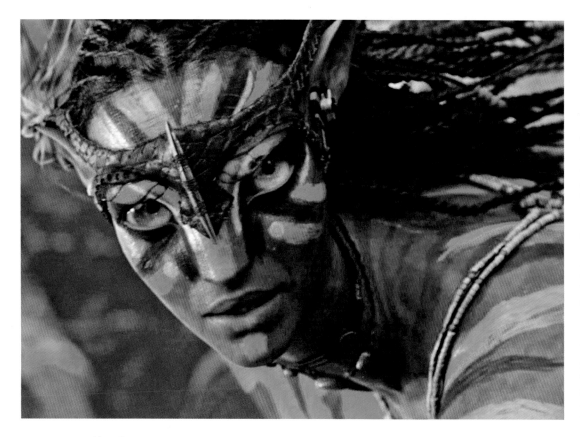

◀ **CG masterpiece**
The challenges of analog special effects are a thing of the past. Projects like *Avatar* demonstrate the extent to which computer graphics can be used to bring a project to life. The sophistication of these methods allows any sci-fi story—no matter how elaborate—the chance to come alive on the big screen.

▼ **Time travel**
Sci-fi themes are endlessly varied. Time travel is one such theme, which consistently inspires new fiction year after year.

Utopia

- A vision of a seemingly perfect society, often with some sinister element concealed from the greater population.
- Typically a high level of technology is at the core of the society's success.
- Themes of pacifism, ecology, spirituality, and philosophy.

The concept of a utopia stems from *Utopia* (1516), a book by social philosopher Sir Thomas More (1478–1535). This sub-genre offers an artist the chance to offer potential solutions to current or future problems. It is also possible to present a utopia through much more modest means; consider the possibility of an alien culture that evolved without technology as the driving force—the Navi from *Avatar* are a good example of this potential utopian world. However there is rarely any fiction where we see a utopia without imperfections or outside threats. Sometimes the audience is presented with the idea that without problems to solve or advancement to pursue, society would simply lose its passion and crumble. Utopias are best presented in a state of conflict or downturn, since a story of true perfection offers limited possibilities and interest.

EXAMPLES
Novel: *Brave New World* by Aldous Huxley (1932)
Movie: *Avatar* (2009)

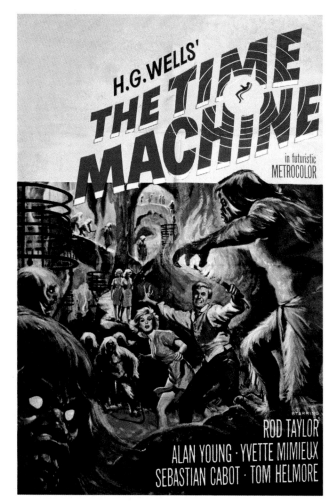

H.G. WELLS'
THE TIME MACHINE
in futuristic METROCOLOR

starring
ROD TAYLOR
ALAN YOUNG · YVETTE MIMIEUX
SEBASTIAN CABOT · TOM HELMORE

Time travel

- A highly modern or futuristic society thrust into a distant past, void of such invention.
- A member of our world (or near future) sent to a bizarre and radically foreign future.

The possibility of time travel has fascinated man for eons. The desire to reclaim or alter our past in hopes of a brighter future strikes a chord with all of us. The possibility for adventure is limitless—time travel offers an endless number of possibilities. This "fish out of water" sub-genre gives us a chance to imagine our future and reexamine our past both artistically and intellectually.

EXAMPLES
Novel and movie: *The Time Machine* (novel by H. G. Wells: 1895; movie: 1960)
Movie: *Twelve Monkeys* (1995), *Land of the Lost* (2009)

Military

- Any of the aforementioned sub-genres have the potential for a military presence.
- A great deal of attention is paid to weaponry and vehicle design.

There is a strong tradition of showing science fiction through a military lens. Often large-scale stories are shown through a variety of view points—the military simply being one such perspective.

EXAMPLES
Novel: *The Forever War* by Joe Haldeman (1974)
Movie: *Starship Troopers* (1997)

Steampunk

- Treats the idea that high technology existed in Victorian England.
- The technology is advanced but constructed within the framework of steam-powered technology.
- A world of robots and airships, with aesthetic values drawn from classical sources.
- A great deal of copper as opposed to sleek, high-tech alloys and composite materials.

This sub-genre does not necessarily take us back in time, but simply proposes that development evolved without the radical advancements that have taken place over the past 200 years. Typically there is still some sense of a monarchy—many aspects of Victorian culture persist.

EXAMPLES
Novels: *The Steampunk Trilogy* by Paul Di Filippo; *Perdido Street Station* by China Miéville (2000); *The Prophecy Machine* by Neal Barrett, Jr.

Cyberpunk

- Cyborgs, or the combination of humans with robotic prosthetics.

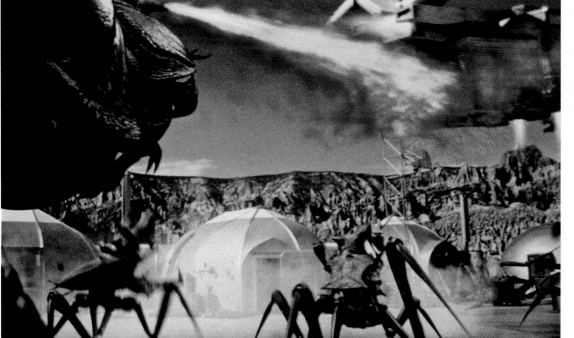

◀ **Extraterrestrial threat**
Themes of war with an alien threat have spawned countless incarnations within the sci-fi genre, such as *Starship Troopers* (1997) shown here in the form of a film still. As an artist, this theme allows for a wealth of invention and imagination.

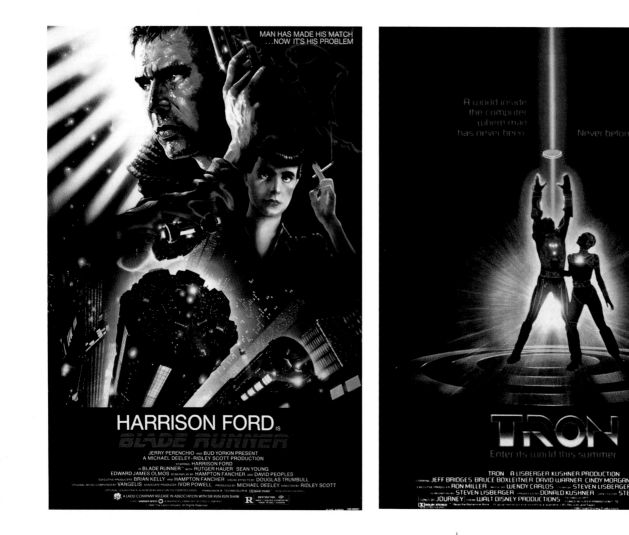

• A bleak vision of the future, a story of oppression told from the street level.

• Heroes tend to be hackers or gang members.

The term "cyberpunk" was first introduced in Bruce Bethke's short story, *Cyberpunk*. Much as we have a military lens through which we can view various sub-genres, we also have a subversive or countercultural lens through which we can view most sci-fi narratives.

EXAMPLES

Novels: *Otherland* by Tad Williams (1996–2001); *Accelerando* by Charles Stross (2005)
Novel and movie: *Neuromancer* (novel by William Gibson: 1984; movie: 2011)
Movies: *Akira* (1988), *Blade Runner* (1982)

Lost world

• Similar to time travel, but deals with the exploration of our own world in the present day.

Explorers have often entertained the notion that remote areas of the Earth could have remained unaffected by the passage of time. The concept of a tropical oasis in the arctic or a deposit of prehistoric life-forms found in a subterranean section of the

▲ Visions of the future

Blade Runner offers a frightening and extremely compelling glimpse of a possible future for our planet. The movie is rich with brilliant design and lighting—a must-see for any artist looking to add to this genre.

▲ ▲ The lighter side

Science fiction need not be dark and serious. This illustration shows sci-fi imagery in a much less serious light.

Earth have been the source of conjecture by scientists and authors for years.

EXAMPLE

Novel and movie: *Journey to the Center of the Earth* (novel by Jules Verne: 1864; movie: 1959 and 2008)

Cyberspace

• Characters exist in the virtual world.

With the advancement of the Internet, society is becoming increasingly sucked into the virtual world. Currently we intimately coexist with a virtual world while remaining physically separate. Take that notion one step further and physically insert a character into the virtual world and you have a narrative set within cyberspace.

EXAMPLES

Movies: *TRON* (1982 and 2010), *The Matrix* (1999), *The Matrix: Reloaded* and *Revolutions* (both 2003)

Invasion

• Rapidly introduces a conflict between two worlds.

- Typically we see this story play out from the human perspective.
- An alien force—usually very technologically advanced and militarized—appears over the Earth and launches an assault.
- Some stories deal with a more subtle or quiet invasion.

Invasion is a classic science fiction scenario. Human-looking aliens or shape-shifters quietly take over the governments of the world. This story would also work with humans as the invader. Visually we expect to see two opposing forces, one appearing technologically dominant and one portrayed in a manner that evokes sympathy.

EXAMPLES
Novel and movie: *War of the Worlds* (novel by H. G. Wells: 1898; movie: 1953 and 2005)
Movie: *Independence Day* (1996)
TV series: *V* (2009–2011)

Super powers

- Fulfills our innate desire to be more than human.
- Themes of responsibility and morality are touched upon in these works.
- The concept of the idealized human—science fiction characters (particularly heroes) are powerful and romanticized in physical stature.

This topic is typically found in the realm of comic books. Every child has dreams of limitless strength, and the ability to fly and perform other heroic tasks. Science fiction often touches upon possible scenarios that could explain the acquisition of such powers. Laboratory experiments gone awry, fabulous

▼ Artificial worlds
As our technology expands, we become increasingly drawn into a virtual world. Projects like *Tron* have taken this concept one step further, and physically transported the audience into cyberspace.

▼ ▼ Invaders
The threat of a malicious alien invader seems to dwell somewhere deep in the human psyche. *War of the Worlds* is a classic within this realm of fiction.

invention, or contact with extraterrestrials are common methods of explaining such phenomena. Comic books with "super human" themes helped to establish the super-power aesthetic (Hollywood helped a lot too).

EXAMPLES
Comic and movie: *Spider-Man* (movie: 2002, 2004, and 2007), *X-Men* (movies: 2000, 2003, and 2006)
Comic, TV series, and movie: *The Incredible Hulk* (TV series: 1978–1982; movies: 2003 and 2008)

Periphery themes

- Western: Elements of the old west juxtaposed with high technology.
- Japanese: Aspects of Japanese culture shown in a futuristic setting.
- Aquatic: Marine life is so exotic and foreign to us that it is an easy transition to convey existing life forms into something even more alien and bizarre.
- Egyptian/Sumerian: Speculation regarding alien intervention exists surrounding these cultures. Taking this imagery and combining it with sophisticated technology is an interesting theme to explore.
- Humorous: Sci-fi themes are often touched upon in illustration with a more lighthearted approach to the subject matter.

EXAMPLE
Movie: *Stargate* (1994)

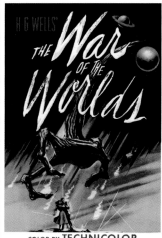

H G WELLS'
THE War OF THE Worlds
COLOR BY TECHNICOLOR
PRODUCED BY GEORGE PAL · DIRECTED BY BYRON HASKIN · SCREEN PLAY BY BARRE LYNDON · A PARAMOUNT PICTURE

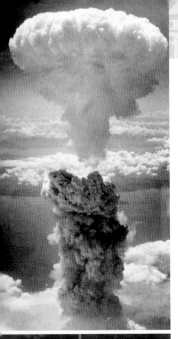

Science fiction and society

Understanding the emergence of science fiction requires some comprehension of the technological advancement of society over the past century.

In the latter half of the nineteenth century there were more advancements in technology than in the past 1,000 years of history. Many revolutionary innovations all date to this short epoch. The framework for the modern world was rapidly taking shape. Technology was quickly on the rise. The future seemed bright and endless in possibilities.

The tone of early science fiction
Early science fiction was representative of a population unaware of the potential hazards of technology. While some of the early science fiction stories dealt with themes of invasion and cataclysm, the overall tone of the imagery and prose depicted science as a savior. As actual scientific progress began to catch up to the fictional suppositions, the ramifications of development became clearer and clearer. As issues like radiation poisoning and pollution became apparent, the fiction and artwork evolved accordingly.

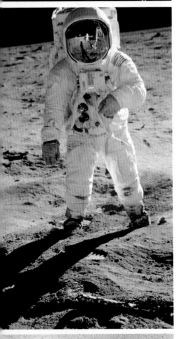

Sci-fi mirrors society
The world was changing and this was evident in all forms of art and media (some research into the shift from modernism to postmodernism would be valuable as a means of acquiring a deeper understanding of the changes taking place in society). To simplify, there was a very optimistic view of the world around the beginning of the twentieth century. Scientific progress seemed to be the answer to all of life's problems.

After two devastating world wars this sense of optimism started to fade. It became clear that in an attempt to solve the existing problems of the world, man had inadvertently created a host of new ones. Most notably, the dropping of the atomic bomb on

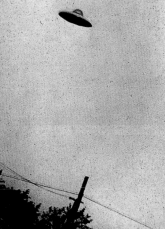

◄ **Memorable moments**
These images address some of the key moments in scientific evolution. Each of these events has had drastic effects on the human psyche and our perception of the world around us. Consider how these events could be elaborated upon to create new stories and imagery.

Hiroshima and Nagasaki made clear the destructive power of scientific progress and the need for caution and foresight when dealing with advanced technology. Science not only had the power to collectively save us, but also to destroy the planet. This shift was pushed further still by the anxiety and paranoia concerning nuclear holocaust during the Cold War. This attitude is expressed vividly in most major artistic avenues, and science fiction was no exception. Darker and more sophisticated themes began to emerge. The exuberant campiness of the early science fiction work was replaced by more serious literature and cinema. More talented authors and artists became drawn to the genre, and the work really began to take off. There are of course exceptions to this rule—some authors addressed sophisticated themes prior to these societal changes, and indeed themes of scientific optimism are still apparent today. The evolution of the genre is not entirely linear, but an overall shift in the tone of the genre does parallel the events in recent history.

The legitimization of sci-fi
The 1950s mark science fiction's jump from an obscure genre to a legitimate aspect of the popular culture. Three major events helped to catapult science fiction into the public arena. First was the launching of satellites into outer space. On October 24, 1946, the Russian satellite "Sputnik" took the first pictures of Earth taken from outer space. This began to give us a greater sense of our role in the universe. Man had been observing the cosmos since the dawn of human history, but now these visions were becoming increasingly clear.

The second key event was the space race. It was evident by the 1950s that man would reach the moon—it was simply a matter of time. The world was inspired by this possibility, and thoughts drifted toward the heavens. It was also right around this time that reports of flying saucers became increasingly prominent in the mainstream media. While these reports were dismissed by authorities, they have inspired a wealth of theories and conjecture. The potential for space exploration and the possibility of contact with extraterrestrials had the public's curiosity piqued. Art was quick to mimic life, since a great deal of sci-fi movies, literature, TV programs and series, and comic books emerged, all attempting to capture man's collective curiosity regarding outer space.

Science fiction and the artist

Science fiction offers the artist great freedom. Artists are given the opportunity to assume a variety of roles and offer insight into a variety of fields.

Industrial designer, architect, costume designer, biologist, engineer, philosopher, botanist, futurist, astronomer, and dreamer—all of these roles are touched upon in the genre. With such a broad spectrum of content at one's disposal, science fiction instantly becomes one of the more appealing genres for visual artists. This is, however, a genre ripe with pitfalls.

▼ **Striking a balance**
The below image demonstrates the strategy of integrating sci-fi elements into a contemporary urban environment. This image proposes that the slum areas of the city have remained as they are, and the downtown city center has expanded into a futuristic metropolis. Images like this one are a good bridge between observing the world around oneself and developing futuristic environments.

Challenges and pitfalls of sci-fi art
Below is a list of questions to ask yourself when coming up with ideas for new projects.

- Are the characters accessible to the viewer, or are they too foreign to relate to?
- Is the story entertaining, or too bizarre to follow?
- Is there a sense of humanity? Nonhuman worlds can still be given a sense of humanity to help engage the audience. The use of archetypes can help to transmit human characteristics to nonhuman entities.
- Is there a balance between science and fiction? Too much dry science and not enough storytelling can make an idea fall short.
- When looking to create something truly unique, stop and consider the diversity of the world around you. Be it natural or man-made, our home planet offers more inspiration than any one artist could ever hope for.

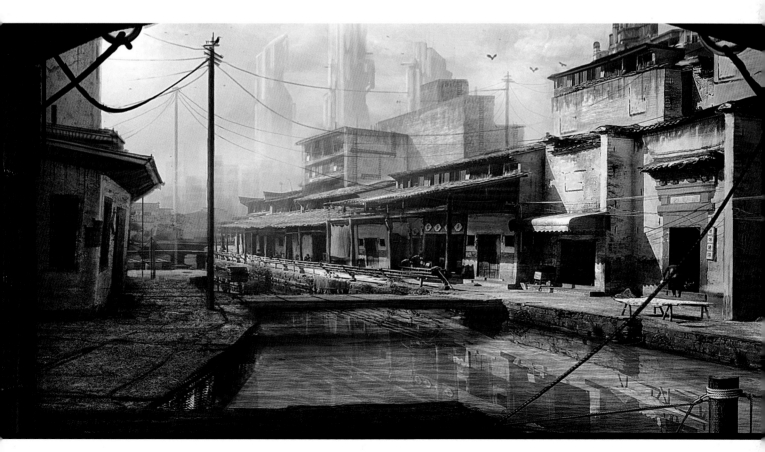

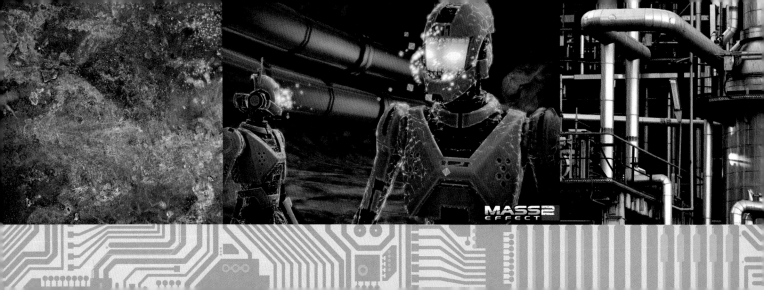

Chapter 1: INSPIRATION

This chapter outlines a variety of places to look for reference, ideas, and inspiration. Technical skills are crucial to the success of a painting, but without an idea as the driving force it is difficult to create something truly captivating. Keep in mind that this is fiction! So make sure the work is telling the viewer a story. The beauty of the genre is how endlessly imaginative these stories can be. Being well versed in what has been done in the past offers a chance to contribute something truly unique and original to the wealth of existing sci-fi artwork. Be sure to give careful consideration to the content of these pages before jumping ahead to the exercises. Understanding the background and "worlds" that exist within this genre is as much of a foundation as perspective or anatomy. This chapter covers some notable science fiction-themed magazines, cinema, illustration, cartoons, TV, video games, comic books, and novels. Consideration is also given to taking inspiration from the world around us– from the patterns in the natural world to the precision of modern architecture and industrial design. Some insight is offered into how to interpret these points of reference and then convert them into something that fits the genre. Methods of organizing and presenting reference are also explained.

Inspiration from media

Science fiction is prevalent in all forms of creative media. Take the time to learn the existing lore to find inspiration and avoid unintentional unoriginality.

This section outlines some of the more notable titles within the genre. Reference is key to good artwork in any genre, and sci-fi offers a wealth of relevant material.

Magazines

While the roots of science fiction literature are difficult to trace, the origin of science fiction artwork is more easily understood. Although early sci-fi novels, such as Jules Verne's *Journey to the Center of the Earth* (1864), had a few illustrations, sci-fi art's most notable point of origin is the pulp magazines of the early twentieth century. The 1926 launch of *Amazing Stories* by Hugo Gernsback was a major starting point for the showcase of science fiction literature and artwork to the mass public. *Amazing Stories* was the result of a positive response to short stories that were run in a few science and technology publications. The short stories were featured at the end of these magazines, and quickly developed a cult following. At this point the genre was dubbed "scientification." Although the name eventually changed, the genre as we know it today was born.

▼ ▶ Early sources
These early publications are a great reference for retro-style sci-fi. Reinterpretation is a great design exercise. Try to reimagine these old stories in a contemporary style.

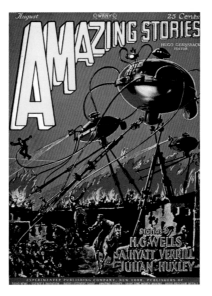

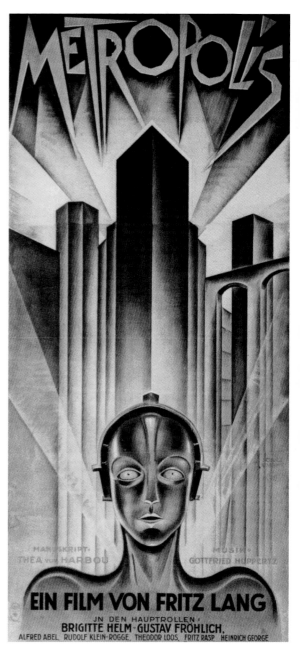

Sci-fi time line 1860–2020

1898 NOVEL:
War of the Worlds

1864 NOVEL:
Journey to the Center of the Earth

1895 NOVEL:
The Time Machine

The motto of the magazine, "Extravagant fiction today... Cold fact tomorrow," was more prophetic than its creator ever could have imagined. Modern robotics, space travel, and electronics were all touched upon within these stories. Many of the innovators of the twentieth century were deeply inspired by the publications as children, and went on to bring these outlandish ideas into fruition in their adult years. A huge aspect of the appeal of these stories was due to the eye-catching cover art. Frank R. Paul worked with Gernsback providing rendering for the practical science publication where the short stories first appeared, and he went on to produce the cover art for *Amazing Stories*.

By today's standards, the artwork and the fiction were amateur at best. The artwork was, however, strong enough to catch the eye of the readers and inspire a new generation of artists and writers. Many new publications emerged in the following years, such as *Astounding Stories*, *Wonder Stories*, *Startling Stories*, etc. The list of illustrators grew and the genre evolved.

Novels

Science fiction novels are a good source of fictional inspiration, and often the cover art is superb. Some authors of note include H. G. Wells, Ray Bradbury, Isaac Asimov, Douglas Adams, and Jules Verne. The beauty of book cover illustration is that, occasionally, the artist will be able to capture the feel of the entire novel summed up in one gorgeous illustration. Some illustrators of note include John Berkey, Boris Vallejo, Vincent Di Fate, and Melvyn Grant.

Cinema

Cinema is another critical arena of science fiction. Some early science fiction movies of note were *20,000 Leagues Under the Sea* (1916), *Metropolis* (1927), and *King Kong* (1933). These movies were limited by the technology and budget available to the creators. By the 1950s, the public's imagination was captured by technology, and the appeal of science fiction was much broader than a cult magazine following. Movies such as *The Day the Earth Stood Still* (1951), *The War of the Worlds* (1952), and *Invasion of the Body Snatchers* (1956) were notable contemporary cinematic creations.

The 1960s offered more impressive special effects, and science fiction movies began to garner higher budgets, as the studios saw them as more of a draw. Visual effects had evolved to a level where representing these outlandish stories on film had

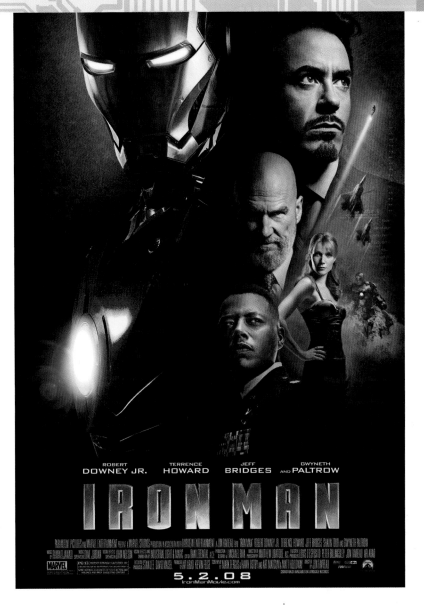

ROBERT DOWNEY JR. TERRENCE HOWARD JEFF BRIDGES GWYNETH AND PALTROW

IRON MAN

5.2.08
IronManMovie.com

▲ **A new twist on an old story**

Modern techniques bring classic stories to the big screen. Recent developments in movie making allow titles like *Iron Man* (2008) to come to life on the big screen.

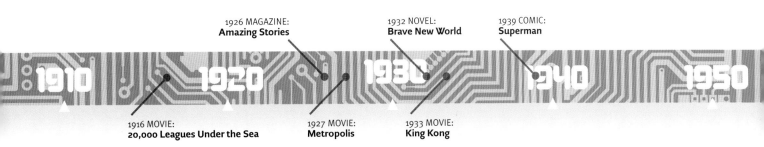

1926 MAGAZINE:
Amazing Stories

1932 NOVEL:
Brave New World

1939 COMIC:
Superman

1910 **1920** **1930** **1940** **1950**

1916 MOVIE:
20,000 Leagues Under the Sea

1927 MOVIE:
Metropolis

1933 MOVIE:
King Kong

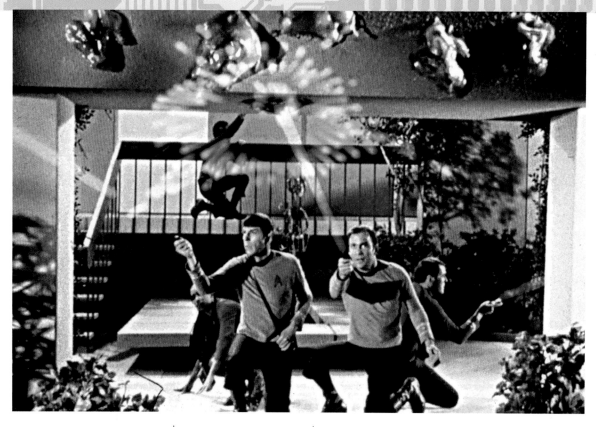

become much more viable. Stanley Kubrick's *2001: A Space Odyssey* (1968) brought a new level of sophistication to the genre, both in terms of visuals and depth of narrative.

Now that the effects were becoming more sophisticated, the stage was set for the true classics of the genre. The next few decades saw movies like *Planet of the Apes* (1968), *Star Wars* (1977), *Close Encounters of the Third Kind* (1977), *Blade Runner* (1982), *E.T.* (1982), *The Terminator* (1984), *Brazil* (1985), *Aliens* (1986), and *Predator* (1987). With a few small exceptions, all of these movies were limited to analog technologies. Practical models and animatronics were used to create the illusions of spaceships and alien creatures.

The advent of computer graphics signaled a huge shift in not only the look of these movies but also the potential for storytelling, which became much less hindered by technical challenges. While simplistic by today's standards, movies like *Tron* (1982) and *The Last Starfighter* (1984)

▲ Cult classics
Star Trek (1966–1969) has been a fan favorite for several generations. The show offers an excellent overview of the development of visual sophistication within sci-fi storytelling. Shown here is a still from one of the early episodes.

gave audiences their first glimpse at computer generated graphics.

As technology developed, so too did the visual quality of science fiction movies. Contemporary movies such as *The Matrix* (1999), *Iron Man* (2008), and *Avatar* (2009) show a new breed of science fiction cinema. These movies can tackle any visual challenge with style and precision. Remember, no matter how complex the visual effects of these movies become, it all begins with a sketch.

Concept art and illustration for cinema

As the visual complexity of the movies developed, the need for concept artists grew. Pioneers such as Syd Mead (*Tron*, *Aliens*, *Blade Runner*) and Scott Robertson (*Star Wars*) not only produced sketches and paintings to help bring to life some of the greatest sci-fi movies to date, but they also were instrumental in defining the realm of science fiction concept art. Both of these artists have been involved in industrial design, in particular conceptual

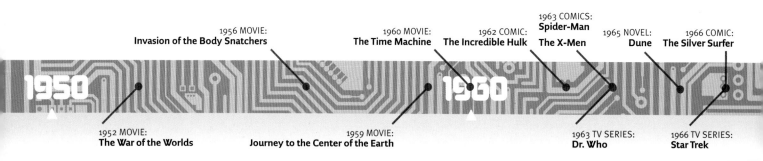

1956 MOVIE:
Invasion of the Body Snatchers

1960 MOVIE:
The Time Machine

1962 COMIC:
The Incredible Hulk

1963 COMICS:
Spider-Man
The X-Men

1965 NOVEL:
Dune

1966 COMIC:
The Silver Surfer

1950

1960

1952 MOVIE:
The War of the Worlds

1959 MOVIE:
Journey to the Center of the Earth

1963 TV SERIES:
Dr. Who

1966 TV SERIES:
Star Trek

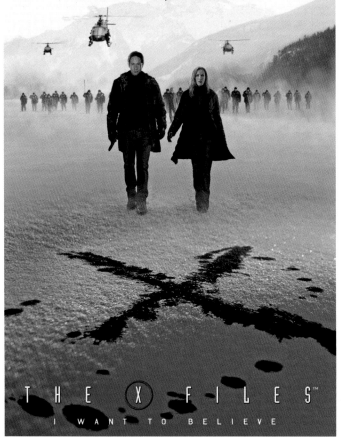

TO FIND THE TRUTH, YOU MUST BELIEVE.

T H E (X) F I L E S™

I WANT TO BELIEVE

◀ **Storytelling**

The X-Files was much more reliant upon storytelling than visual effects and imagery. Be sure to pay consideration to fiction as well as visuals when conceiving sci-fi artwork.

▼ **Comedy**

Science fiction doesn't have to be dire and serious. *Futurama* combined sci-fi themes with great comedic writing.

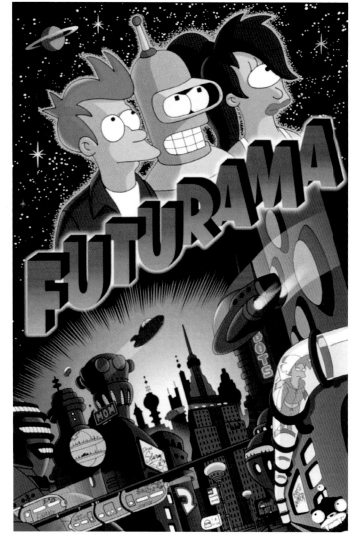

automotive design. This strong technical skill set, coupled with a good understanding of anatomy, architecture, and a seemingly limitless imagination made them perfect candidates to develop and populate the rich visual worlds of these iconic movies. Another early pioneer in science fiction art is illustrator Drew Struzan, who was most notable for the highly memorable posters for movies such as *Star Wars* (1977), *E.T.* (1982), and *Blade Runner* (1982).

Cartoons

Science fiction has garnered some excellent animated projects—both TV series and feature movies. These works are often spin-offs of other media, such as comic books and movies. The beauty of hand-drawn animation is the breadth of drawing

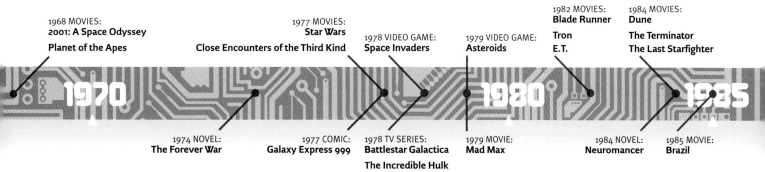

1968 MOVIES:
2001: A Space Odyssey
Planet of the Apes

1977 MOVIES:
Star Wars
Close Encounters of the Third Kind

1978 VIDEO GAME:
Space Invaders

1979 VIDEO GAME:
Asteroids

1982 MOVIES:
Blade Runner
Tron
E.T.

1984 MOVIES:
Dune
The Terminator
The Last Starfighter

1970 **1980** **1985**

1974 NOVEL:
The Forever War

1977 COMIC:
Galaxy Express 999

1978 TV SERIES:
Battlestar Galactica
The Incredible Hulk

1979 MOVIE:
Mad Max

1984 NOVEL:
Neuromancer

1985 MOVIE:
Brazil

that goes into it. Animators are masters of drawing body language, expression, and action. An examination of both Western and Eastern work is worthwhile. There is a wide difference in design aesthetics between the two. Some Western titles of note include *Exo Squad* (1993), *Star Wars: The Clone Wars* (2008), *Futurama* (1999), and *Aeon Flux* (1991). Eastern titles of note include *Akira* (1988), *Full Metal Alchemist* (2003), *Cowboy Bebop* (1998), and *Castle in the Sky* (1986).

TV

Due to tighter time constraints and lower budgets, sci-fi television series tend to be slightly less polished than movies (visually speaking). That being said, there are still some fabulous titles worth exploring. One advantage television has over a movie is the sheer volume of work. A successful series can run for years, thus producing hundreds of hours of content as opposed to a 2–3 hour movie. This allows the creators to really explore the subtleties of their creations. Some series of note include *Star Trek* (1966), *Babylon 5* (1994), *Battlestar Galactica* (1978), *The X-Files* (1993), and *Stargate* (1997).

Video games

The evolution of game art is similar to the evolution of visual effects for cinema. A lot of the software used to create special effects in movies is also used in game development. Contemporary video game

▲ **Video games**
Modern video games rival movies in their visual quality. One perk of working in this genre is the ability to treat video games as research. The screenshots above are taken from various versions of *Fallout*.

cinematics are at an extremely high level—nearly indistinguishable from movies. In addition to the quality of the finished product, a lot of today's most talented concept artists are involved in the pre-production aspect of game development. Early sci-fi video games like *Space Invaders* (1978) and *Asteroids* (1979) have their role in paving the way for the titles we see today, but visually they aren't much to look at. Some titles of note include *Halo* (2001), *Mass Effect* (2007), *Super Mario Galaxy* (2007), *Final Fantasy* (1987), *BioShock* (2007), *Gears of War* (2006), and *Fallout* (1997).

Comic books

The vast majority of comic books fall into the realm of science fiction, mostly fitting into the "super powers" sub-genre. Comic books offer great reference for figure drawing and character design. Comic book artists are masters of portraying the human form. This work is also excellent reference for hard-angle perspective shots. Comic book artists often employ exaggerated three-point perspective grids in their drawing to aid the impact of the narrative. Be sure to reference both Western and Eastern influences. Japanese manga is an excellent source of inspiration. Some Western titles of note include *The Silver Surfer* (1966), *The X-Men* (1963), *Spider-Man* (1963), and *Superman* (1939). Eastern titles of note include *Appleseed* (2004), *Ghost in the Shell* (1989), *Galaxy Express 999* (1977), and *Mobile Suit Gundam Wing* (1995).

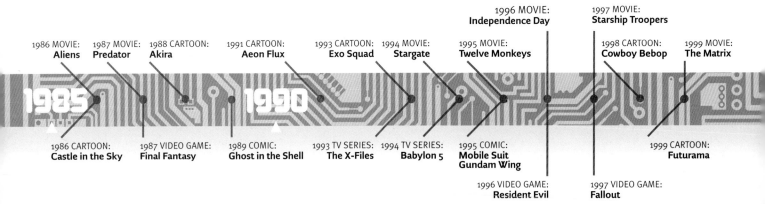

1986 MOVIE:
Aliens

1987 MOVIE:
Predator

1988 CARTOON:
Akira

1991 CARTOON:
Aeon Flux

1993 CARTOON:
Exo Squad

1994 MOVIE:
Stargate

1995 MOVIE:
Twelve Monkeys

1996 MOVIE:
Independence Day

1997 MOVIE:
Starship Troopers

1998 CARTOON:
Cowboy Bebop

1999 MOVIE:
The Matrix

1985

1990

1986 CARTOON:
Castle in the Sky

1987 VIDEO GAME:
Final Fantasy

1989 COMIC:
Ghost in the Shell

1993 TV SERIES:
The X-Files

1994 TV SERIES:
Babylon 5

1995 COMIC:
Mobile Suit Gundam Wing

1996 VIDEO GAME:
Resident Evil

1997 VIDEO GAME:
Fallout

1999 CARTOON:
Futurama

◀ Halo

Halo is a great example of a franchise that has created a vast and expansive fiction. Many cultures and species help to frame this elaborate epic. Look to *Halo* as reference when designing new worlds in Chapter 3.

▼ Mass Effect

Mass Effect is a particularly artistically successful video game franchise. Fabulous design and high-quality graphics help bring this title to life.

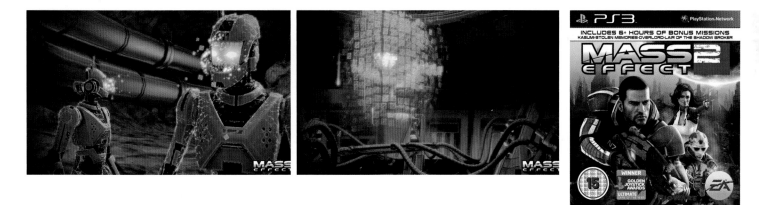

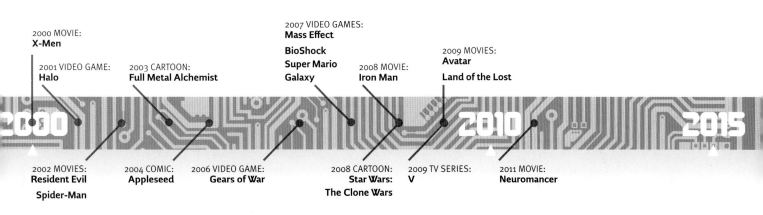

2000 MOVIE:
X-Men

2001 VIDEO GAME:
Halo

2003 CARTOON:
Full Metal Alchemist

2007 VIDEO GAMES:
Mass Effect

BioShock

Super Mario Galaxy

2008 MOVIE:
Iron Man

2009 MOVIES:
Avatar

Land of the Lost

2000

2010

2015

2002 MOVIES:
Resident Evil

Spider-Man

2004 COMIC:
Appleseed

2006 VIDEO GAME:
Gears of War

2008 CARTOON:
Star Wars: The Clone Wars

2009 TV SERIES:
V

2011 MOVIE:
Neuromancer

Gathering references

Gathering references is a vital part of any painting. Every aspect should be covered; every detail, no matter how trivial, should be given at least some consideration before the painting is started.

Things can be tweaked and adjusted on the canvas as the painting develops, but the clearer the objective is at the onset, the smoother the process will be.

Where to start
Photographs, movie stills, and other paintings are a good place to start. Be careful to select images for the right reasons and for the right piece. As an artist it's common to feel "over-inspired," in that there are too many things to draw from. Keep every inspiring image and begin to assemble a directory of images. Not all of them will be appropriate for the same project, but a time will come for each source of inspiration to be used. This image-gathering process also helps to establish a personal style—rather than having a vague idea of what makes one unique as an artist, strive to make concrete definitions of individual preferences.

Reference gathering for originality
Nowadays there has been a multitude of fantastic artwork created in all genres. This makes it increasingly difficult not to be unintentionally derivative of another artist's work. A big part of reference gathering is learning what has been done. It's common for an artist to create something without realizing that it is very similar to an existing image. This can be frustrating, as it makes the work appear to be taken from another source. By being aware of what's been done already, it's easier to find new ground to cover.

▲ **Jungle creatures**
Jungles are rich with flora and fauna. Use these organisms as starting points for unique designs.

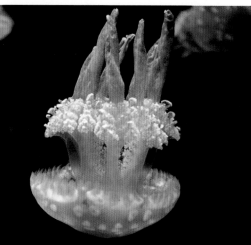

▶ **Deep-sea creatures**
The oceans are filled with bizarre life-forms. The shapes and colors of marine life offer an endless source of inspiration for exotic alien design.

▶ **Natural phenomena**
The spectacular drama and violence of natural phenomena such as volcanoes provide great inspiration for other-worldly design.

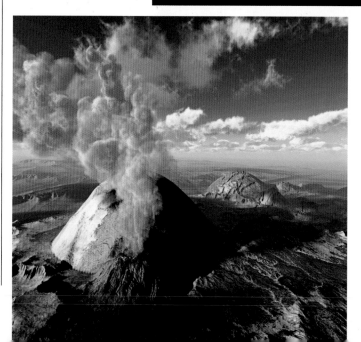

Exercise: Alien plant

Combine the reference photographs (right) of a coconut tree, a bug-infested plant, and a banana flower to create a unique plant. Keep the basic structure of a plant in mind: root, flower, leaves, and fruit.

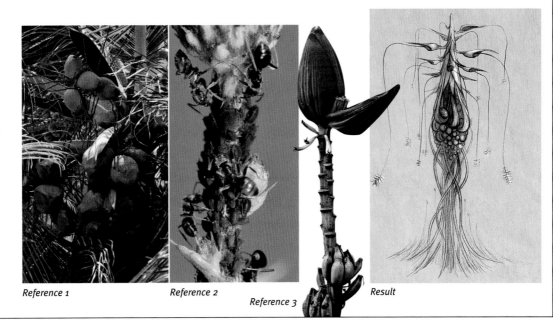

Reference 1 *Reference 2* *Reference 3* *Result*

Exercise: Fungus tree

Use this sketch of a banyan tree as reference for the overall shape and formation of an alien tree. Use the internal structure and details of fungus to give the alien plant an exotic feel. Small details such as veins and vents give the design additional elements of interest and complexity.

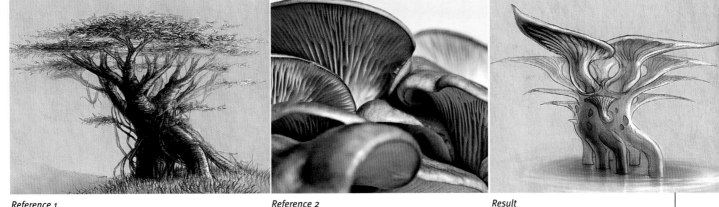

Reference 1 *Reference 2* *Result*

The natural world as a model

Nature is the ultimate source for design inspiration—an artist can find endless inspiration from the natural world.

Understanding the patterns and visual relationships of the forms in the natural world is a fantastic asset for any artist. The science fiction genre calls for a great deal of invention, both organic and artificial. Although the world is almost entirely explored, there are still flora and fauna from the deep sea and remote jungles that would appear alien to most human beings.

The natural world not only offers a great deal of inspiration, but it also demonstrates how things form, grow, and interact with one another. Aerial photographs give a great sense of the macrocosm of nature. What may appear as chaos from a foot away takes on a startlingly coherent sense of organization from 1000 feet away. Understanding the relationships between microcosms and macrocosms helps to give an artist the tools to design vast new worlds.

The man-made world as a model

The world we live in is at times indistinguishable from what would have been considered science fiction as little as twenty years ago.

Technological expansion is vast and rapid, thus creating a great deal of fantastic reference to draw upon when creating science fiction artwork. Conversely, this expansion presents the artist with a challenge—how can one's creations read as truly fictitious and original when so much of the real world is already pushing the boundaries of fiction?

Be aware of your surroundings

As an artist, it is important to be a keen observer of the world around oneself. This is true for any genre of art, since observation skills are the backbone of representational artwork. In science fiction, the challenge is somewhat skewed, as one is not looking to simply observe and report, but to reinvent, elaborate, theorize, and expand. By being well aware of the level of sophistication of contemporary society, the artist is able to truly look forward and avoid unintentional reinvention of existing items.

A good knowledge of modern communications devices, computers, automotives, aircraft, industrial machinery, weaponry, fashion, architecture, engineering, and accepted scientific knowledge (as well as the most "out there" theories circulating in the fringe circles) are valuable assets to a sci-fi artist.

Levels of complexity

Often in science fiction, one expects to see an added level of complexity to existing technologies. Elaborating on what exists is a great way to develop new imagery, but be careful not to add complexity merely for the sake of it. While every minute detail in a painting doesn't have to be completely justified, some sense of logic should dictate the appearance of even the most advanced-looking subject matter. One rule to keep in mind is human interaction— consider how people would interact with an imagined item. Does the scale accommodate a human? Is the object tangible? Asking these sorts of questions helps to give some sense of believability to scientific conjecture.

Unlikely sources

The fabrication of even the most mundane of modern objects can provide unexpected inspiration. Always be on the lookout for an intricate hinge or hydraulic system—nowadays, inspiration can come from unlikely corners of the industrial design world. These areas offer some inspiring forms that might well be overlooked.

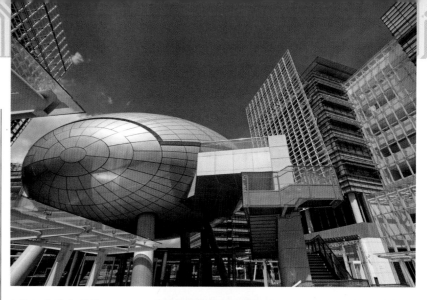

▲ **Futuristic building**
Visions of the future exist in our man-made landscape. Look to these designs when designing new architectural forms.

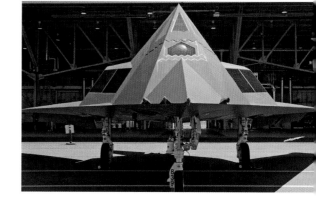

▶ **Modern warplane**
Military craft could easily be mistaken for something from another world. Reference these designs to create spaceships and futuristic vehicles.

Conventional sources

Military technology is prevalent in many of the science fiction sub-genres. As civilians, it's easy to be unaware of the state of contemporary military technology. Do some research and see what exists. Look into the rumors and speculation surrounding the more secretive projects. This sort of speculation isn't particularly valuable in most walks of life, since it is nearly impossible to substantiate, but as an artist looking for inspiration, these rumors are ideal.

Concept car design has a long-standing tradition of introducing the world to fantastic visions of futuristic design. It's interesting to consider the concepts from decades ago that represent an antiquated vision of an imagined future. Be careful with this avenue of reference, since it can lead to a more nostalgic science fiction vibe—this is fine as long as this is the intended style of the artwork. The shapes and structures of these visionary designs can be applied to all avenues of design.

Seeing the abstract

Often the discovery of a small group of unusual abstract shapes can lead to the conception of an entire futuristic city. Look past the literal intention of objects when looking for inspiration. Be on the lookout for captivating abstract shapes and forms when looking to create a new design. The cropping of photographs can help to isolate key shapes, which can then be expanded upon.

▲ **Abstract shapes**
Be on the lookout for interesting shapes. This section of machinery could inspire the layout of a futuristic city.

Man-made materials

While the world of man-made materials is broad and far-reaching, there are certain materials that go hand in hand with science fiction. Below are some looks to consider.

Give thought to how these various materials contribute to the storytelling in each painting. Materials are an important way to add functional clarity and aesthetics to artwork, but they also provide a narrative sub-text about the subject matter.

Slick and clean

Chrome

Glass

Brushed metal

L.E.D. lighting

Monitors

Gritty and complex

Industrial noise

Rusty metal

Leaks and stains

Grunge

Tangled wires

Designing an image

The way in which reference imagery is interpreted and synthesized to create your design is equally as important as the nature of the material.

There is no need to impose undue limitations on a creatively boundless area, but some sense of logic must dictate the early stages of the process. Just because something can be created does not necessarily mean it should. A small written paragraph can often help to frame one's ideas and clarify the intended outcome of an image.

Visual problem solving

Try to approach design in terms of practical visual problem solving. This holds true for every genre, but because science fiction requires so much invention, a greater focus must be given to design. Each of the step-by-step projects in Chapter 3 is introduced with a brief description followed by a concept design panel. This helps to outline the type of questions that need to be addressed to successfully solve the specific challenges presented by each concept. This process helps to provide a logical framework for the imagery before the pencil hits the paper.

Form vs. function

Designers often stress the importance of establishing a balance between form and function. The scales can tip in either direction depending on the requirements of the design and the aesthetics of the designer. In science fiction, try to consider the attributes of the hypothetical culture in which an object is manufactured or created. Is the culture utilitarian, ostentatious, or somewhere in the middle? How do these attitudes affect the overall appearance of various objects? Just because a culture may be more utilitarian doesn't mean the imagery cannot be interesting. This is where the artistic foundations come into play—with the language of the design clarified, the artist must then give consideration to how the attributes will be presented. The focus on presentation should only be delved into once the rationale behind the imagery is established.

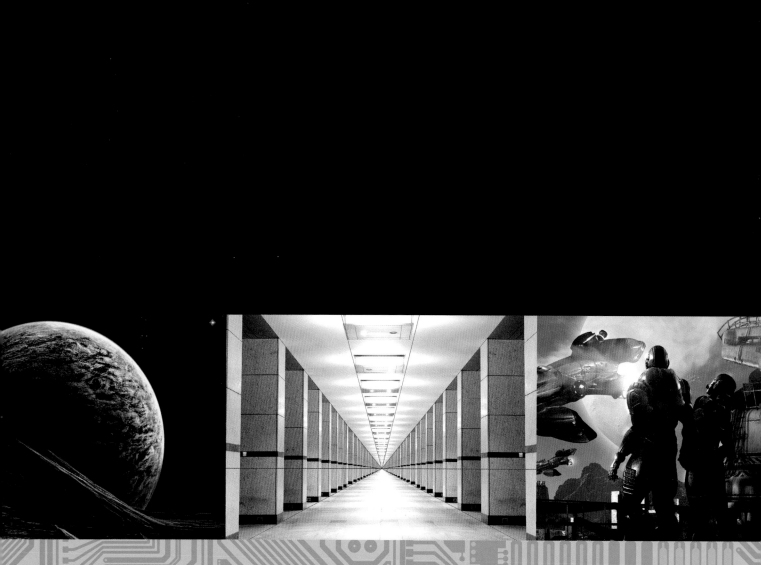

step paintings shown in Chapter 3. These skills are the technical backbone of all representational image making–be it sci-fi, fantasy, or real world subject matter. Be sure to experiment with the techniques outlined in this chapter before attempting the step-by-step paintings. These technical skills add believability and interest to artwork. Topics such as perspective and anatomy may feel dry at first, but they help add vitality and dimension to images–without a solid grasp of

audience. Science fiction is a challenging genre, since it requires a great deal of imagination as well as observation. Other genres allow the artist to record directly from the natural world, which is not always a possibility when creating sci-fi imagery. This chapter will provide the necessary skills to take an idea from your imagination to the canvas successfully. The strength of an idea is always critical, so be sure to combine these skills with the conceptual design and research themes covered in Chapter 1.

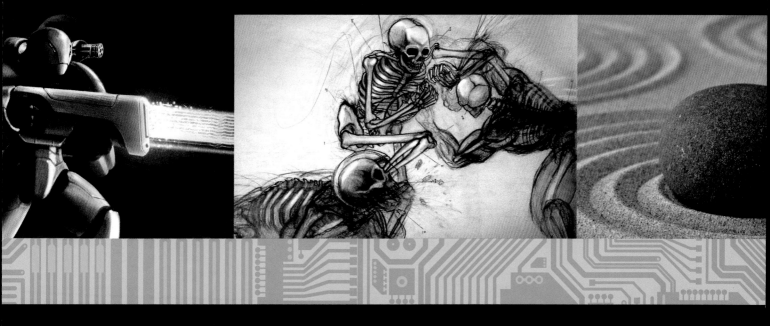

Traditional tools

Traditional tools and techniques are better suited to the developmental stages of science fiction artwork, such as producing concept sketches, and line-art for later scanning.

Traditional tools

While digital tools allow for fast rendering, nondestructive alteration, and quick experimentation, which make them very well suited to the complexity of science fiction artwork, traditional drawing skills are still a crucial skill for an artist to develop. Think of these tools as a means of planning a finished painting. Use these mediums to quickly explore and invent subject matter. Keep in mind that these sketches can be easily scanned and integrated into the digital process. Mediums such as gouache, watercolor, oil paint, acrylic paint, and airbrush have been used in science fiction artwork with fabulous results over the years; however, tight deadlines and the tendency toward iteration in the design process are leading more and more artists working in the genre toward digital painting techniques (see page 32).

Pencil

A wide range in pencils is essential for creating successful drawings. H2 and HB pencils are recommended for the initial construction of the drawing. Working with lighter lead at this stage allows the artist the ability to clean up construction lines as the drawing progresses. 2B, 4B, 6B, and 8B are recommended for executing the final drawing. Use the darker pencils sparingly to create isolated areas of strong contrast. Darker lead becomes increasingly difficult to erase, so leave these values to the end to ensure they are placed accurately and will not have to be revised.

Eraser

Think of the eraser as a drawing tool as well as a way to clean up mistakes. Use a blade to maintain a sharp edge on one side of the eraser when drafting—doing

Eraser

Willow charcoal

Charcoal sticks

Grayscale markers

Pencil sharpener

Pencils

so makes the eraser a much more versatile drawing tool. Having a soft edge and a hard edge allows you to create a variety of lines. White cubic erasers are recommended; prism-shaped erasers are also desirable but can be difficult to find. Pink erasers tend to leave pigment on the page and be more destructive to the surface of the paper, and are therefore not recommended. Kneadable erasers are also an option, but tend to lack the precision of cubic erasers.

Blending stumps

Blending stumps are useful for softening edges and blending values together. They are suitable for use with graphite, chalk, charcoal, and conté. They are sold in a variety of sizes allowing for different levels of detail and control.

Willow charcoal

Willow charcoal is a very forgiving medium. The softness of the charcoal makes it very easy to manipulate and edit. This type of charcoal is recommended for the initial construction of charcoal/chalk drawings. The medium can be frustrating, as it is very easily smudged or removed from the surface of the paper, and is therefore not recommended for final rendering of images.

Charcoal sticks

Charcoal comes in a variety of forms. Typically the more compressed types will produce lines with more density of material; i.e., more charcoal stays on the page. Experiment with different types to see what produces the most desirable results. Remember, more compression means increased indelibility. Sticks come in square and cylindrical forms. When deciding on shape, consider the intended look of the drawing. Square edges will produce sharper lines. Holding the stick sideways allows the artist to block in large areas quickly and produce an even tone. Charcoal adheres better to rougher drawing surfaces, however charcoal can produce soft, subtle effects on smoother surfaces.

Conté

Conté consists of charcoal or graphite powder mixed with a wax- or clay-based material. This medium works best with a rough, dense paper, since the

Ballpoint pen

Spray Fixative

Chalk and charcoal are messy mediums and lack permanence. The medium never dries and will remain active and malleable for years. This causes the drawings to substantially degrade over time. Spray fixatives help to bind the pigment to the surface and offer slightly more permanence to the drawings; however, the drawings are still prone to smudging. Be sure to carefully follow the spraying instructions. Over-spraying or holding the can too close to the page can be damaging. Overall, expect a slight darkening to the drawing once sprayed.

Paper

sticks are quite sharp and can be destructive to delicate surfaces. Conté comes in a variety of colors—typically black, white, and a range of earth tones.

Chalk pastel

Chalk pastels are an excellent way to quickly experiment with color. They can be used in conjunction with nearly all other mediums and are relatively easy to erase and manipulate. Like paint, higher quality pastels consist of higher quality pigments and produce richer hues. Higher quality pastels also have better flow—they apply smoothly to most surfaces and are less susceptible to breaking or crumbling.

Grayscale markers

Grayscale markers allow for quickly executed values studies. These markers are a good way to add value and shading to ink line drawings. Be sure that the ink has dried before adding any strokes with the markers. This is a wet medium and can cause ink to smudge if not sufficiently dry. The different tips allow for precision line work and quick block-ins.

Ink

Ink pens are excellent for precise line work and crosshatching. Be careful with cheap ballpoint pens—when mixed with other mediums, such as markers, black ink can take on a purple tint. Fluid inks produce light washes of color and tone. Ink combines well with most other mediums. It dries quickly, but be sure to allow for sufficient drying time—it is an indelible medium but is prone to smudging when not entirely fixed to the page.

Chalk pastels

Right-angle ruler

Ink and pen

Paper

Choosing the right paper for the right drawing is crucial. Most of the time it's a matter of preference, but some mediums won't adhere to certain papers. Smooth surfaces tend to work better with ink and markers, whereas a rougher surface is typically better suited to chalk and charcoal. Consider the color of the paper and how it will affect the drawing. White paper allows negative space to read as the white value in a drawing, and when dealing with toned paper, whites must be added in to account for the darkness of the page.

Tracing paper

Tracing paper is useful for checking the perspective on a drawing. Having the grid laid out on a separate transparency allows for accuracy without a messy build up of construction lines (see page 45).

Rulers

Ruler sets containing ellipses and right angles are useful for drafting architecture and industrial design assets. Developing a steady hand and the ability to draw straight and curved lines freehand is more desirable, but these tools allow for added precision when needed.

Easel

A standing easel allows for a more energetic approach to drawing and painting. Working hunched over a drafting table tends to tighten up the artist's approach to drawing and painting. A standing approach allows for more range and fluidity of motion. When standing, an artist can utilize the entire arm starting with the shoulder, as opposed to being limited to the motion of the wrist when seated.

Easel

Digital tools and techniques

When approaching a painting, the consideration of process and tools is of great importance. Artists have a wide variety of mediums and methods to consider, but tight deadlines and the likelihood of iteration and alterations make digital painting far more desirable.

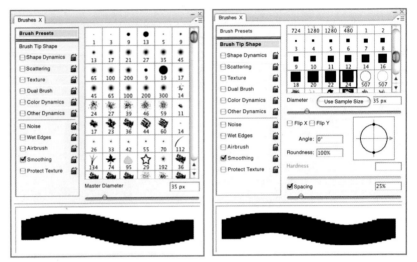

Traditionally, mediums such as airbrush, gouache, acrylic, and oil paint have been used in sci-fi illustration, but contemporary artists working in the genre can rarely afford the added time and potential complications that arise from the use of traditional media. Much of the theory and process of traditional media is directly transferable to digital painting. Digital techniques allow for bold experimentation without any destructive consequences. Given the highly detailed and experimental nature of science fiction artwork, this book will focus predominantly on digital painting techniques; however, much of this theory can be applied to conventional hand painting. Photoshop is an industry standard for digital painting, therefore instruction will be given with specific reference to the Photoshop interface.

Basic theory

Always work from general to specific. It is easy to get caught up in detail far too early on in the creative process. Focus on building the levels of detail in a painting in a coherent step-by-step fashion. Try to accurately establish the dominant masses of a painting throughout the entire composition prior to the execution of subtle detail; doing so will prevent unnecessary repainting of laborious detail. Imagine you are painting a figure and have decided to focus on the face before the overall pose is established. The face is perfectly rendered, but once the body is further refined it becomes apparent that the position of the head is inaccurate—this can lead to the loss of a great deal of work and could easily have been avoided through adherence to diligent process.

▲ Brush menu

This is the brush menu in Photoshop. Experiment with these settings to customize the look and feel of brushwork.

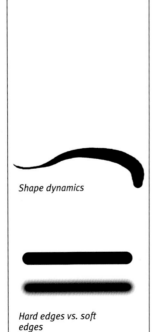

Shape dynamics

Hard edges vs. soft edges

Software

There is a wide variety of software platforms available to digital artists. Photoshop is the most versatile and therefore highly recommended. Corel Painter and ArtRage are also worth experimenting with. Using 3D modeling software can be a great way to block out the basic forms of a painting. Maya, 3DS Max, and Google Sketch Up are all suitable for this type of work.

Brushes

Photoshop allows for an endless variety of brushes. Basic brushes come with the program and custom brushes can easily be created or purchased online. In theory, the basic round brush is versatile enough to create any painting; however, the use of custom brushes can speed up the process significantly. Following is a breakdown of the various controls to define the look of a brushstroke. (All the features can be found under the brush window—hit F5 to bring up the brush window—additional options are found under "Brush tip shape" in the brush window.)

Shape dynamics

Tablets come with drivers that must be installed to ensure optimized function. Turning on "Shape dynamics" in the brush window makes the tablet respond to the amount of pressure the artist applies with the stylus. Heavier pressure will produce bolder lines, which is very similar to how a paintbrush responds to pressure.

Hardness

This allows for control over the hardness and softness of edge quality. Softer brushes are easier

to blend and tend to be more suited to lighting and atmospheric effects. Harder edges offer more precision but can be jarring if used incorrectly. Keep in mind that sharp detail will pop out at the viewer and soft detail will recede into the painting—use this to define certain areas of a painting and take focus off of less important aspects.

Opacity

The lower the opacity is set, the more transparent a brushstroke becomes. In the early stages of a painting the artist should typically use a high-opacity brush to block in solid shapes. Lower opacity helps to blend colors/values together and produce softer, more subtle effects. Opacity can also be adjusted to individual layers, thus allowing for additional control.

Flow

Flow can be understood as a digital representation of the viscosity/fluidity of the paint on a brush. High flow produces strokes reminiscent of a wet media, and low flow mimics dry brush techniques.

Spacing

Typically, spacing should be set to zero to produce a smooth stroke. In certain situations, spacing can be used to create interesting effects.

Scattering

Experimenting with scattering can produce haphazard brushwork reminiscent of spattered paint. This technique can be a good way to break away from the often overly perfect, plastic surface quality of digital paintings. Coupling scattering with spacing is a great way to produce randomized strokes.

Brush-based tools

All of the following tools can be controlled in terms of hardness, diameter, shape, flow, opacity, and various custom dynamics.

Paintbrush tool

This is the primary tool for digital painting; however, there are many other tools that possess similar functionality. All brush-based tools can be controlled through the Brush window (hit F5 to access this window). Quick changes to brushes can be made by hitting the button on the tablet pen. Alt····}click on an area of the composition to sample colors while painting. This is much more efficient than constantly picking new colors. Some artists may like to paint quick swatches of the colors they intend to use in a painting outside of the confines of the composition and then use these swatches like a conventional palette by alt····}clicking them.

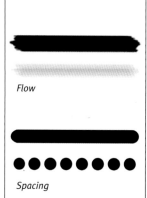

Opacity

Flow

Spacing

Scattering

Eraser tool

Because elements can be divided into layers, the eraser can be applied to a painting much as an eraser would be used on a graphite drawing. Keep in mind that all of the same controls and different brushes can be used when erasing, so the edge quality can be highly refined by using this tool in conjunction with the brush tool.

Clone stamp tool

This tool allows the artist the ability to replicate specific areas of the painting with the control of a brush. This can be particularly useful when texturing. A section of photographic or highly rendered texture can essentially be used as a palette. Hit alt to sample from a specific area and then paint normally to reproduce that area. Clone stamp has a variety of sample options: all layers, current layer, or current and below. Redefine source points often to avoid repetitive-looking textures.

Dodge tool

The Dodge tool allows the artist to add highlights to a painting. Dodge will find an accurate highlight value for each color, which makes it more efficient than hand picking highlight colors. Dodge has a range allowing for the introduction of highlight to shadow, mid-tone, and highlight areas. Note: Dodge only works on one layer at a time.

Burn tool

Burn allows for the adding of shadows to the elements of a single layer. Burn can be very quick to crush colors to pure black, which is rarely an accurate depiction of shadows. Use this tool sparingly to avoid excessively dark areas.

Blur

Using the blur brush allows for the precise positioning of blurs. Blur filters will affect the entirety of a layer or selection, which can make them undesirable for precision work.

Custom brushes

Any grayscale image under 2500 x 2500 pixels can be converted into a brush. To create a brush: Edit····}Define brush preset. When designing a custom brush, give some consideration to the type of stroke desired. Brushes can help to define internal detail and edge quality.

Some brushes have a great deal of versatility, and others are highly specialized. Use these brushes to mimic traditional mediums and to apply quick surface and texture effects.

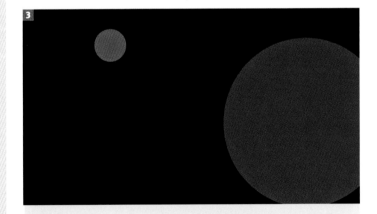

Digital hardware

Graphics tablets

Graphics tablets are vital for digital painting. Painting with a mouse is possible, but can be extremely frustrating, since it is in no way a reflection of actual drawing and painting. There is a wide range of options when selecting a tablet. A 6 x 8 in. (15 x 20 cm) workable surface is recommended. Anything smaller can be awkward, and the larger tablets are difficult to transport. Monitor-based tablets are also available. These are the most expensive option, but are well worth the investment. Standard tablets translate the artist's drawings from the workable surface of the tablet onto the screen, which tends to feel a bit unnatural at first. Monitor-based tablets are a closer representation of analog drawing and painting, since the pen is applied directly to the image. If you usually work in traditional mediums, you may find the transition from traditional to digital tools challenging, since the surface of the tablet is much smoother than paper. Try placing a sheet of paper over the surface of the tablet. This will offer slightly more resistance when painting and produce a more natural feel. However, the paper will cause the tip of the pen to wear down at a faster rate. Be sure to correctly install all relevant drivers and software to optimize the performance of the tablet.

Dual monitor work station

Having two active monitors allows the artist to view reference material while painting without having to shuffle back and forth. This style of workstation is an industry standard for digital artists. Be sure to adjust the monitors so that the image is not stretched. Any distortion to the height–width ratio will give an inaccurate representation of what the final printed image will look like.

Scanner/printer

Combination scanning and printing units are a desirable piece of equipment for digital artists. Being able to scan hand-rendered sketches is an aid to the artistic process, since it allows you to combine traditional and digital elements. Printers are helpful for the examination of your work. Getting the work off the computer and reviewing a printed image is a valuable exercise.

Application

The rendering of this planetscape will demonstrate a standard approach to digital painting, which can be applied to the exercises in this book.

1 PREPARATION: Begin in grayscale to establish the overall value range (spread of lights and darks). Use a large brush to block in the dominant shapes of the composition. Keep the edges hard to promote visual clarity and definition.

Divide layers based upon depth. The layer lowest on the hierarchy should express the area farthest away from the viewer. Dividing the layers in this fashion allows for greater control, and a logical layout of assets. Control⸺click on the thumbnail image of the layer (found in the Layers window) to make a clean selection of the contents of that layer. These layer selections allow color and detail to be added only to the desired area without any lengthy cleanup.

2 BLOCKING IN: Lay in solid black to express the void of space. The Paint bucket tool allows you to block in large solid areas quickly. Simply select the tool and click on an empty layer to fill.

3 DEFINING PLANETS: Select a large, round brush with a hard edge, and make a single mark to define the shape of the planet. Use the Transform tool (Edit⸺Transform) to make adjustments to the scale and position of the object and add the second planet.

TIP *In this instance the planets have been blocked in using their mid-tone value. This decision was made to ensure that they pop out and read when placed on a black background. Often objects will be blocked in using their shadow value, but in this case the planets would have blended into the background. Blocking in objects based on their highlight value is not advisable. This would create extra work, since shadows tend to be an object's dominant spatial mass.*

4 ADDING LAYERS: Layers can also be used to do quick experimentations. Any changes that could potentially be destructive to a painting should be tested on a separate layer so that they can be easily discarded if deemed to be undesirable.

5 GROUND PLANE: Again, use the mid-tone value to block in the basic shape. A hard brush set to 100% opacity allows for clearly defined silhouettes. The standard round brush with Shape dynamics turned on is suitable for this portion. Use slightly less pen pressure at the tips of the shapes to give a finer line. Brush size could also be reduced when dealing with the edge detail, but relying on pen pressure makes for a faster execution.

6 BASIC GROUND PLANE SHADOW: Apply a basic shadow to the planets and ground plane. The shadow can either be applied directly to each of the corresponding layers, or in three separate layers each positioned directly above the corresponding asset. More layers means more control, but it can also make for larger file sizes. To minimize file size, merge layers together once the desired appearance is achieved (Layers⸱⸱⸱⸱⸱⸱⸳merge layers).

7 LIGHT SOURCE: Before painting of the shadows is done, a decision about the light source must be made. One of the keys to good painting is the use of highlight and shadow to define volume. In addition to creating volume, lighting also affects the overall composition. So, give some consideration to what sorts of shadows and highlights will be created based upon the positioning of the light source. Once a light source is decided upon, be sure to remain consistent with the application of highlights and shadows based upon that light angle.

8 PLANET SHADOWS: Make a layer selection of the planet shape. With this selection made, paint strokes will only affect the selected area. Use a large, soft brush with full opacity to apply the

shadow. Simply tap the pen on the surface of the tablet once to get a spherical shadow. The soft edge on the brush creates a smooth transition from shadow to mid-tone; if a harder edge brush were used, the results would appear jagged and unnatural. The shadow color can be sampled from the black of the background.

9 GROUND PLANE SHADOW DETAIL: Define the shadow side of the spikes with a hard brush. Consider the base geometric structure of these features and how light would hit the surface. The shadow can express a small amount of surface detail, but don't get caught up in a lot of texture painting at this stage—focus more on defining the basic volumetric structures of the painting. Based upon the angle of the light, cast shadows should appear on the ground. Drop the opacity and hardness down to roughly 20% when painting these shadows. The shape of the shadows helps to define the light angle, but also accentuates the lay of the land. The right side of the ground plane shows a subtle incline; make sure the shadow appears to travel up this incline.

10 HIGHLIGHTS: With the mid-tones and shadows defined, the highlights can be tackled. The highlights can be applied with a lighter value of paint corresponding to the angle of the light, but Photoshop offers other possibilities. Here is a tip for executing highlights quickly. Make a new layer. Set the Blending mode of the layer to "Color dodge."

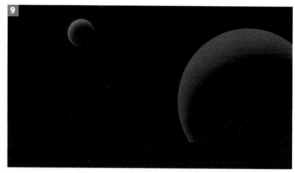

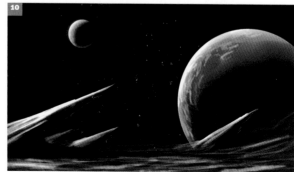

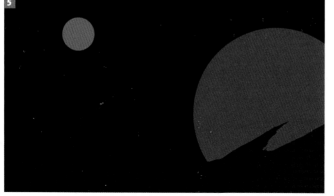

Using the Paint bucket tool, fill the layer with solid black. Because of the blending mode, the black will not be visible. Now select the Dodge tool and set the range to Shadows (if using Photoshop CS5, turn off "Protect tones" in the Dodge options). Use this brush to define the areas of highlight. Subtle detail can also be introduced into the shadow areas with this method. Let some of the mid-tones show through; don't push the painting of highlights so far that the values transition directly from highlight to shadow. Again, consider the geometric properties of the various objects. The planets are spherical, so use an ellipsoid rim light to define the highlight area. The tops of the spikes are much flatter, so let the motion of the brushstrokes reflect this. The direction at which a brushstroke is applied helps to define the volume. Layer selections can still be made to avoid painting highlights outside of the parameters of the various shapes. If you make a mistake, simply paint with a solid black brush to eliminate highlights. The highlights should give a rough description of the surface/texture of these objects. Keep in mind that highlight and shadow are used to express volume, so only apply highlights to the portion of the object facing the light most directly.

11 BASIC COLOR PASS: The most efficient way to perform this color pass is to create a new layer and set the Blending mode to Overlay. Then simply use the Paint bucket tool to fill the layer with the desired color. This method allows for quick exploration of different palettes. Start with one color and then use Image adjustments to manipulate the color and experiment with different looks. Start by simply adding one color to express the overall atmosphere of the scene. Additional colors can be added in later passes. The palette of this specific image is quite limited, so a one-color pass is useful in defining the overall look; however, more complicated palettes may call for a wider spread in hues at this preliminary stage.

12 ADDING FINE DETAILS: Some finer details can now be added to the surfaces of the planets and ground plane. The smaller planet is a gas giant and should have softer detail. Use a brush set to 20% hardness and 20% opacity to define this area. Ensure that the detail doesn't obliterate the treatment of highlights and shadows. Source some reference material to ensure accurate results. Make sure that detail reads as being organic—if the brushstrokes run straight across horizontally, the 3D spherical structure of the planet will appear to flatten to a 2D circular shape.

13 BASIC PLANET TERRAIN: A basic impression of terrain is given to the larger planet. Add small hits of orange light to create the sense of cities on the distant planet. Rather than painting each individual light, turn on the Scatter setting to give quick, randomized pockets of detail. The Scatter settings can be fine tuned to produce the desired result. Experiment with different scatter settings to define these distant cities, but make sure that the scale of detail appears accurate.

14 TEXTURING 1: Use photographs such as the ones opposite to define the surface of the ground plane and larger planet. Open your photos in Photoshop and drag them onto the painting. The photo will automatically become a new layer. Make sure to use photos of an equal or higher resolution to the rest of the painting to ensure high quality and consistent results. Set the Blending mode of the new layer to Overlay. The colors of the photo will be apparent. The colors can either be corrected using Image adjustments to match the painting, or removed so that only the texture from the photo is added, and the color omitted. To remove color, hit Image····⟩Adjustments····⟩Desaturate. Useful tools for color matching include Hue and Saturation, Color Balance, and Levels. All of these options can be found under Image····⟩Adjustments. Use the Transform tool to conform the details of the texture to the structure of the objects. If the texture were

▼ **Blending modes**

The screengrabs below show how to access blending modes. Using blending modes is a great way to add color, light, shadow, and texture to an image. Experiment with the various modes to become familiar with the possible results.

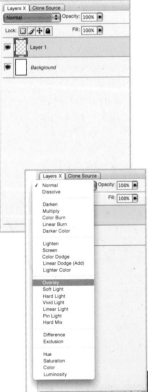

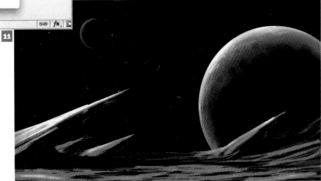

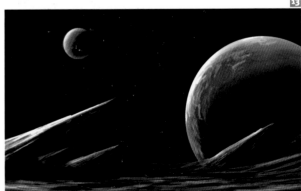

▶ Transform tool

Transform is a powerful tool. This is a great way to quickly alter the scale, orientation, perspective, and proportion of a layer or selection.

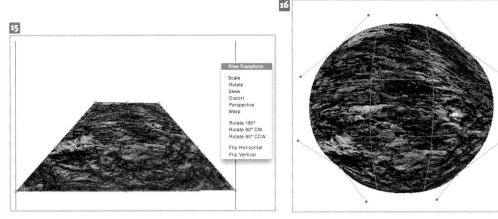

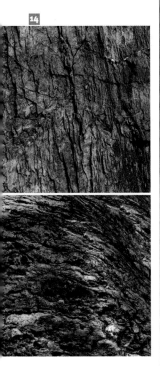

▲ Using textures

Photographic textures allow an artist to add a convincing surface quality to a painting without the need for laborious rendering. Take care to ensure that the photographs merge naturally with the painted elements.

applied without any sort of transformation, the objects would appear flattened. Make sure that the scale and flow of detail corresponds to the earlier painted portions.

15 TEXTURING 2: The texturing task is best divided into logical sections. Begin by simply texturing the ground plane. Use the Warp function to account for the slope on the right side of the ground plane (Warp is one of the Transform modes). The spikes of rock should each be handled individually to ensure that the flow of the texture corresponds to the flow of the structure.

16 TEXTURING 3: Texturing the larger planet is more difficult, since the spherical shape requires special attention. Use Warp to pull the corner points of the texture in toward the center of the sphere—this will give the texture the appearance of volume.

17 ATMOSPHERE DEVELOPMENT: The atmosphere must remain very thin to maintain the visibility within the outer space scene. Create a new layer. Use a large, round brush set to 0% hardness and 10% opacity, and paint a stroke to represent a low-lying dusty atmosphere on the ground plane. The brush should be large enough that this pass is executed in one stroke.

18 RENDERING DETAIL: The basics of structure, highlight, shadow, mid-tone, color, and texture are

now established. Switch back to a small, hard, round brush and begin to render additional detail. This detail should help to merge the appearance of the photos with the rest of the painting. Try zooming in closer to the image at this stage to get a good sense of the finer detail. Custom brushes may be useful at this stage. When selecting a custom brush, look for a brush with an edge quality that represents the shapes seen in the texture. This will make the strokes blend seamlessly with both the painted and photographic aspects of the painting.

19 DETAIL REFINEMENT: The clone stamp tool can also be very useful at this stage of the painting. The overall shapes of the rocks in the foreground are somewhat simplistic and require refinement. The image is already so detailed that painting entirely new portions to the rock structure would be very labor intensive. Instead, use the existing texture detail as a palette and define the desired areas of texture by Alt-clicking them. Then reproduce the texture as needed to add more detail to the painting. Frequently redefining the source point from various areas helps to avoid a repetitive look to the textures.

20 BACKGROUND FINE DETAIL: Finally, the fine detail can be added to the background. Some stars should appear brighter and larger than others. For the large stars, simply dot the brush once. Setting the gradient tool to "Diamond gradient" will help to add quick halos to the stars.

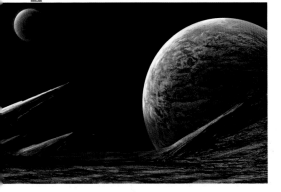

TIP *This general workflow should be considered when approaching the paintings in Chapter 3. Other specific instructions will be given when relevant.*

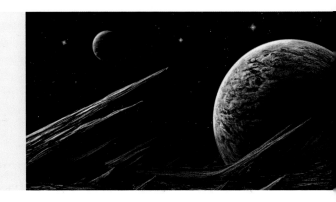

Composition

Composition is the underlying structural arrangement of an image. Arrangement is equally as important as content. A poor composition can detract from the legibility and beauty of an otherwise interesting painting. Conversely, a strong composition can make even the most mundane of subject matter engaging and visually compelling.

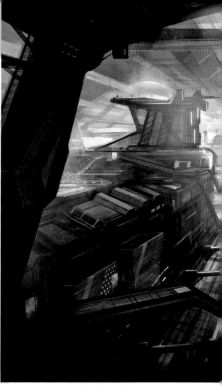

"Unearthly" by Lorenz Hideyoshi Ruwwe
A series of well-placed focal points leads the viewer though this interesting environment. This painting demonstrates a strong use of foreground, middle ground, and background elements to create a sense of space, structure, and scale.

A strong composition reinforces the hierarchy of visual elements of a painting while taking aesthetics and balance into mind. While there are no hard rules for creating a successful composition, there are certainly tried-and-tested guidelines, which can aid the process significantly. In science fiction artwork, the artist is confronted with a barrage of detail and complexity. Without an understanding of composition, an expertly rendered, wonderfully intricate painting can fall short. Seeing through the complexity of an image to the underlying simplicity of the composition is a vital skill.

All images exist on an abstract level. The squinting of one's eyes reveals the base forms of an image. Blur filters in Photoshop can also help in the examination of a painting's primary structure. On a subconscious level, the viewer perceives the overall shapes, position, and balance of a composition before they examine the subtleties of the content. If a painting is unsuccessful on this base abstract level, it will not capture an audience's attention.

▲ Seeing through detail
It's easy to get caught up in details and lose sight of the bigger picture. Applying a blur filter to an image is a great way to see past the details and analyze an image based upon its compositional structure.

▲ Poor placement
Notice how the flow of this image is interrupted by the placement of the elements. Awkward positioning can destroy the overall harmony and legibility of a composition.

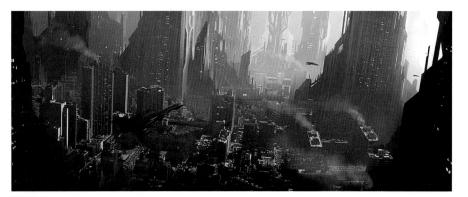

▼ Focal placement
This elaborate metropolis is rich with interesting detail. Positioning the ship on the axis point of the grid allows for an easy read in spite of the complexity of the image.

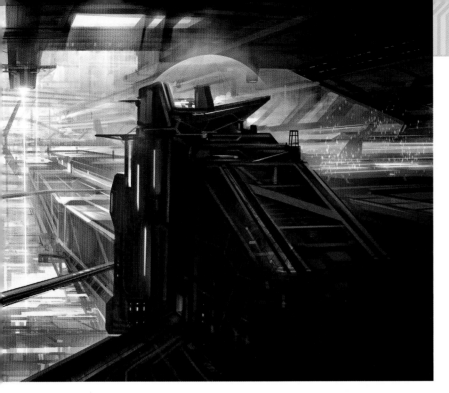

again disrupt the flow of the image. An image can have a variety of focal areas, but when multiple elements are introduced it is important to establish a logical visual hierarchy to the image. Having a variety of interest in a painting is great, but make sure that supporting elements do not become overly dominant. Focal points are created not only through successful placement of elements, but also through the implementation of different types of visual contrast. See Color theory (page 51) for a breakdown of different types of contrast.

Number of elements

As a general rule of thumb, compositions containing an odd number of elements tend to be more successful. Creating a triangulation between focal areas establishes a more fluid path than having two dominant elements, which tends to create a sense of visual competition. However, this could be desirable in an image expressing two dueling forces. Be conscious of these sorts of decisions—rather than treating these guidelines as hardened rules, try to use them strategically to support the concept and narrative behind each image on a case-by-case basis.

Avoid dead zones

Dead zones or dead ends refer to areas of a painting that disrupt the overall composition. Strong compositions aim to create a visual path that leads the viewer's eye through the scene, thus causing the viewer to take in all the various elements of the painting. The awkward placement of elements can cause tension. One frequent cause of this tension is referred to as "kissing" elements. This implies that two elements are just barely making contact—it is better to either have elements definitely overlap or space them in such a way that they have enough room to read individually. Dead zones can also come as the result of empty areas becoming too dominant. Negative space is important as it gives breathing room to the various elements of a painting and helps to fight visual congestion, but when this empty space becomes too dominant, the viewer's eye can get trapped in a dead zone and stay there. Be sure that the negative space serves the overall flow of the composition as opposed to making the path of the eye stop dead in its tracks.

Creative cropping

As an image develops, try experimenting with various crops and extensions to the canvas. Any additions or subtractions made to an image should aim to strengthen the composition. When working digitally, the artist has the option to experiment in a nondestructive fashion with various crops and extensions—make sure you utilize this luxury.

▶ Classical sources
Look to the past for compositional inspiration. Countless possibilities have been explored—use this wealth of imagery as a jump-off point to create new arrangements.

Start simple
Before delving into the realm of science fiction, take a look at more simplistic approaches to composition. Try to apply the harmonious simplicity of traditional Zen imagery. These minimalist compositions express the foundation upon which much more sophisticated imagery can be developed. Look to traditional landscape imagery and portraiture as a starting point for entering the complex world of image composition.

Preparing or examining a composition
Below are some guidelines and elements to consider, which will help you recognize and create great compositions.

Focal clarity
The focal point of the image should be immediately clear. The placement of a focal point is crucial. Typically the focal point should fall on or close to the intersection points on the "rule of thirds" grid. This grid divides the canvas into thirds on the horizontal and vertical planes. The intersection points are well-suited focal areas. Focal points that fall dead center tend to create a sense of stasis. A strong composition should lead the viewer through the entire scene. Placing the focal point too close to the edge of the canvas tends to create tension and

▲ Compositional use of values

Notice how the areas of high contrast in values are positioned in focal areas—this helps to draw the eye to the correct areas.

▼ Finding balance

When working on a painting for an extended period of time, it can become difficult to objectively analyze the image. Flipping the canvas allows the artist to take a fresh look at a painting to see if anything is out of balance.

Value range

A wide range in values (lights and darks) helps to create believability and interest in a painting. A strong contrast in value will create an area of interest. Images with a low range in values tend to appear flat and lifeless. Not all images need to portray a full range in values, but an extremely limited range will detract from the quality of the image. Consider the composition from an abstract perspective—the eye is drawn to areas of contrast, therefore if values are carefully placed, it is much easier to reinforce the intended visual path. Seeing value in a color image can be challenging—Photoshop allows the artist the ability to desaturate an image. Run this check to ensure the colors are expressing a wide range in value.

Unity

Compositions should feel harmonized. Shapes, values, colors, and placement all attribute to the sense of balance. Scrutinize paintings for areas that feel out of place or distracting. Harmony cannot exist without the elimination of disruptive elements. Use the foundational concepts in this chapter to identify and eliminate disharmonious elements.

Flip the canvas

Photoshop makes it easy to flip a canvas both horizontally and vertically. A composition should appear balanced regardless of how it is flipped. The logical structure of the painting may collapse once the image is flipped, but the overall abstract underpinnings of the painting should remain balanced.

Simplicity

Consider the use of basic geometric forms to underpin the flow of a composition. No matter how complex a painting may be in terms of subject matter and rendering, the overall flow of a composition should remain relatively simple. Try to implement basic shapes like circles, zigzags, diamonds, triangles, and figure eights to establish visual pathways. Being too obvious in this approach can make a painting feel contrived, therefore some disguising can be necessary. However, some compositions call for a very balanced pathway, particularly symmetrical compositions. Symmetry is difficult to pull off, but when done effectively it can be extremely powerful. Consider its use relative to the narrative of the image. Symmetry conveys stability and balance—make sure you are using it for the right reasons.

▼ ▶ Basic shapes

Create visual paths based on basic shapes to guide the viewer's eye through a scene. The path can remain very simple, no matter how complex the subject matter may become.

Shape language

With so much detail and complexity in science fiction artwork, it's difficult to know where to begin, and how to see the big picture without getting lost in details.

In focusing on details, it's easy to lose sight of harmony and create something that is rich in detail but visually chaotic.

Deconstructing shapes

When constructing a form in a drawing, it's important to have a good understanding of the geometric shapes that comprise that object. When composing an image or designing something, it is also important to be conscious of why you are selecting those specific shapes. Just because something is drawn accurately doesn't mean it is a successful solution to a visual problem.

Shapes have underlying connotations. There are subtleties to these rules, but typically rounder, softer shapes will convey benevolence and sharper, more jagged shapes will imply malevolence. Strong, solid shapes can communicate strength, whereas thin, delicate shapes can denote fragility and weakness. Plan your shape language in the same way you plan your composition and palette—with hierarchy in mind.

Recognizing and using shapes

Keeping a recipe or language of specific shapes in mind helps to keep the image from becoming unmanageable. These shapes can be geometrically primitive or infinitely complex. Whatever avenue is explored, try to keep either rhythmic consistency or deliberate contrast in mind. Give consideration to the negative spaces as well—these shapes may not be the focus of the image, but they help to balance the composition and tie elements together. When examining successful artwork, try to see through the intimidating complexity and sophistication of the image to the underlying language of abstract shapes. Being able to see past the literal aspects of the subject matter to the subtleties of the forms and how they relate to one another is a useful artistic skill.

Shape language in action

This image appears detailed at first glance, but it is very basic in terms of composition. The setting is a military barracks, so it needs to appear sturdy. The primary shape is a cube/square. Domes/circles serve as secondary shapes. The cylindrical exhaust stacks are the tertiary accent shape.

If this tertiary shape were too dominant, it would detract from the overall stability of the structures, but as an accent it provides a subtle visual contrast that gives the scene more interest. Keep this hierarchical approach in mind when deciding upon shapes.

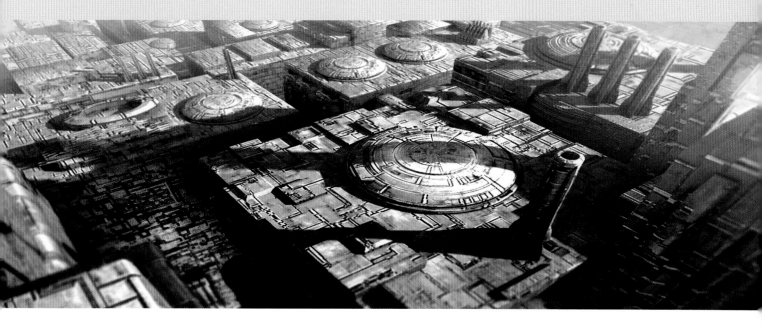

Anatomy

Anatomy is the backbone of successful figure drawing. Early artists paralleled doctors in their approach to understanding the human form. Now a great deal of material exists to describe the inner mechanics of the body, and artists can forgo a trip to the morgue.

◀ Quick gesture
To begin a figurative sketch, perform a gesture drawing. Try to express the weight, proportion, and energy of the pose as quickly and clearly as possible.

▼ Anatomy in motion
Understanding the skeletal system and how it moves is an important exercise when learning anatomy. Try placing a sheet of tracing paper over a photograph of a human in motion, and draw the skeletal structure of that figure.

▲ "Alien Princess Zoethomae" by Adriana Nieto
This image shows an imaginative exaggeration of the human form—the result feels alien, yet possible and functional. Striking this balance is vital when designing alien characters.

Life drawing, or drawing from a model is the best way to sharpen your observational drawing skills and gain a stronger understanding of anatomy. Medical anatomy courses are valuable for artists who desire a deeper understanding of the body and its form and function.

Gesture drawing
Gesture drawing aims to express the primary energy and weight of a specific pose. Gesture drawing should be approached quickly and energetically, but with a keen eye for proportion and weight. Look for the aspect of the anatomy that is bearing the weight of the figure. Express this tension in the execution of the gesture. Gestures can be reduced to one line—this line is known as the line of action. When beginning a figurative painting, try to express the entirety of the energetic properties of pose in one decisive line. Once that line is established, build up a basic gesture drawing to define the pose.

Getting under the surface
Depicting the human form without an understanding of the inner workings of the body will cause the drawings to appear flat and stiff. The human body is fantastically complex and intricate—the surface of the form offers a mere glimpse of the entirety of the form. These drawings illustrate the muscular and skeletal systems of the body. Drawing with an understanding of these systems leads to more accurate portrayals of the surface of the body. Pay close attention to the anatomical features that are visible on the surface of the body—these structures help to define the subtleties of the body's mechanics.

▶ Muscular system
Use this figure as reference for humanoid figures and a starting point for the creation of more exotic creatures. Understanding these muscle groups will add believability to your work.

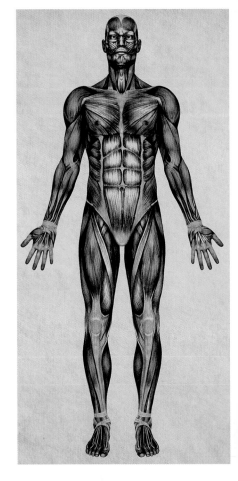

Armor study

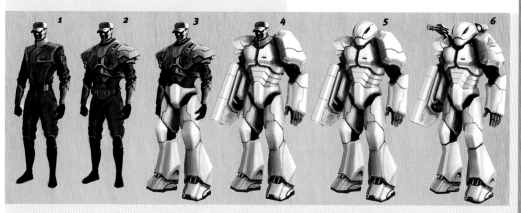

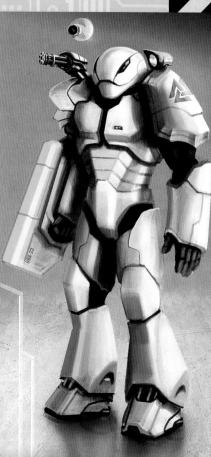

Science fiction presents unique challenges pertaining to anatomy. Consider the armor design of this astronaut figure. Armor has to be designed with a firm knowledge of the body's proportions and movements. The armor must accommodate the figure's range of movement (this will be reduced due to the bulk of the armor) as well as the physical structure of the inhabitant. Developing armor step-by-step is useful in ensuring a harmonious relationship between the function of the armor and the form of the figure.

1 Start with a sketch of a soldier in his regular fatigues. 2 Build up his armor with a secondary chest and shoulder plate. 3 Add on portions of armor, piece by piece, to ensure the anatomy fits. 4 The human hand reaches to the end of the wrist in the armor and controls a robotic hand. 5 Segmented abdominal pads suggest that the figure will still be able to bend. 6 Position the shoulder-mounted cannon.

▶ **Astronaut soldier**

Heavy armor is necessary to this design, but it's important to convey the idea that there is a human being under there.

Alien creatures

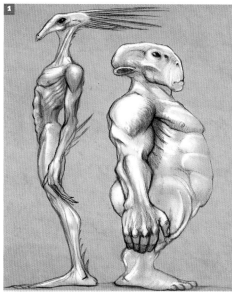

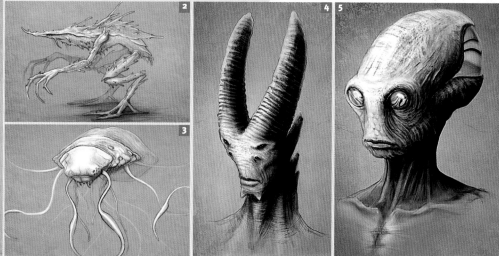

The creation of alien figures is an interesting anatomical exercise. The possibilities for the appearance of alien life are innumerable. Anything is possible. However, much of the successful alien designs use human anatomy as a foundation.

1 Consider the variation of human body types, and how those variants could be exaggerated to create new creatures.

2 Push that exaggeration one step further to create something even more alien. Elements of animal and insect anatomy can be blended with the human form to create unique body types. No matter how exaggerated or bizarre the forms may become, always ensure that the body still looks capable of movement. Ensure that the anatomical design decisions support the intended concept.

3 The marine-inspired design demonstrates the extent to which a creature can be manipulated. Science fiction offers the chance for profound invention and imagination—sometimes it's best to simply let your imagination run wild.

4/5 The face is typically the most identifiable and interesting aspect of any design. Doing head studies is a good first step when conceptualizing a fictitious creature. The designs show two possibilities for alien heads. Look to the animal kingdom for inspiration. As the appearance of aliens is entirely speculative, have fun with the design process and try to conceive unique designs that don't depend upon existing stereotypes.

Perspective

The method of drawing and painting in accurate perspective is commonly attributed to Brunelleschi, *c.* 1415. Prior to this development, paintings tended to appear flat and out of perspective, as they were not a true representation of spatial relationships as they occur in the natural world. Perspective communicates the relative position of objects to the viewer and each other.

▼ One-point perspective
Tracing the lines of perspective on a photograph is a good exercise to undergo before attempting to draw in perspective.

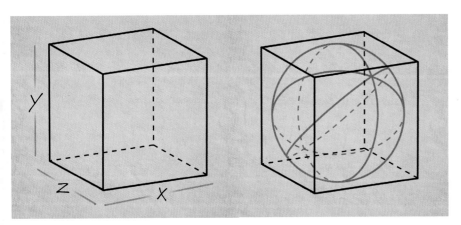

▲ Cubic volume
This image shows the x-, y-, and z-axis of a cubic volume. With the basic structure of a cube understood, more complex shapes can be addressed. Initially, a cube can be used to describe the footprint of any object. Drawing with cubic space in mind makes a grid much more versatile and accurate. All shapes can be contained within a cube or series of cubes, no matter how complex.

Introducing perspective

Drawing with accurate perspective can seem laborious and stifling at first, but the results are worth the effort. Perspective offers tangible three-dimensional properties to an image and adds to the volumetric illusion that makes representative artwork so captivating and impressive. Furthermore, a disregard for perspective discredits an artist's work as it shows a lack of fundamental comprehension of foundational art skills, and an inability to accurately depict objects in space.

Perspective exists in several common schemes or "grids," which are generally referred to as one-point, two-point, and three-point perspective. These three methods can be combined to produce an endless variety of results. With the three primary forms of perspective understood, an artist can accurately depict any conceivable form.

Choosing the right vantage point

An understanding of the methods used to create accurate perspective is vital, but it means little without the foresight to use it appropriately. Perspective helps to ground a viewer in the scene. Give thought to the location of the optimal vantage for each scene. When used appropriately, perspective becomes a very useful storytelling tool. Low-angle shots can be used to make an object appear large and powerful. High-angle shots can create a sense of weakness when applied to a figure; conversely, high-angle shots can create a sense of vertigo and altitude when applied to an environment.

Three dimensions

All forms in 3D space consist of an x-, y-, and z-axis. All perspective scenarios contain one or more vanishing points and a horizon line. The vanishing point is the area where lines of perspective converge—this convergence will invariably fall on the horizon line. The horizon line is the point at which objects appear flat to the viewer, or directly aligned with the viewer's line of sight/eye level. Objects below the horizon line will be viewed increasingly from above, meaning that the viewer will be able to see more of the top surface of a form as it recedes below the horizon line. Objects above the horizon line increasingly display their underside as they move upward. The top and bottom surfaces of an object will not be visible if located directly on the horizon line, as they are flush to the eye level of the viewer. Keep in mind that the horizon line can be tilted—this introduces another element to the equation. If the horizon line were straight, all vertical forms (i.e., the

y-axis of a cubic structure) would run straight up and down at 90 degrees. The vertical lines are relative to the horizon line; if the horizon line rotates, so must the vertical lines. Straight vertical lines should always create a right angle relative to the horizon line.

Breaking shapes down into cubic forms makes them easier to integrate into a perspective grid. When working with shapes such as cylinders and spheres, try to envision them contained within a bounding box (a cube that represents their spatial footprint).

One-point perspective

The term "one point" refers to the fact that this perspective scenario contains one vanishing point. Another way of looking at it is that only one axis is in perspective, in this case, the z-axis. A good way to familiarize yourself with perspective is to establish the perspective grid on a photograph. Trace two or more structural lines on the z-axis of an object and find the point at which these lines converge. This point of convergence is the vanishing point. All other structural lines on the z-axis should correspond to this vanishing point. Being able to identify the vanishing point in a photograph is useful as it can be deemed accurate (provided there is no distortion to the lens).

How to draw: This is the most common and basic form of perspective, but it can create very compelling effects. Start by blocking in the basic shapes of the painting. Some artists may prefer to start with the grid and add the shapes on top to ensure accuracy. Others may choose to do an initial block-in unencumbered by the constraints of a grid, and then add the grid later to clean up any inconsistencies in the shapes. Some revisions are inherently necessary throughout the execution of a painting or drawing. Having the perspective grid on a separate layer on the top of the hierarchy in digital projects is advisable. For traditional artwork, tracing paper can be a good way to handle perspective, since the construction lines tend to be messy and can detract from the overall appearance of the artwork.

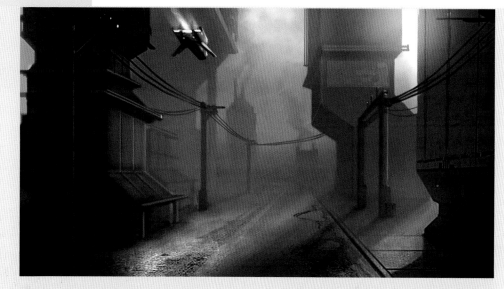

▲ This alleyway is constructed using a one-point perspective grid. Although the grid is simple, the sense of space is convincingly established and the volumetric properties of the structures feel tangible. Notice how the lines of perspective pull the viewer's eye into the page.

▼ Be sure to conform all lines on the z-axis to the perspective grid. Scrutinize each detail by tracing its trajectory to the vanishing point—doing so will ensure accuracy. One flawed line can ruin the whole scene.

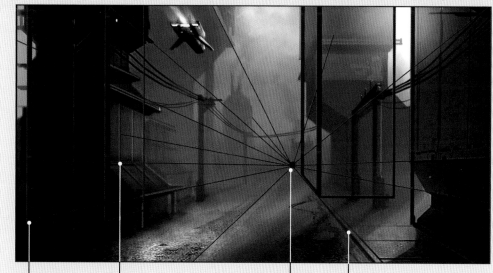

Cubic primitives *Horizon line* *Vanishing point* *Lines in perspective (z-axis)*

Two-point perspective

Two-point perspective allows the artist to express a scene similar to the one shown in the one-point perspective section, but with a rotation. This form of drawing gives the artist the ability to accurately express the corner of an object in perspective.

How to draw: When establishing a grid, pay careful attention to which geometric face corresponds with which vanishing point. Visualizing forms in their base cubic structure helps to eliminate any confusion. Once the two vanishing points are established, draw a straight line connecting them. This is the horizon line. In this instance, the two vanishing points are at the same height, and therefore the horizon is straight. If the horizon were rotated, the lines on the y-axis would have to be altered to correspond with the tilt of the horizon. Remember—all straight vertical lines should form a 90-degree angle with the horizon line.

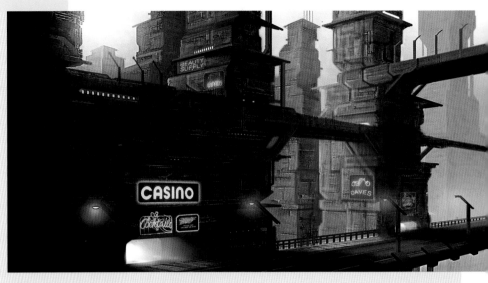

▼ Two-point perspective allows for a thorough representation of the architectural forms in this drawing. A great deal about the layout and visual style of this city is communicated in this quick sketch. Showing the perspective on multiple axes communicates more about a form than drawing with a single axis in perspective.

▼ As the drawing becomes more detailed, it becomes easier to confuse which vanishing point relates to which line. Analyze the drawing as it relates to the grid—be sure that all forms are corresponding to the correct vanishing point.

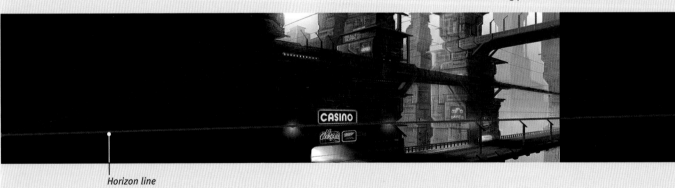

Horizon line

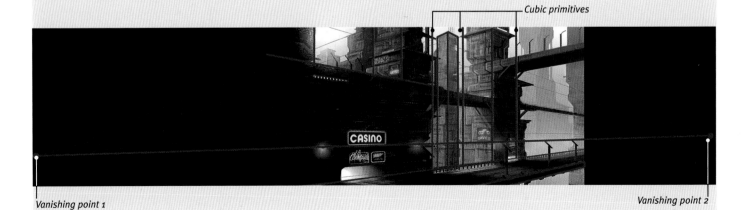

Cubic primitives

Vanishing point 1

Vanishing point 2

Three-point perspective

Three-point perspective takes into account the principles of two-point perspective and introduces a third vanishing point to account for vertical distortion (the y-axis). Typically this comes as the result of an extreme vantage point, i.e., from the top of a building looking down at the street below, or at the base of a large building looking up. The vertical lines no longer appear straight; they too will conform to a vanishing point when this distortion is present. When looking down at an object the third vanishing point will appear well below the horizon line—the opposite occurs when looking up at an object. With all perspective drawing, the vanishing point may fall outside the confines of the composition. In digital projects, a simple canvas size adjustment can accommodate this issue. Traditional mediums often call for very large sheets of paper to determine construction. Three-point perspective typically requires the most working space, since the third vanishing point tends to be farthest from the horizon line. This type of drawing can become quite complex and is better understood once the finer points of one- and two-point perspective are grasped.

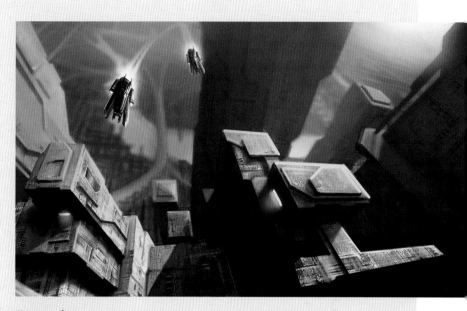

How to draw:

▲ This image uses a three-point perspective grid to convey a sense of action and altitude. Keep in mind that three-point perspective can be used in an inverse fashion with the y-axis vanishing point located below the scene.

▼ Notice how the horizon line is tilted. To determine if a horizon is tilted, connect the x and z vanishing points with a straight line and observe the angle of the line. Use cubic structures to define the footprints of the buildings if needed.

Vanishing point z-axis　　　　*Horizon line*

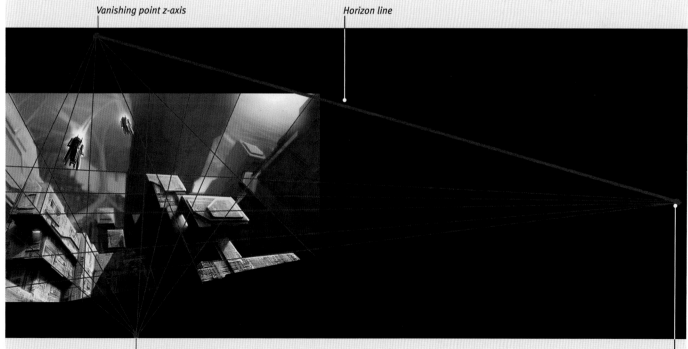

Vanishing point y-axis　　　　*Vanishing point x-axis*

Rendering complex elements

With the basics of perspective grasped, the rendering of complex subject matter can be explored. Sci-fi environments are rich with vehicles, architecture, and industrial design assets.

These sorts of man-made items are challenging to render and equally difficult to invent. Use the perspective concepts outlined in the previous section to depict this type of subject matter with a sense of accuracy and visual interest. This section will also address "abstraction," which is a helpful catalyst in the design process.

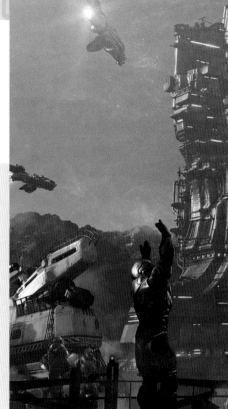

▶ **"Moonwater" by Angel Alonso**
This image shows a successful integration of vehicles, architecture, characters, and industrial design elements. Well-conceived designs and a mastery of technical drawing allow an artist the ability to create the sense of reality in the unreal.

Abstraction

Once you understand the basics of volumetric drawing, you can explore the more complex aspects of design. Science fiction requires a great deal of invention, since many of the desired aspects simply don't exist. Approaching the design of brand-new elements requires a creative approach. The concept of abstraction is a very valuable tool when tackling challenging designs. Abstraction is the process of taking inspiration from the characteristics of an existing object and applying certain aspects of that object to the invention of something new. The aspects drawn upon can be visual, behavioral, or both.

In the example opposite, the challenge is the conceptualization of a futuristic weapon. Before the pencil hits the paper, it's important to understand what's needed so that a reasonable solution can be worked out. The idea for this weapon is a pulse gun, a powerful weapon capable of delivering heavy blasts of destructive energy. Slow to reload and somewhat cumbersome, but effective in short bursts, the gun is built for brute force as opposed to tactical precision. The gun would emit a large burst of energy, so it should appear "front heavy." The handle should be easy to grasp, with the bulk of the form in the front section.

A big part of design comes from asking the right questions. In this case—what in reality possesses these characteristics? What is both powerful in

stance and perhaps wild and chaotic in its attack? A buffalo comes to mind—strong and powerful but devoid of precision and subtlety. Footage of an enraged buffalo shows that—when provoked—the animal is capable of a great deal of destruction. The body type is also suitable, since it holds most of its weight in the front region, much like the intended form of this weapon.

1 BEGIN WITH A COMPARATIVE THUMBNAIL ANALYSIS: Take attributes of the buffalo's silhouette and translate them into the functional components of the weapon. The abstraction should serve as an inspiration, not a mirror. If the silhouette of the creature is too prominent in the design, it will appear contrived and somewhat silly. Strike a balance between conventional weapon components and elements inspired by the form of the creature.

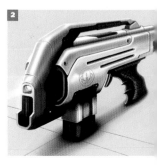

2 TWO-POINT PERSPECTIVE offers a descriptive view of this design. Give consideration to the various materials used to create this object. The impression of a blue light source helps to define the metallic areas. When rendering polished metal, keep in mind that the most intense highlights will appear directly next to the highest saturation reflections. Seams and bolts help to communicate the construction of this weapon. Make sure the gun handle accommodates a human hand. The object should appear to the viewer as if they could reach into the page and grab it.

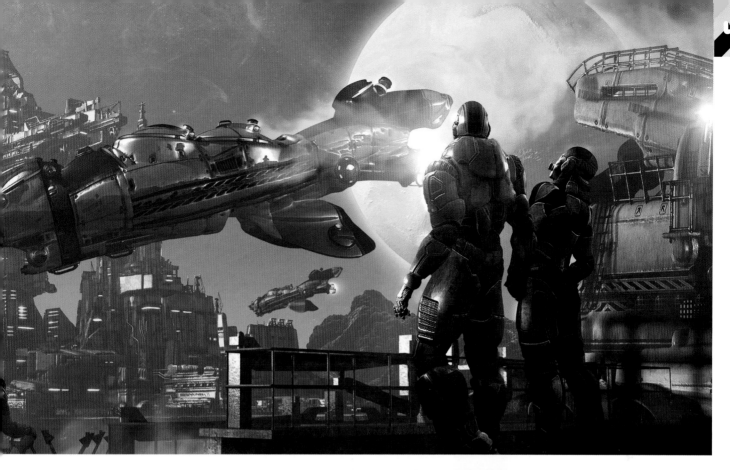

◄ Truck in progress

◄ Truck in progress

The overall shape of the truck is cubic, which makes the base perspective easy to determine. A primitive cubic shape can be used to communicate the footprint of the vehicle if needed. Keep in mind that each additional detail must coincide with that initial structure. Each added element brings a new level of complexity to the grid.

▼ Final truck design

As a military transport unit, the truck would have to be structurally sound and large enough to accommodate a large number of passengers. The front end appears durable and capable of ramming through obstacles. Elements such as door handles give clues to how big a human would be relative to this vehicle. Make sure that such elements are consistent throughout the design.

Vehicle design

This book explores increasingly complex vehicle designs. At the outset, it's best to master something relatively simple in form. This military transport vehicle is a good foundational study. Two-point perspective offers a descriptive representation of this vehicle. Showing simply a front, side, or top view would leave much to the imagination. Often 2D artists are employed to design elements to be built by 3D artists for various projects. Being able to draw descriptively in accurate perspective is a huge asset.

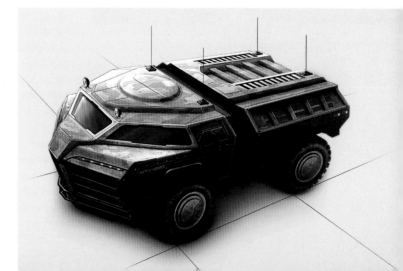

Color theory

Color is one of the most difficult aspects of painting to master. The observation, reproduction, and conceptualization of color are as much a science as an art form.

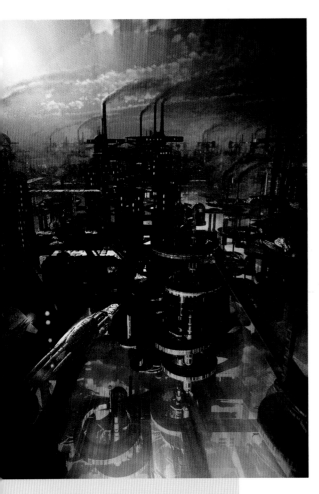

▲ ▶ Primary, secondary, and tertiary colors
These figures show the progression of hues in the standard color wheel. Become familiar with these charts to understand where the various hues sit and how they are created.

▲ "Future Cityscape" by Uwe Jarling
A bold use of color helps to bring this scene to life. Contrast is achieved through a use of opposing color temperatures and contrasting levels of saturation.

Careful observation of the subtleties of color in the natural world is a good place to start. Take note of the colors found in the highlights and shadows of objects in the world. It's wrong to assume that all shadows are black and all highlights are white—there is always color present at some level, and it takes a keen eye to isolate exactly what is being observed.

The color wheel

While this type of critical visual analysis can take years to develop, there are guidelines that can help make the challenges of color easier to grasp. The first concept to familiarize yourself with is the color wheel. The color wheel begins by taking the three primary colors—red, yellow, and blue—and spacing them equidistantly on a circle. The primary colors are the colors from which all other hues are mixed. (The word hue can be used interchangeably with color.) The next step in establishing the color wheel is to show the secondary colors. Secondary colors are the hues produced by mixing the primary colors together (red + blue = violet, blue + yellow = green, and red + yellow = orange). The colors are placed in their respective areas corresponding to which colors have been mixed to produce them; for example, orange will appear between red and yellow. The secondary colors can be mixed to produce tertiary colors, which will appear in their corresponding locations relative to which hues have been mixed to produce them. Standard color wheels show a breakdown of twelve hues—this chart can be endlessly expanded, the spectrum of color is well represented in twelve divisions.

The placement of colors on the color wheel expresses certain relationships based upon the relative position of the hues. Two colors directly across from one another on the color wheel are known as complementary colors. Three colors next to each other on a twelve-section color wheel are known as analogous colors.

▼ Complementary and analogous colors
These figures help to identify the relationship between various colors. Keep in mind that these sections can be rotated to multiple combinations. Committing these relationships to memory is important for painters.

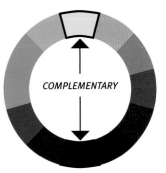

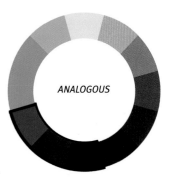

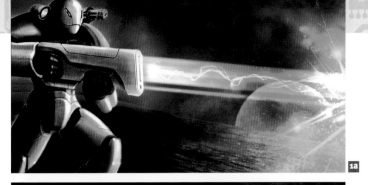

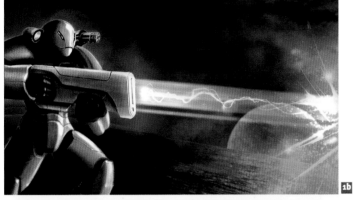

Color contrast

The successful use of color comes primarily from the implementation of color contrast. Johannes Itten was the first to identify the seven strategies of color contrast. These strategies have become accepted as a means to create successful color artwork.

1 Contrast of values

This form of contrast is created by the placement of light values next to dark values (1a). This method can be applied to various color schemes. Seeing value in color can be very challenging. Photoshop allows the artist the ability to desaturate a composition and read the color strictly in terms of value (1b). This image also represents an analogous color scheme.

2 Contrast of proportion/extension

This method of contrast is achieved through the relative placement and scale of different sections of color, i.e., letting one hue occupy a dominant section of a composition.

3 Contrast of temperature

Colors can be described as warm and cool in terms of temperature. Placing warm hues next to cool hues creates a visual contrast.

4 Simultaneous contrast

This refers to placement of complementary colors to create vibration. By placing complements directly next to one another, a visual vibration is created at the bordering regions of the color sections.

5 Contrast of complements

Combinations such as red and green, violet and yellow, and blue and orange create strong color contrast.

6 Contrast of hue

This simply refers to the use of contrasting colors. The farther away a color is from another color on the color wheel, the more they contrast one another. This is similar to the theory behind complementary colors, but more variation can be explored and the hues don't have to be opposites on the color wheel to achieve this type of contrast.

7 Contrast of saturation

Contrast in saturation is achieved by placing a high-saturation color among low-saturation colors. The high-saturation color will naturally pop out and draw attention. This can be applied to many color combinations but often works nicely with monochromatic palettes.

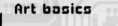

Visual narrative

One of the artist's many roles is that of storyteller. An image without narrative fails to capture the viewer's imagination.

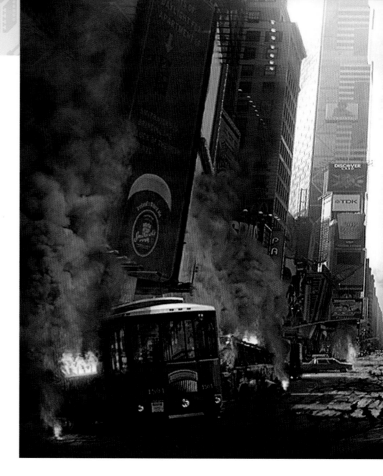

Visual artwork often acts as a companion to literature—ideally the image could stand alone and be understood without the text. Think of cover images for novels. The best ones are eye catching but also give a glimpse into the style and genre of that particular novel.

There are limitations as to what can be communicated in a single image. Thinking in terms of film shots can be helpful when deciding upon the content of an image. Trying to cram too much content into one image can be detrimental. Consider the various shots explained below when setting up a composition.

ESTABLISHING SHOT: These images set the scene. They are often large in scale and zoomed out from the subject so that a great deal of content can be in frame at once. They help to describe the atmosphere, mood, and landscape.

ANTICIPATION SHOT: This shot sets the stage for what is about to happen. It creates a feeling of suspense and uncertainty. This is often the calm before the storm and alludes to conflict or action to follow.

ACTION SHOT: This shot describes a point of interaction, impact, or exchange. The message is clear, and the subtleties are out the window.

AFTERMATH SHOT: The aftermath shot above communicates what has happened. Imagine a point in a story where a character has walked into the aftermath of a battle and is trying to decipher what has happened. The tension of the two previous shots has dwindled, but there is still a story to be told.

THE IMPORTANCE OF ANGLES: The angle of view can also help to tell a story. Flat shots with a centered horizon line feel stable and calm. Tilting the frame

▲ Combining the shots
This matte painting shows the aftermath of a fallen meteor, but the faint spark of light from within the meteor gives the impression that there is more devastation to come. Often in cinema and literature the audience is lulled into a false sense of security; just when the action appears to have dwindled, a second more brutal assault is launched. This shot depicts an iconic setting, which also helps to elaborate on the narrative.

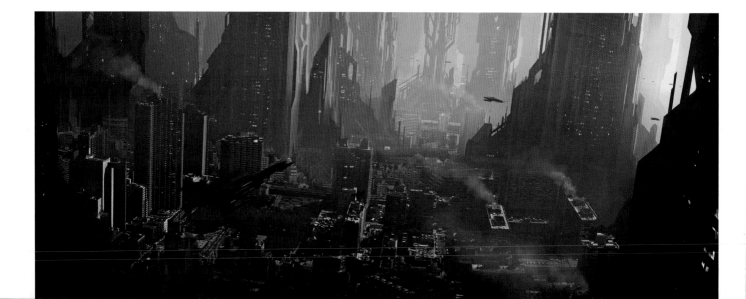

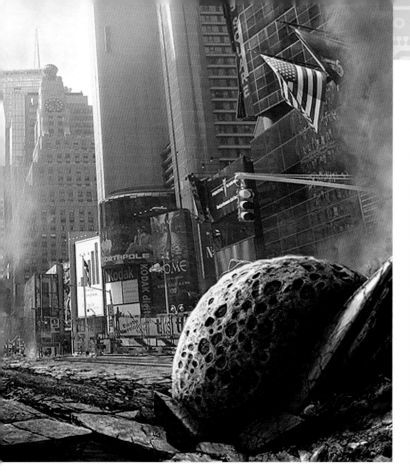

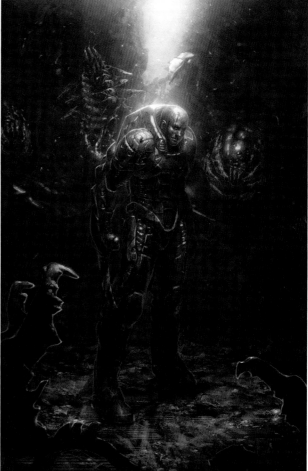

▼ Looming danger
It's unclear whether the figure realizes what he has in store, but the audience certainly does. This sense of tension helps to draw the viewer into the scene and sets the stage for conflict.

can add action, tension, or dynamism. A bird's-eye view makes things feel smaller or perhaps weaker than they actually are; conversely, a worm's-eye view can make things feel larger or more powerful than they truly are. Combinations of these effects can also be useful—a bird's-eye view with a tilt can create a sense of vertigo.

▶ Chaos
This scene is a great example of all-out action. Notice how the tilt of the horizon adds to the chaotic nature of the shot. This is a simple device that can add a lot of dynamism to an action shot.

◀ Setting the stage
This wide establishing shot communicates a great deal of information about the world. The mood content and scale of the painting make it a perfect way to introduce a viewer to this city for the first time.

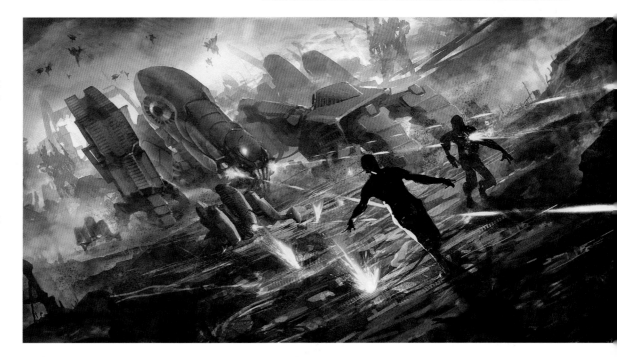

CREATING NEW WORLDS

Chapter 3:

This chapter will explore five separate sci-fi worlds, introducing a wider variety of concepts and imagery. Themes of war, peace, prosperity, invention, cultivation, deception, and industry will be explored within these images. Use the design process outlined in the first chapter coupled with the foundational art skills of the second chapter to approach the challenges in the following pages.

These pages will feature a wide range in subject matter including characters, vehicles, architecture, creatures, landscapes, and robots. In addition to the step-by-step exercises, works of art from a variety of talented artists will be supplied at the beginning of each world to inspire your creations within these sci-fi worlds.

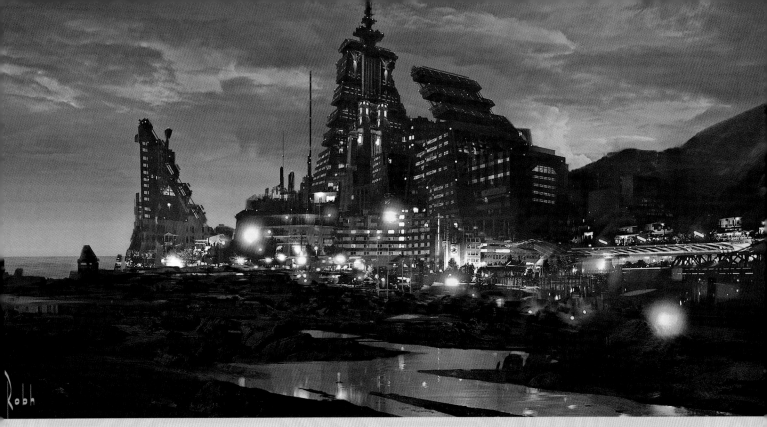

Dystopia
interpretations

Dystopian themes allow artists the ability to look into the future and propose possible negative outcomes. Analyze current social, environmental, and political systems and consider how they could evolve. This proposed evolution offers the artist a tool to both critique today's world and invent a new one.

▲ **"City by the Bay" by Robh Ruppel**
These worlds need not be devoid of beauty. Polluted skies and heavy light pollution offer a broad range of vibrant colors—pairing these hues with interesting architectural silhouettes makes for a beautiful piece of artwork.

▼ **"Dystopia" by Elreviae**
The sun rises on this overdeveloped metropolis. Enormous industrial architecture towers over the landscape, dwarfing the dense and congested cityscape below.

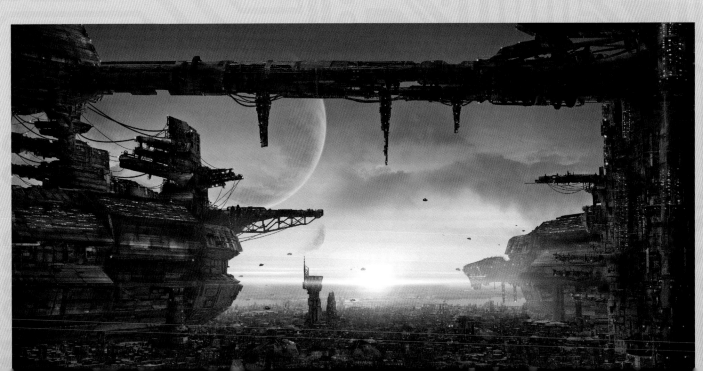

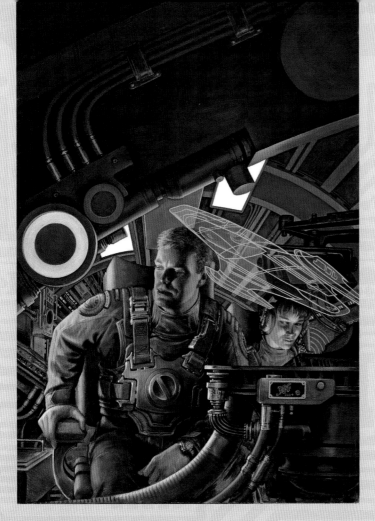

◄ **"Way to Glory" by Stephen Hickman**
Militarized space exploration and conquest are a recurring dystopian theme. These stories offer insight into the possibility of humanity's aggressive tendencies expanding off-world and wreaking havoc in the cosmos.

Geoff Taylor's dystopian future is a vision of our existing society gone wrong. The aggressive tendencies of our world have become amplified by scientific progress. The cities are overdeveloped and plagued by conflict between organized crime factions and a militant police force. The natural world is scarcely visible. The following pages feature examples of Geoff's interpretation of this world. ▷

▼ **"Destroyed City" by Carlos Long**
War-torn cities and worn-out slums tell the story of a collapsed society. These environments offer a great setting for a variety of sci-fi storytelling.

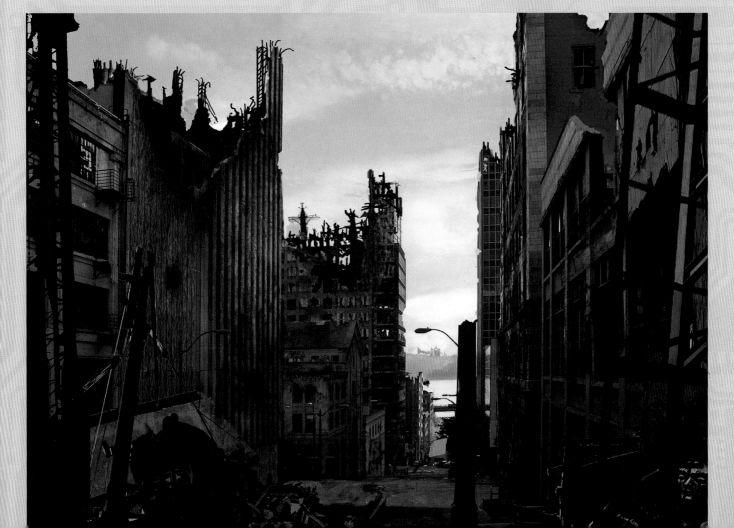

Police officer

The enforcer of an oppressed society, this militarized police officer is a foot soldier for a harsh ruling regime.

This linear pencil sketch helps establish the volume of the figure. Breaking down the human figure into a series of primitive geometric shapes is a valuable exercise when approaching figurative artwork.

Reference the uniform of this modern police officer to create an updated futuristic vision.

1 Basic sketch: The first sketch breaks down the basic geometric shapes of the figure. The costume is relatively simple and not a drastic departure from the human form. However, take the time to break down the anatomical structure of the torso under the armor. The armor is one area in the design where the human anatomy isn't clear—it would be difficult to draw this bulky armor convincingly without a solid understanding of the underlying structure of the figure (see page 43).

The weapon can be painted separately and rotated into the figure's hands using the Transform tool.

CONCEPT DESIGN

This design draws from modern day riot police (above). In contemporary society these figures tend to denote oppression, violence, and control.

Use sharp angles and jagged facets to define the shapes—these also speak of the nature of the character. The overall color scheme is very basic—the figure is primarily composed of dark grays and black. The simplicity of this palette really allows the accent reds to pop out and create contrast and visual interest. The character's eyes are not visible because of his visor, so his attitude has to be conveyed through body language as opposed to facial expression. There is a feeling of arrogance in his stance—the subtle head tilt helps to get this point across. The shapes in the chest armor are mirrored in the weapon design—this helps to harmonize the image.

Building up lighter values on top of a dark silhouette brings the figure to life quickly and accurately.

2 Silhouette: The next step is to block in a silhouette based upon the structures of the geometric sketch. Start with a large, full-opacity, hard-edged brush and block in the overall mass of the figure using a dark shadow value. Slowly build up detail by adding increasingly lighter values and finer brush work. Approach the painting in a series of passes, working from larger shapes to finer details. As the details become smaller, use a smaller brush. At this stage, consider the shape language (see page 41). Notice how the hexagonal lines of the gun relate to the officer's body armor.

3 Value and lighting: Now that the internal structure and overall shape of the character have been defined, the values can be blocked in. Decide upon a light angle, and use that lighting to define the various volumes via highlight and shadow. In this instance, the light is coming in from the top right.

Consider where the structures reach their crest or peak. In this instance the crest in the lighting is most intense. Look how the cylindrical structures of the legs and arms catch more light in certain areas—these are the crests of these volumes. On the left boot, the highlights pop out at the peak of the shinbone and the tip of the big toe.

Pay close consideration to the folds in the fabric and how light interacts with these shapes. Give the character a contact shadow to help make him feel weighted and tangible.

4 Surface effects: In this image we see gun metal, glass on the visor, heavy fabric clothing, Kevlar armor, glossy leather, and matte metal on the helmet. These materials all have contrasting visual attributes.

The visor has the highest intensity of reflection and highlight. In addition to intensity, it's also important to consider the shapes that these highlights take on. In this instance, vertical streaks of light values help define the glass on the visor. The leather is similar but slightly less intense.

Vertical streaks of light values help define the glass.

Use subtle red tones as a rim light to add depth to this otherwise limited palette.

Use similar materials on the gun to keep the painting harmonized.

The accent colors really pop out from the dark desaturated palette.

Create the mid-tones by using a highlight value set to low opacity— simply double up the strokes in areas where the highlight should appear more intense.

Allow brushstrokes to stay visible on the pant legs.

Glass: Paint the dark values first. Next, paint the mid-tone values with a soft-edged, low-opacity brush. Finally, the highlights can be executed with a high-opacity hard-edged brush—these strokes should fall directly in the center of the form.

Matte metal: Begin by blocking in the shadow value. Use a soft brush to create a smooth transition from shadow to mid-tone. The highlight strength is low, so at the center of the mid-tone area, paint some subtle highlights with a soft, low-opacity brush.

Glossy leather: Start with the shadow value on the leather. The material has a very limited amount of mid-tones—the transition from highlight to shadow is much more abrupt. The highlights should appear tight and of a high intensity.

5 Color: Translating the values of the grayscale drawing to color is the next stage of this painting. Seeing value in color can be tricky, so using the grayscale as a guide helps a lot. The overall color palette is very simple. Stick to a dark, desaturated palette for the majority of the painting so that the accent colors really pop out.

Use warm earth tones for the skin and badge, and reflect those tones in the backdrop.

Use subtle red tones as a rim light to add depth to this otherwise limited palette. A rim light is light that catches the outer edge of a figure—this is one way to introduce additional lighting and color into a painting.

Pay close consideration to the folds in the fabric and how light interacts with these shapes.

Giving the character a contact shadow helps to make him feel weighted and tangible.

The highlights pop out at the peak of the shinbone and the tip of the big toe.

6 Rendering: With the overall structure and palette of the painting resolved, begin to tighten up and start focusing on details. Switch to a smaller brush and begin to define the subtleties of certain key areas. Allow brushstrokes to stay visible on the pant legs, since they are not an area of interest—this helps the tightly rendered weapon to pop out.

See pages 34–37 for more details on the digital process.

DYSTOPIAN EARTH

Robot

Unrelenting construction and expansion requires a tireless worker. With expansion scaling into the cosmos, a worker who requires no oxygen or food becomes increasingly desirable.

CONCEPT DESIGN

This design is comprised of elements of automotive/motorcycle design coupled with contemporary astronaut design. A rigid pose helps to convey the idea that the robot is just coming off the assembly line. This pose alludes to the mass-produced nature of the robot. The anatomy of the robot is relatively human—the culture that is hypothetically manufacturing the robot is human, so it's natural that they would project aspects of their own appearance upon their creation. Additionally, the human body is well suited to complex manual labor, therefore deviating drastically from the human form is not necessary.

Design development

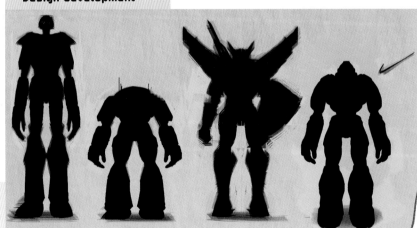

1 Thumbnail sketches: Begin with a series of silhouette thumbnails to define the overall shape. Use a large brush to block in the rough shape of the figure. Then clean up the form with a small eraser and brush to express the finer points of the design. All work can be done at full opacity with a hard-edged brush. Keeping the robot's body type in the mid-range (not too delicate/not too bulky) makes him a logical solution for the expressed design challenges.

2 Line-art: With the body type decided upon, it's time to invent the internal structure of the machine. Elements of the motorcycle reference are carefully blended with human anatomy. Keep the brush size large and the level of detail relatively low.

See pages 34–37 for more details on the digital process.

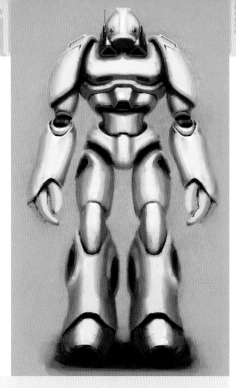

3 Color: Start by blocking in the color of the background. Place the line art on top of the background layer. Build up lighter values to define the internal structure of the robot. Sample the background color—use this hue for the mid-tones. The highlights should still be in the same color range as the mid-tones, but with a value closer to white.

4 Surface effects: The outside material is reminiscent of the metal shown in the reference material, so it has a gloss finish. However the finish is somewhat matte, so it lacks extreme highlights. Soft brushes work best to describe matte finishes.

5 Rendering: Now that the shapes are defined, begin to render details. Various vents and seams add visual interest to the figure. Details help the design to feel functional and give clues as to how it may have been constructed. Highlights are positioned in the core of the volumes. Soft shading on the outer edges allows the highlights to pop forward, giving the figure a good sense of volume. Subtle contact shadows at areas of overlap add increased volumetric properties to the painting.

Try to repeat similar shapes throughout the painting—notice the similarity between the intake on the center of the chest and the two intakes on the robot's head.

This form is referenced from the intake of the motorcycle.

The darker shadows under the shoulder pad help to give added volume to the painting. Shadows are key to the definition of shape—consider the overall lighting and how it would produce shadows.

Lights influenced by the reflectors seen on the cargo packs for the motorcycle offer a sharp hit of high color saturation and help bring the figure to life.

Seams help to communicate how the robot would be built. When designing manufactured items, it's important to think about how the smaller parts come together to comprise the finished product.

DYSTOPIAN EARTH

Light aircraft

Tactical military vehicles are essential on a planet steeped in conflict. These ships are built for espionage, so speed and maneuverability are important. They offer room for one pilot and limited artillery.

1 Thumbnail sketches: Begin with a series of silhouette thumbnail sketches. At this stage, focus entirely on shape. Sharp angles and parallel lines are the shape language for this design (see page 41). Notice how many of the lines and angles in the ship correspond with each other—this helps to create a sleek harmonized look to the craft while still keeping the simple, stripped-down aesthetic intact.

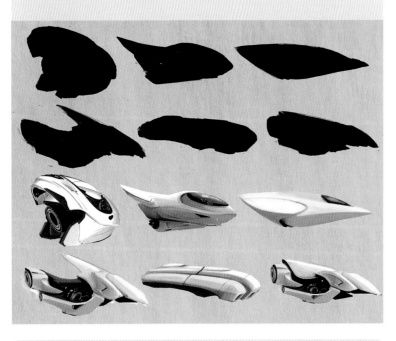

2 Value study: Below are three steps showing how to take a thumbnail sketch to a refined value study. Start by laying in the shadow value at full opacity with a sharp brush. Next paint the mid-tone range to define the lighting and structure. The craft will be lit from above so use a lighter value on the top of the chassis and darker value on the lower section to imply that the area is in shadow. The cockpit should read as the darkest value, since the material will be a tinted glass that should be much darker than the rest of the design. Paint this step on its own layer so that it can be easily transferred into the final painting.

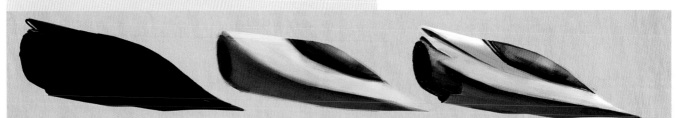

CONCEPT DESIGN

The aircraft is stripped down to its bare essentials: cockpit and engine. This design was the result of a series of thumbnail sketches, and the inspiration came from an old doodle of a bird (above). Taking inspiration from unlikely places helps to create unique design solutions.

The next challenge was to make this craft seem believable. The science fiction genre offers the artist a great deal of freedom, but it's still important to make things feel possible and functional, however outlandish they may be. Adding various flaps to the aerodynamic shape of the ship helps to sell the idea that this ship can actually take flight and maneuver. Taking some reference from contemporary fighter jet design (below) gives the craft more grounding in reality and makes it more tangible.

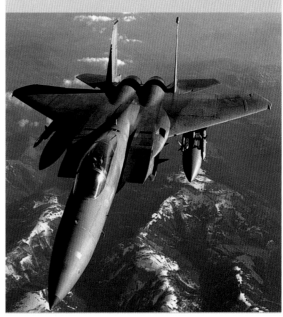

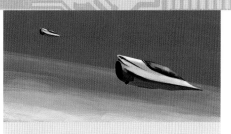

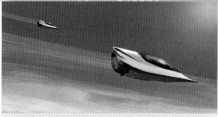

3 Backdrop: Now set up the scene. The focus of this painting is the vehicle, so keep the environment simple. Start with a tilted horizon line to emphasize the speed of the craft. Keeping the cloud layer at the bottom helps to create a sense of altitude. The clouds also create a frame or border so that the scene doesn't feel too empty.

4 Lighting: Position the sun at the top-right corner of the painting—this gives the opportunity to add highlights to the cockpit and top of the craft, which helps to show the materials.

5 Surface effects: This ship is made from glass and polished metal; both materials have intense reflective and specular properties. These materials make the ship feel slick and modern. The softness of the clouds offers a nice contrast in materials and reinforces the fact that the focus is on the ship.

6 Color: The warm tones of the afterburner and sunlight contrast with the cool blue sky and clouds. Use high-saturation orange to make the afterburner feel hot. As the exhaust moves farther away from the ship, the saturation and opacity of the orange dissipates. Add color by creating a layer set to overlay on top of the grayscale ship. Make a layer selection (Ctrl---click the thumbnail of the layer) to ensure that the blue only affects the ship and not the background.

7 Rendering: Paint the clouds with a soft-edged brush. Place larger clouds closer to the viewer, becoming smaller in size as they fade into the background. This creates perspective (the second ship also plays a key role in creating this sense of distance). The metal has lower reflective properties than the glass, so there will be more blue in the glass than the metal. The engine section of the ship is made from a different type of metal, with more of a matte finish, so there will be even less blue on this section. The highlight

strengths of the materials break down in a similar fashion: The glass has the highest intensity of highlights, there is slightly less intensity on the body of the ship, and the lowest intensity is on the engine section.

Paint very sharp lines for the construction seams on a separate layer so that they can be edited without impacting the rest of the painting. The seams help to convey the volume of the craft. Be sure to adhere to the contours of the craft when painting these lines.

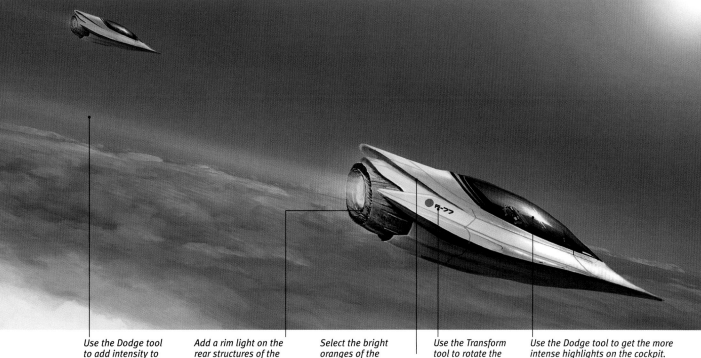

Use the Dodge tool to add intensity to the value of the afterburner.

Add a rim light on the rear structures of the craft to imply that the color from the afterburner is hitting the back of the craft.

Select the bright oranges of the afterburner. Use a small soft brush and trace the outer edges of the rear structure of the craft.

Use the Transform tool to rotate the decal text into position (it should flow with the angle of the craft).

Use the Dodge tool to get the more intense highlights on the cockpit.

See pages 34–37 for more details on the digital process.

DYSTOPIAN EARTH

Aerial police cruiser

In this dystopian vision, this highly maneuverable, heavily armed vehicle offers air support when police work becomes volatile.

1 Getting started: Consider how the shape of the vehicle communicates its type of movement—a more streamlined jet-like design such as the one below implies that the cruiser would be fast, but lacking in precise maneuverability. The craft must appear to hover, as opposed to being propelled by a jet engine. The idea is to take the characteristics of a helicopter and improve upon them to make something new. Consider the chassis of a helicopter when designing the body of the cruiser. Round shapes help to tell the story of a craft capable of moving swiftly in any given direction.

Concept design

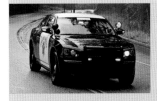

This craft is a synthesis of the modern police cruiser and helicopter. The vertical layout of futuristic cities makes ground pursuit difficult, therefore a more versatile vehicle is needed. Recognition is key to any standard police vehicle—familiar elements such as flashing blue and red lights, coupled with the classic white-on-black paint motif, make this vehicle easily identifiable as an instrument of law enforcement. A variety of lights and weapons give the desired function without hindering the compact form of the cruiser.

3 Materials: This painting offers a chance to explore different rendering techniques to achieve a variety of surfaces. The distinction between various surfaces adds an added depth of believability and visual interest to a painting.

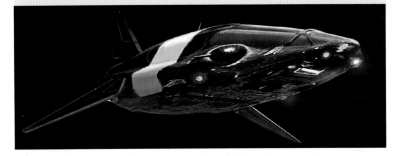

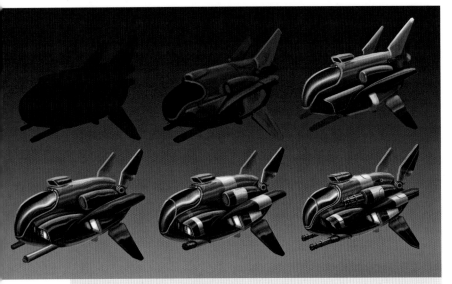

4 Base metal rendering: This chassis of the craft is highly reflective metal. The highlights are thin and appear at the crest of each form. When painting reflections, consider the relative position of the various aspects of the craft. The side turret is reflected in the side of the chassis and on the top side of the front light mount. Reflections should appear with slightly less clarity than the actual objects. The area of maximum highlight should occlude the reflection.

2 Blocking in: Use a base of blue when blocking in the initial form of the painting, Although the paint job is predominantly black, the final image will be rendered with a blue tint to communicate the reflection of city lights on the surface of the vehicle. Render the vehicle in passes as shown above, slowly building up the level of detail and surface quality with each pass.

5 **Cockpit rendering:** The cockpit is made up of a tinted reflective surface. The tint decreases visibility of the occupant. The surface of this glass has different reflective and highlight properties than the metal of the chassis. Create highlights that are wider with a soft-edged brush—this implies a slightly coarser surface. The reflections should be more generalized compared to the mirror-like qualities of the metal.

6 **Gun metal rendering:** This surface features less highlights and reflections than the cockpit. The highlights appear as a soft gradient without any sharp transitions between highlight, mid-tone, and shadow. The reflectivity offers no mirroring of other objects—at most it may catch a bit of colored lighting.

7 **Detailed rendering:** Small details, such as construction seams and decals, add finishing touches to the rendering of this vehicle. Small orange lights communicate the footprint of the craft to observers at night—they also allow for a small hint of warm color that contrasts nicely with the overall cool palette of the painting. These fine details make the image feel more tangible.

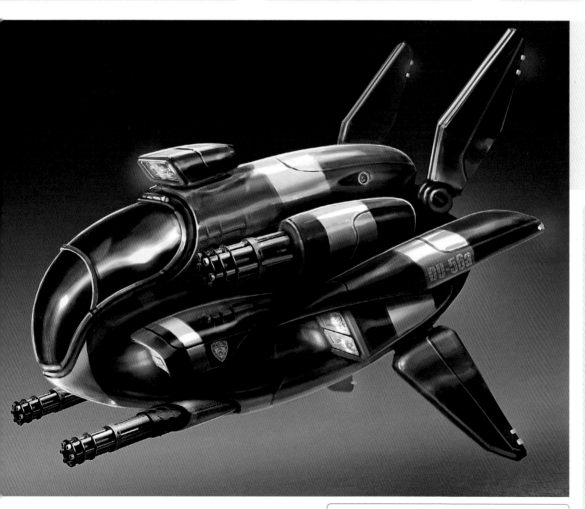

8 **Edge treatment:** This final pass shows the impact of edge detail on the painting. No matter how well rendered the internal mass of an image may be, the overall quality will fall short without a careful edge treatment.

Rendering tips: Use a soft brush set to a low opacity to express the internal portions of metallic surfaces of the craft. Soft transitions can be achieved by layering soft, low-opacity strokes. The outside edges of the structures require much more precise brushwork. Switch to a hard-edged brush set to 100% opacity. Attempt lines over and over until they are perfect (using the Undo function). Longer strokes will produce cleaner results, and practice will improve hand-eye coordination.

See pages 34–37 for more details on the digital process.

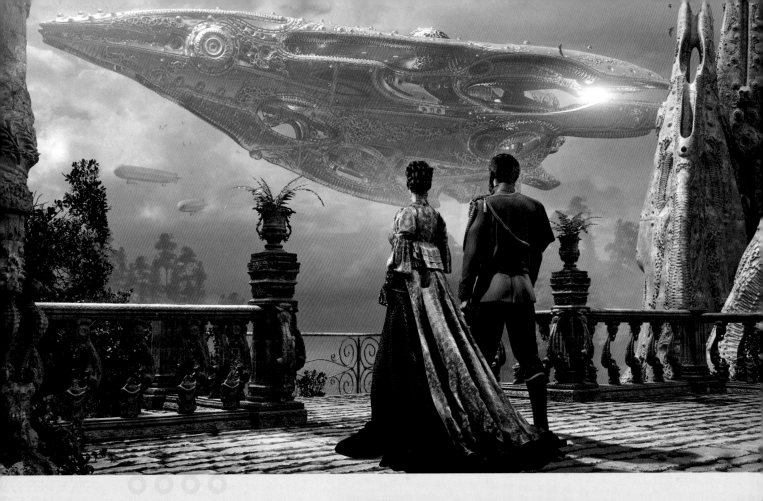

Utopia
interpretations

The artwork on these two pages shows a variety of utopian environments. These visions demonstrate a future, or parallel world, where society has progressed with a regard for the natural world and a sense of beauty and balance in the design. This imagery allows an artist the ability to present positive future scenarios and propose possible means by which these societies can be achieved.

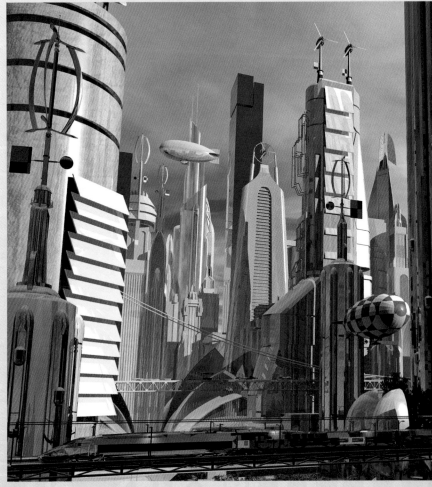

◄ **"Atreides" by Angel Alonso**

Elegant costumes, classical architecture, beautiful gardens, and high-tech vehicles come together to create this stunning environment. A balance between man-made and organic imagery is expertly communicated in this image.

▶ **"The City" by Tom Godfrey**

A city occupies this lush coastline. A welcoming light source gives this environment a benevolent mood. The organic shapes of the architecture blend nicely with the natural world.

▼ **"Bustling Metropolis" by Franco Bambilla**

This scene shows a city with a harmonious blend of various architectural styles. It creates the sense that a variety of cultures are peacefully coexisting. The atmosphere feels clean, and green space is scattered throughout the rooftops.

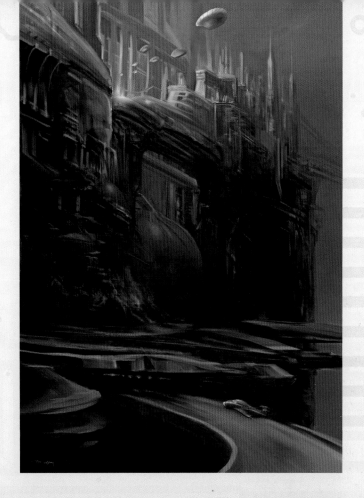

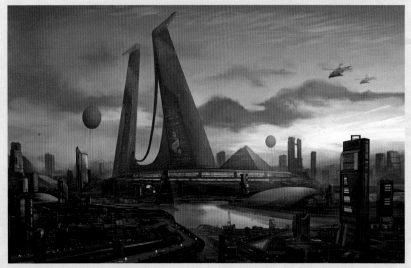

▲ **"Megastructure" by Lorenz Hideyoshi Ruwwe**

This city is heavily developed, but with a sense of balance and order. The ellipsoid shapes and warm lighting give an air of calmness and harmony to this futuristic cityscape.

Geoff Taylor's utopian vision is an Earth-like planet with a culture governed by science, but managing to maintain a balance with its natural world. A reverence for nature and education is at the core of the cultural values. Scientific progress governed by these positive faculties has allowed for remarkable progress and even exploration into the far reaches of space. The following pages feature examples of Geoff's interpretation of this world. ▷

Scientist

The backbone of this utopian society is the scientific elite. Their ingenuity allows for astonishing feats of architecture, engineering, and physics.

CONCEPT DESIGN

This character should appear focused and serious, without a sense of anger or malice, so an expression of concentration must be carefully established. The computer system allows for some invention, such as the floating screens with a complex interface. The small floating orbs were inspired by a still shot of a robot from a short film. The devices are intended to capture and record the scientist's work.

1 Getting started: The background can remain soft and undefined, since the focus will be applied to the character. Use the paint bucket tool to fill the background with a solid color. Create a new layer and add some soft brushstrokes to communicate the light coming from the monitor.

2 Blocking in: Block in the figure and the rough shapes of the screens—keep composition and legibility in mind. The screens should appear in front of the figure without completely obscuring him and detracting from his prominence in the painting. Use a hard-edged brush to define the silhouette of the figure and the screens. The internal portions of the skin require a softer-edged brush to express the smooth gradients of colored lighting.

3 Color: The computer screens offer a chance for some interesting lighting. Keep the overall ambient lighting dark so that the cyan glow of the computers becomes the primary light source. Flesh tones take on the hues of their surroundings, so be sure to give a strong impression of the cyan lighting on the figure's face. The challenge here is to make the figure feel lit with the colored light and not appear to have green skin; keeping some warmer hues in the mid-tone and shadow range of the face will help to establish the correct feel.

The eyes of the character are a natural focal point in any portrait. Give special consideration to the difference in skin and eyeball texture. The eyeballs should feel more reflective with higher value highlights.

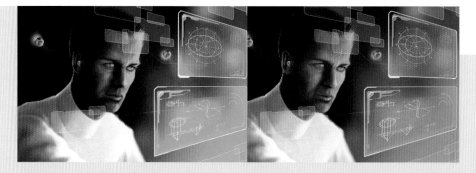

It can be difficult to read value and color at the same time, so position a Hue and Saturation adjustment layer (with the Saturation turned all the way down) at the top of the layer hierarchy. This can be turned off and on to test the values, which is a good way to ensure that the image maintains a strong contrast in values.

A contrast of color temperature, complements, and proportion of fields is implemented in this painting (see page 51). The cool cyan/green glow of the monitors complements the warmth on the left side of the figure and the small hits of red scattered sparingly throughout the painting.

4 Monitors: Varying levels of transparency aids communication of the screens and reflections. Construct the screens flat with no perspective, then use the Transform tool to ensure accurate perspective. Use a hard-edged brush to create intricate frames for the monitors. Use the shift key while painting to execute straight lines.

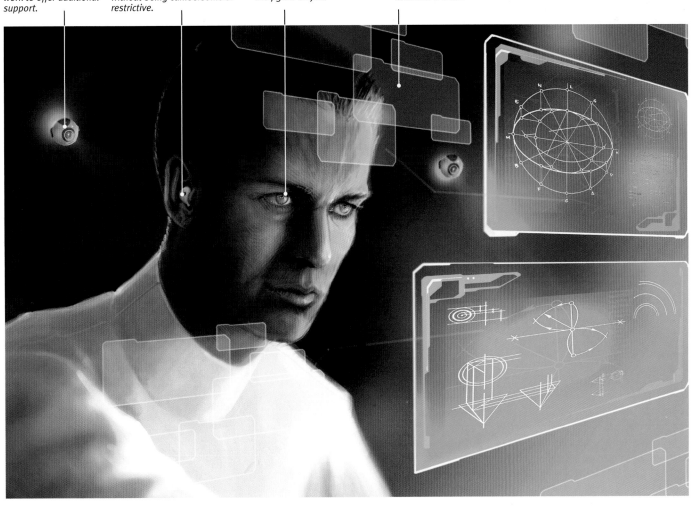

Small recording devices scan the scientist's work to offer additional support.

A wireless ear piece connects the scientist to his tools without being cumbersome or restrictive.

Sharp highlights draw attention to the figure's eyes.

Layering of monitors suggests a great deal of intricacy in the scientist's work.

See pages 34–37 for more details on the digital process.

University

This enlightened society holds education in high esteem. This building is both a place of learning and a shrine to the natural world.

1 Getting started: Make some quick planning sketches in pencil to establish the architectural style of the university. While the sketches don't offer any clues to the composition or perspective of the painting, they help to define the angles and proportions of the structure. Drawing straight lines freehand is a useful skill, but use a ruler if you haven't mastered this.

This reference is from modern-day eco-architecture. Eco-architecture seeks to minimize environmental disruption, minimize energy use, and promote sustainability. These are the exact intended themes of this painting.

CONCEPT DESIGN

The university building should feel harmonized with the environment, but at the same time be sleek and modern, as in the reference photograph for an eco-building, below.
The building should have a sense of grandeur while harmonizing with the natural surroundings. This is a university, therefore it should have distinct segments while still feeling like one cohesive unit.

The right section shows a three-step platform system intended to emulate terrace farming. This speaks of the ecological nature of the building. The top surfaces are covered in greenery and the main material is wood. The idea is that all the trees that were disrupted in the excavation for the foundation were either transplanted onto the rooftops or used in the construction of the building. The wind turbine on the far right shows a clean power source for the university and establishes the technology of the culture.

2 Line art: If you want to use the featured design, rather than one of your own sketches, scan the above line art to set up the architecture of the shot. Experiment with different design embellishments. The final version of the university features various flags and paths and trees on the structure to help bring it to life. This image is constructed with the principle of one-point perspective (see page 45). However, certain aspects of the form are rotated off axis and, therefore, have different vanishing points. When dealing with complex forms such as this, keep in mind that an endless number of vanishing points are possible, as long as they all converge on the same horizon line.

Allow a few highlights to define the outer edge of each tree.

The sunset lighting casts some interesting shadows and helps to emphasize the form of the building.

See pages 34–37 for more details on the digital process.

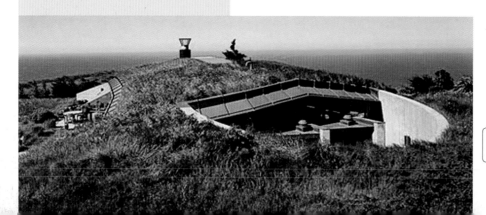

3 Value study: Do a grayscale sketch to establish the values and composition of the painting. Start by blocking in the light gray tones of the sky and ocean. Use the Dodge tool to lighten the sky in the top left to indicate the sun's position. Lay in a darker value for the terrain, then use a darker value to define the shapes of the trees. The groups of trees should become increasingly dark toward the foreground.

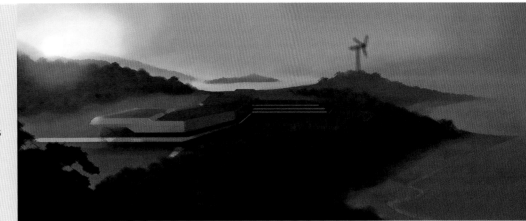

4 Materials: The shot is quite wide, so the building is shown in the context of the surrounding landscape. Therefore the rendering of materials is slightly less detailed and intensive than it would be if it was a close-up shot. The structure is primarily constructed of wood, and most of the surfaces are covered with grass, garden space, and walking paths. The sunlight does not make contact with any of the visible windows; therefore the reflective and specular properties of the glass should remain quite low. The clouds can be achieved through dozens of soft, low-opacity brushstrokes. Start with a large brush to define the overall shape, and shift to a smaller brush size to define the more delicate edges.

5 Color: This image is composed with contrasting hues in mind. The bulk of the palette is comprised of cool green tones, which allow the warmer red tones to pop out and draw attention to themselves. The warm orange tones of the sun and highlights are amplified by the placement of the red flags.

Use a Scatter brush to quickly define the foliage of the trees. Scatter settings can create hundreds of dots very quickly. Be sure to redefine the color frequently to get an accurate range in hues. Experiment with a variety of greens and reds. Shift to lighter values when defining the areas that would be in direct sunlight.

6 Lighting: Make sure that all the cast shadows correspond accurately with the angle of the sun. The clouds should pick up some highlights from the sun, and the shape of the clouds on the right side of the image should create a visual path to lead the eye around the composition.

Strong highlights on the left side of the building draw the eye to that area.

The lighting helps to establish the focal point.

The surrounding trees pick up a few dots of highlight but are mostly quite dark, since the sun is situated behind them.

Cruiser

A large spaceship draws energy from the matter around it and pulls itself through space at incomprehensible speeds. It is preparing to dock at a space station the size of a small moon, which hovers above a scorching hot gas giant.

CONCEPT DESIGN

This ship is heavily inspired by the late great John Berkey—a true master of sci-fi illustration. His large transport ships always had a sense of luxury and style (right). Combine this influence with the shape of a shark and design of a yacht. Getting a ship to feel large enough can be challenging. A lot of fine detail is the key to communicating the scale of the craft. The smaller scout ships mounted to the hull also provide visual clues about the scale.

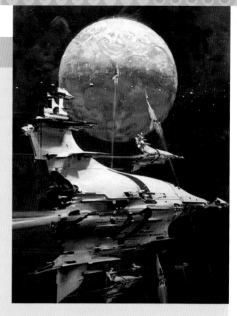

Design development

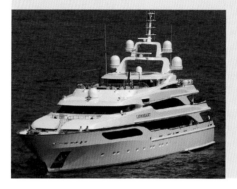

1 Basic sketches: Begin with some basic exploration sketches. Experiment with different shapes and forms. Since the idea is to combine the classic Berkey ship with a shark, do a quick sketch of a shark to get comfortable with that form. Due to the nature of the scene, the ship will be lit from below. Do your sketches with this in mind.

3 Color: Select a warm/cool color contrast (see page 51). The void of space should feel cold, to create a strong contrast with the heat coming from the planet. The intense blue emissions from the ship match the saturation of the orange of the planet. This creates a strong vibration between the oranges and blues, without one being too dominant. The surface of the ship reflects color subtly, which spreads the colors throughout the composition.

4 Surface effects: The ship is comprised of a material similar to a contemporary space shuttle; it has strong highlights, but doesn't feel overly glossy or reflective. The space station is made from the same material as the ship, so the same rules apply. The atmosphere is rich with stars and space dust—this helps to break up the black void of space and contributes to the composition.

2 Grayscale sketch: Begin with a dark silhouette of your chosen design. Make a layer selection of the silhouette to ensure that all additional brushstrokes fall within the confines of the silhouette. The light source will be below the ship—begin by painting darker values on the top of the craft and lighter values on the underside. Next, reduce the brush size and begin to define the various details of the ship. Once all the volumetric properties of the design are resolved, paint the small windows.

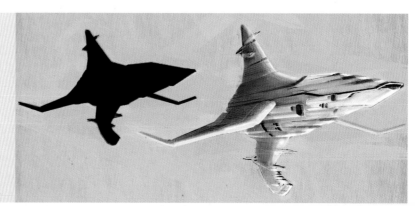

5 Rendering: Create a flat sheet of texture then use the Transform tool in Photoshop to apply it to the surface of the ship and space station. When transforming, it's important to keep volume and perspective in mind, otherwise the texture will flatten the objects and detract from the quality of the painting (see page 37). The misty feel in the background is achieved through hundreds of small, soft, low-opacity brushstrokes. Details such as vents, windows, decals, and numbers add extra detail to the ship and contribute to the scale of the structure—these are handled with a sharper, higher-opacity brush.

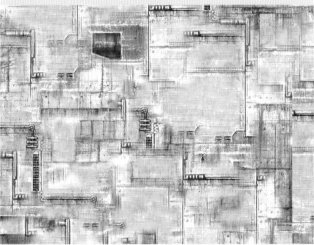

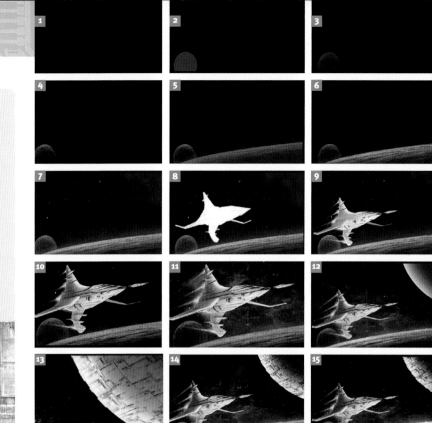

6 Layering: This step-by-step breakdown of the painting shows a repetitive process of blocking in major shapes (1–2), giving them core shadows to define the volumes (3–8), lighting the volumes (9–10), and then rendering detail (11–15).

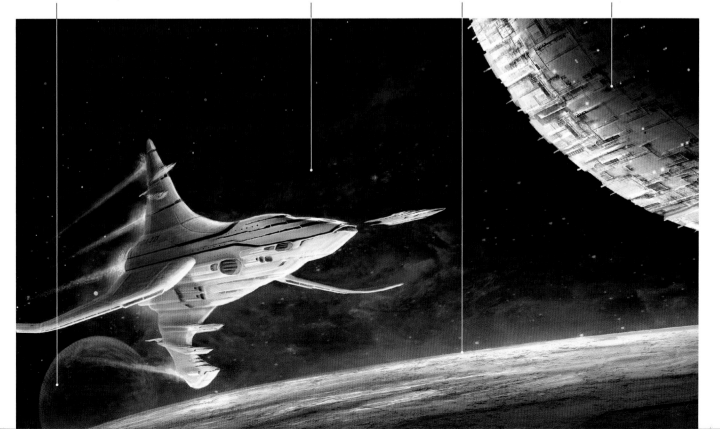

A repetition of elliptical shapes helps to harmonize the overall composition.

The flow of the background nebulas mimics the angle of the trail of the ship.

A strong contrast in color temperature helps to bring this scene to life.

Small details such as lights and stars help to convey the scale of the scene.

Whale watching

This Earth-like planet is full of creatures not too different from our own. Small one-man submarines are used to interact with fantastic marine life.

CONCEPT DESIGN

Some planets could be very similar to our own. Taking an existing creature and elaborating upon it helps to create something that is both interesting and accessible.

Elements of various whales (blue whale and humpback whale) are elaborated upon to create an interesting creature. The submarine needs to appear light, maneuverable, and believable as an aquatic craft.

Design development

1 Thumbnail sketches: Draw some silhouette sketches to show some different concepts for the look of the whale. This descriptive side view helps to define the overall look of the creature as quickly as possible.

2 Pencil sketches: The submarine sketches at right explore a few different takes on the vehicle. The four-winged craft is interesting, but aspects of it look superfluous. The next design feels too mundane, so elements of those two craft were combined to come up with a viable solution. Explore some submarine designs of your own.

Sketch a more detailed profile of the whale. Although the composition will exhibit the whale in a more dynamic perspective, all of the necessary anatomical information should be expressed in the sketch. By designing the creature with six eyes and six fins it feels alien, but the consistency of numbers (three per side) helps the design to feel organized and plausible.

The shapes of the armor plating on the creature's head are reminiscent of the shape of its fins—this establishes a harmony in the design.

The segmented tail of the whale is reminiscent of the body of a crustacean—this hybridization helps to give an alien feel. The segments also help to describe how the creature would move.

See pages 34–37 for more details on the digital process.

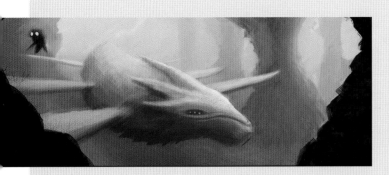

3 Value study: Begin by blocking in the background value. Use a large brush for the first pass of the painting. Once the placement of the elements is determined, switch to a smaller brush and define the various edges. Keep in mind that the light source is from above. When painting the whale, begin by blocking in the shadow value (relative to the value of the surrounding objects). Next switch to a mid-tone value and create a gradient from mid-tone to shadow on the body of the creature. Next switch to the Dodge tool to express the highlight values closest to the light source.

4 Colors: Color is visible under water, but only at close distances. The farther something is from the viewer, the more the color of the water will affect it. Use an analogous color scheme for this painting. Start by creating a new layer and set the blending mode to overlay. Use the Paint bucket tool to block in a solid layer of blue. Make a new layer and leave the mode set to normal. Paint in a range of greens in the mid-tones to expand the range of the palette.

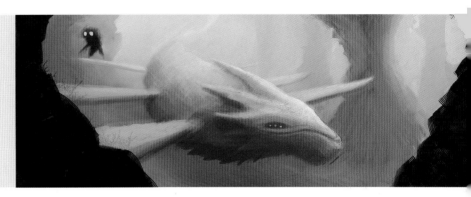

Tiny bubbles coming out of the back of the craft help to give it a sense of motion (use Scatter brush for this detail).

Coral branches add interesting shapes and help break up the foreground rocks.

A school of tiny fish helps to populate this underwater environment.

5 Rendering: The key to making this whale seem large is to add fine detail. The detail should only be visible on the areas of the elements closest to the viewer. As the elements move farther away on the z-axis, soften the detail and make them increasingly less apparent. Add sharp highlights to the back of the submarine, which give strong contrast to the object, and draw attention to a critical aspect of the narrative.

There are two methods for rendering the fine detail. An overlay of photographs can help to define the surface of the whale's skin, and the rock texture. These details can also be hand rendered. Hand rendering allows for more control, but will take longer. Painting tiny circles of various sizes will develop the rough texture of the whale's skin. The rock can be achieved through a series of sharp, overlapping brushstrokes to imply the rough nature of the surface of the rock.

Biodome

This rugged coastline features a giant structure containing multiple biodomes—each containing biological life from distant planets. The surrounding buildings house the various scientists and technicians needed to maintain and study the exotic samples of flora and fauna.

CONCEPT DESIGN

This landscape is a slightly idealized version of Earth. The plants and rocks are all familiar. The inspiration for the main structure comes from the formation of fungus on a log.
Taking reference directly from the natural world helps this hi-tech structure feel unified with nature. The shapes are intentionally contrasting with the trees and cliff to draw attention to it, but the overall impression of the building is still organic. The smaller buildings have strong verticality, which relates to the evergreen trees—this helps to visually integrate the rest of the architecture into the natural environment.

Design development

1 Thumbnail sketches: Draw some thumbnail silhouette sketches to explore design possibilities leading up to the final design of the biodome. The early sketches above feel too alien for this Earth-like planet. The end result feels foreign without being too bizarre.

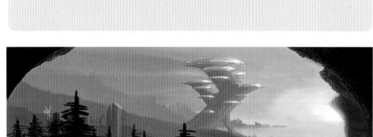

2 Value study: This is a large-scale environment, so the control of values is important. Use this sketch to determine the composition and overall flow of the painting. Placing the viewer in a cliff-side cave helps to darken the foreground lighting and separate the various layers of depth and value from one another. The lines of the coastline, cave mouth, and clouds help to lead the viewer's eye not only to the focal point but also around the entire painting.

See pages 34–37 for more details on the digital process.

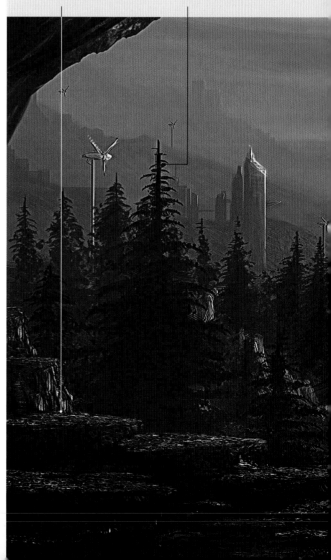

Consider the angle of the sun—the flat tops of the rocks should be slightly illuminated while the rest falls into shadow.

For the evergreen trees, start with a silhouette and add subtle internal detail so that they don't appear flat.

3 Colors: The desired effect is a hazy sunset that doesn't feel polluted. Soft, warm pastel shades help to accomplish this. Paint the sky and water with a soft brush. Once the color range of the sky and water is established, use the Dodge tool to denote the position of the sun. The brush should be large and soft.

Work from the back of the composition, increasing the brush hardness with each progressive depth layer. Objects farther away from the viewer take on more sky color, since more atmosphere is between the viewer and the object. Paint the foreground rocks with a solid block-in of their shadow value. Next use a warm earth tone hue to denote the highlight area— consider how the sunlight would fall on the top of these planes.

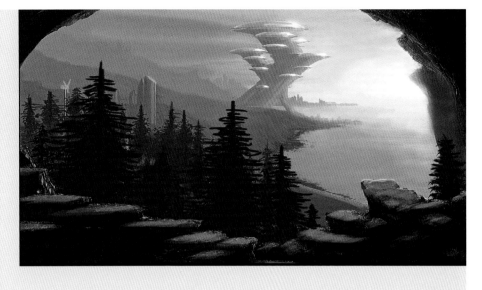

Use a small amount of internal detail in the distant domes to communicate that they are populated with organic material.

The intensity of the highlights on the water should decrease as they get farther away from the source.

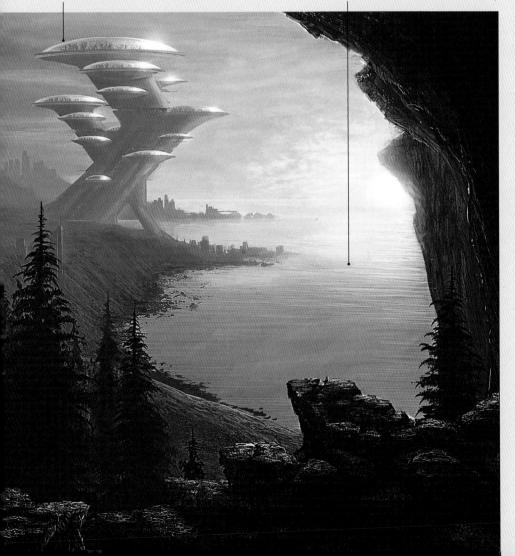

4 Rendering:

Rocks: Use an overlay of photographic rock texture to express the surface of the foreground rocks. Use the Transform tool to align the flow of the texture to the perspective.

Trees: Experiment with various brush shapes to speed up the process of defining the edges of the trees. The brush shape should have a pattern/ distribution with an organic feel to emulate the branches of a tree.

Buildings: The buildings are metallic and should produce sharp highlights on the right side. The glass on the main structure should produce intense highlights. Use the Dodge tool to express the strong highlights on the glass areas of the biodome. The haziness of the atmosphere allows for a spread of the highlight value—to achieve this effect, use a Dodge brush big enough to expand outside of the parameters of the structure.

Water: The water is in direct sunlight— consider the fall off of the sunlight. To make the surface of the water reflective, let the colors of the sky make an impression on the water. Use a Dodge brush set to 50% hardness and 10% opacity to define the highlights on the surface of the water. The highlights should run horizontally across the surface of the water.

Lab

Endless catacombs of computer terminals span the subterranean portions of the city. The scientists are fast asleep as the robot workers begin the night shift. Fast, dexterous, hovering robots perform a multitude of tasks in this heavily reinforced data facility.

CONCEPT DESIGN

The basic structure of the environment is inspired by concourses at arenas, military bunkers, and underground parking lots. The architecture of the city above is delicate and intricate, but down here design aesthetic is sacrificed for practicality's sake. Thick, poured cement walls help to convey the feeling of security and protection. The inspiration for the robot comes from the small craft designs from the movie *Batteries Not Included* (1987).

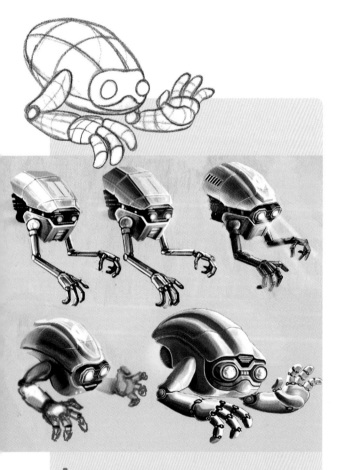

2 Line art: Begin with a basic line drawing to lay out the base structure and perspective of the shot. The final painting will have a slight lens distortion effect. This effect is easily achievable by warping the entire image in Photoshop. Rather than starting with curved shapes, it's easier to paint the scene without any lens distortion and then add it as a final touch. This helps to keep all the lines of perspective straight during the construction stage of the painting.

1 Getting started: The setting is relatively simple given the constraints of the design, so focus on the robot design first and let the scene build from there. Begin with a basic sketch, breaking down the major shapes that comprise the figure.

Experiment with a few different treatments, as shown above. Start each sketch with a basic line drawing. Slowly build detail by painting with a hard-edged full-opacity brush.

3 Value study: Now it's time to create a value study to define the lighting and atmosphere of the scene. Isolated pools of light help to guide the viewer's eye through the scene. Keep the overall ambiance quite dark to align with the "night shift" concept. Begin to position the robot workers—their placement is crucial, since the viewer's eye will be drawn to them. Give each one some slight variety to its appearance. This gives each one a sense of individuality and helps to expand upon the narrative.

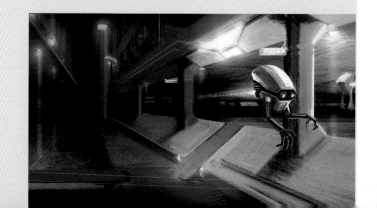

See pages 34–37 for more details on the digital process.

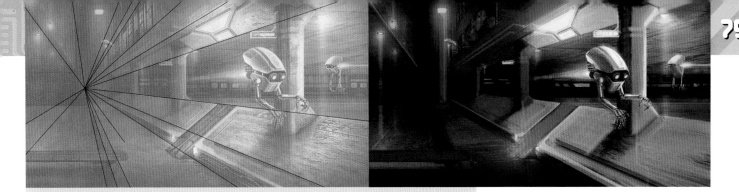

4 Color: The gray of the concrete needs to be punctuated with sharp hits of eye-catching color. Incorporate a secondary accent color to serve as detail on the cement. Use cyan for the lighting—emissive cyan lighting has a futuristic feel and it plays nicely with the yellows of the accent paint color. The color study brings this painting to a fairly well-defined level.

Ensure that the perspective is still accurate by overlaying a perspective grid as a separate layer before getting into heavy detail. Making changes to perspective at this stage is still fairly painless; waiting until the painting is tightly rendered to make these adjustments causes major problems.

5 Materials: Give the cement a subtle reflective property to add some interest to an otherwise drab portion of the painting. Add some transparent glass signs, and emissive computer screens to add some futuristic elements to the environment. The robots are made from polished, highly reflective metal. Their own exhaust also adds to their visual punch.

6 Rendering: Letters and numbers on the wall add visual interest and provide additional context to the scene. Cuts, grooves, and embossed segments in the cement reflect the shapes seen in the robots. Create the cement texture by placing a layer of photographic texture on top of the base painting of the concrete. Be sure to Transform the texture to account for the perspective of the shot. Set this texture layer to "Overlay" (see page 37).

7 Lighting: Lighting is a crucial aspect of this scene—use a soft brush at a low opacity to create volumetric shafts of light. Give consideration to the fall off of the lighting—it should be more intense at the point of origin and then increasingly soft and transparent as it travels farther from the source. Use a soft, low-opacity brush to render lighting effects. Create these effects on a separate layer and experiment with blending modes such as Screen, Soft light, and Overlay.

8 Lens correction: The final step is to add some lens distortion to the shot. Doing so creates a stronger sense of motion and pulls the attention of the viewer more directly to the focal point. The curved shapes created by this lens distortion fit nicely with the playful nature of the scene. Use the Transform→Warp function in Photoshop to create the effect.

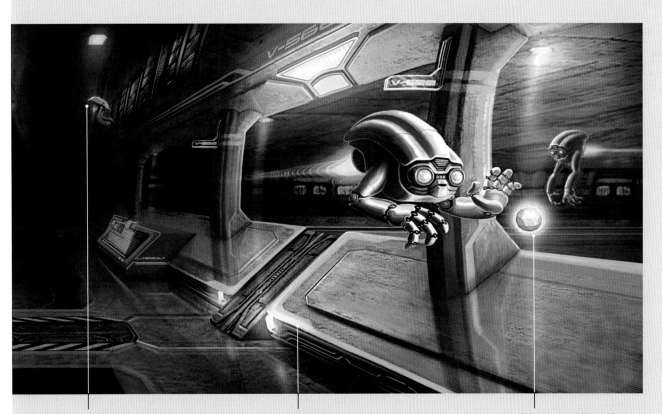

Distant workers help to occupy the scene and expand upon the narrative.

The warm yellow of the decals creates a sharp contrast in temperatures with the cool cyan lighting.

This glowing orb provides a secondary light source, which illuminates the main figure.

Jungle
interpretations

The prospect of designing an alien jungle offers an artist a great deal of creative freedom. Earth jungles are rich with fascinating subject matter– having the chance to elaborate upon that model is a thoroughly inspiring exercise. This setting allows a chance to invent entirely new organic life forms.

▶ **"Stella Doppia 61 Cygni" by Franco Brambilla**
Alien life forms interact with a spacecraft in this aerial view of an alien jungle. Interesting shapes and moons add an element of depth to this image.

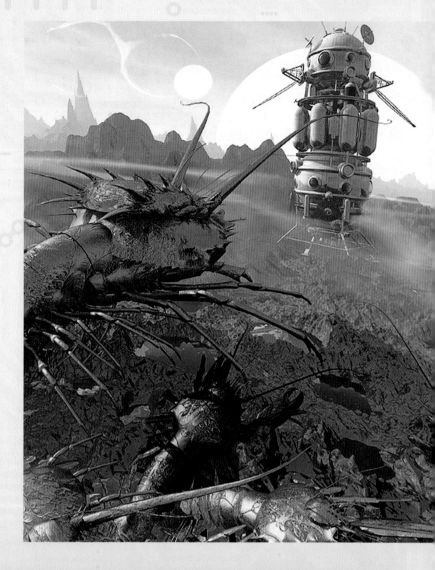

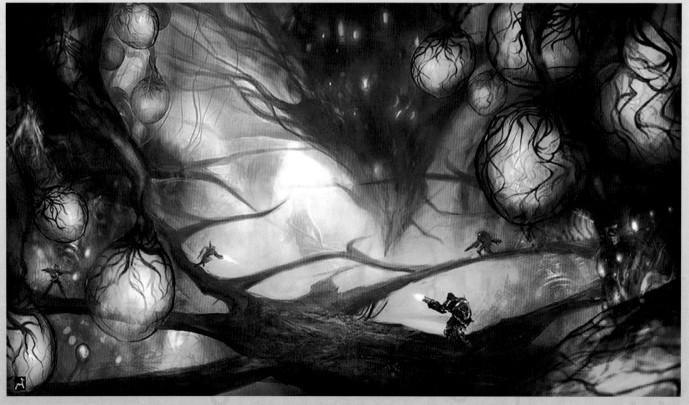

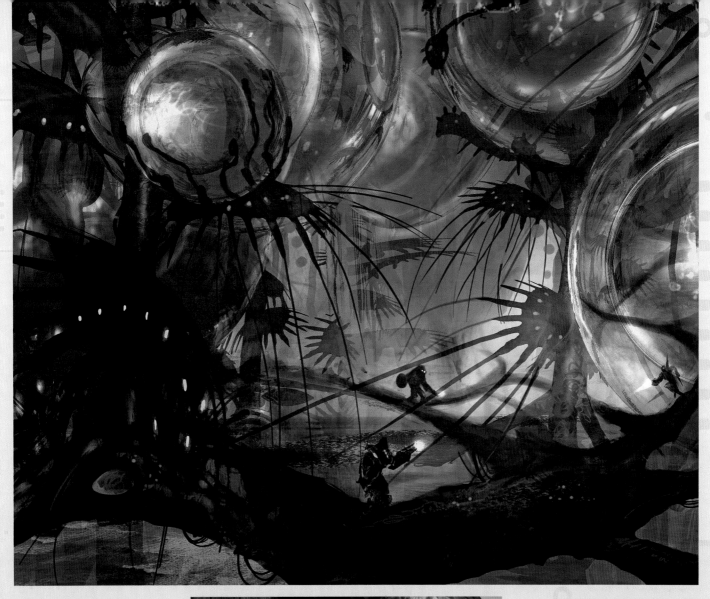

▲ "Globularasgard" by Carlos Long

Interesting silhouettes and a vibrant palette bring this exotic jungle scene to life. The strange shapes and palette give this jungle a distinctly alien feel.

◄ "Snake Mountain" by Tom Godfrey

These spore-like creatures show a creative approach to the design of alien life-forms. Rich colors and organic shapes make these organisms feel like sentient jungle plants.

◄ "Asgard" by Carlos Long

An eerie atmosphere and the figure's sense of caution give this jungle a sense of mystery. Bizarre emissive orbs protrude from the plant life, giving the flora a distinctly alien feel.

Geoff Taylor's lush biosphere is home to an alien race of peaceful and somewhat simple means. Although some level of technology exists, it is not the driving force behind the civilization. Coexistence with the natural environment is the dominant theme. There is a strong sense of harmony between the creatures and their surroundings. The following pages feature examples of Geoff's interpretation of this world. ▷

EXOTIC JUNGLE

Jungle

A lone figure walks through a lush, vibrant jungle. The jungle is pristine, only walking paths disrupt this natural environment. The figure sticks to the trees whenever possible so as to disrupt the floor of the jungle as little as possible.

CONCEPT DESIGN

A harmonized language of shapes helps to convey the figure's unity with his surroundings (see page 41).
Notice how the curve in the figure's neck relates to the shapes seen in the tree branches. The bend in his arm is reflected in the shapes seen in the vines (see page 41). Designing a figure that feels both alien and friendly can be difficult. The figure needs to have more of a sage-like feel, conveyed by the elongated cranium. His anatomy is closely linked to our own—some aspects are simply exaggerated to give him a unique and unusual appearance.

1 Gesture drawing: Begin with a gesture drawing. This quick, loose sketch helps to define the character's gait. He should feel jovial and friendly, so use curved, fluid lines to put some bounce in his step.

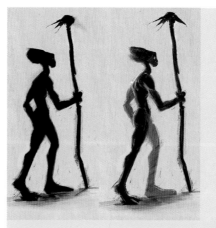

2 Silhouette: Next, transplant the gesture into a silhouette. This helps to define the body type of the figure. The figure will be backlit in the final painting, so apply a rim light (light that catches the outer edge of the figure) to the silhouette to define more of the structure. The lighting should correspond with the physical features.

For the purposes of this painting, the figure will not be developed too far past the silhouette stage, since the lighting will not reveal him in his entirety.

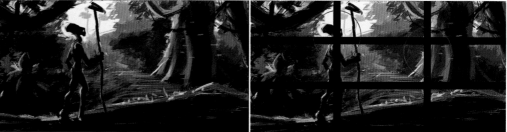

3 Value and lighting: Place the figure into the environment. Use large, fast brushstrokes to define the jungle. Use lighting to create strong silhouettes in the foreground and points of contrast in the middle ground. Use values to communicate this. Darker values in the foreground help to separate the foreground and give a sense of depth and space to the scene.

The values will also help to create the sense of depth needed to properly convey the scale of this scene. Values should become lighter and lighter as they move toward the background—notice how soft and light the most distant tree is.

Remember the rule of thirds when composing this scene (see page 38). Place the focal areas at the points of intersection on the grid. Use a contrast in values to create focal points. Experiment with placement and exaggerate the lines.

Use the below layer structure to keep the painting organized:
Layer 1: Background sky
Layer 2: Background forest
Layer 3: Middle ground forest
Layer 4: Foreground log
Layer 5: Figure
Layer 6: Foreground vines

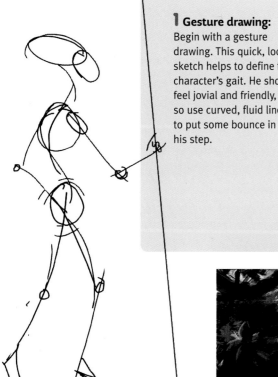

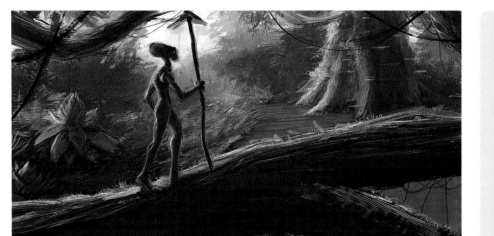

4 Surface effects: Because the jungle is dry, the highlight strength remains fairly minimal. The dominant shaft of light picks up on a few leaves, and stronger highlights appear where there is direct contact with the light source. The figure's skin is a slight departure from the setting. He has sharper and stronger highlights on his skin—adding a few key highlights to him also helps to separate him visually from the background.

Use a hard-edged brush to define the details in the foreground—use a progressively softer brush to render details farther from the viewer. Small edge details on the foreground log should be painted with a small, hard-edged brush set to 100% opacity.

The bark needs to be understood as a series of segments coming together to comprise a whole. Define individual sections of bark by painting their perimeters with a shadow value. Each section of bark should be painted to express volumes—use sharp delicate brushstrokes to define the rim light on each section of bark. Paint the foreground vines on a separate layer to allow for a quick, clean execution of the edge work.

5 Color: The palette is based on the principle of complementary colors (see page 50–51). Red opposes green on the color wheel, and therefore creates color vibration/contrast. The deep red hues of the figure contrast nicely with the greens of the jungle. Earth tones help to fill in the gaps and define the jungle floor and separate the trunks of the trees from vegetation.

6 Rendering: This piece is detail oriented. While the lighting scenario limits the level of detail in the foreground, it highlights a multitude of detail in the middle ground. Instead of drawing every individual leaf, just focus on the areas where the light defines the shapes. The masses in the background were initially just blocked out in terms of value. Now you need to define them as individual trees. Be sure to adhere to the values blocked out in the early stages so that a sense of depth is maintained. Remember the rule of "general to specific." Define all the main structures before dealing with each little crack in the bark or leaf on the tree.

See pages 34–37 for more details on the digital process.

The overall structure of the forest is familiar, but some of the plant life feels exotic.

The level of detail behind the figure is slightly lower to allow the figure to read and avoid visual congestion in this key area.

Background elements remain silhouetted.

Foreground elements become increasingly detailed.

A repetition of curved organic shapes brings unity to this piece.

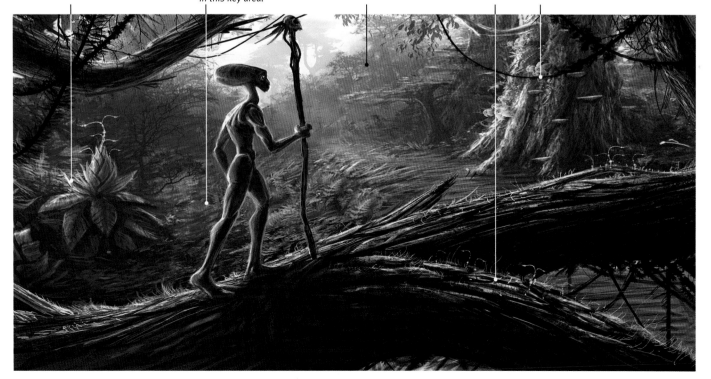

EXOTIC JUNGLE

Elder

These ancient sages live in harmony with the vast jungles and forests of the planet.

CONCEPT DESIGN

Portraiture is predominantly conveying personality. With a nonhuman subject, the task becomes increasingly difficult. To design this character, look for relevant cultural references in our world. *Tibetan Man* **by Zhiwei Tu offers some inspiration for the overall feel of the portrait.** Draw upon a parallel from the natural world for the design of the figure. The tortoise seems a logical solution—these gentle creatures live long lives and offer interesting anatomical features to reference, such as a long neck and expressive face.

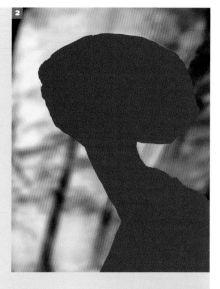

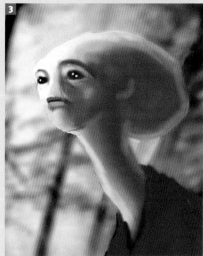

1 Getting started:

1 Start with a soft focus background offering a light source that will accentuate the features of the character's face. This can be achieved through using large, soft brushstrokes or applying a blur filter to a photograph. The background can remain fairly nondescript but can communicate a simple setting that relates to the figure, such as the one above. Soft focus allows the freedom to explore abstract shapes, which support the structure and pose of the figure.

2 Begin by blocking in the shadow value of the figure's flesh tone and robe.

3 Slowly build up detail by adding progressively lighter values. Work from general to specific in terms of shape and from dark to light in terms of value. Note how the line of the tree in the background creates a point of intersection with the figure's head, which helps to draw focus to the right area.

4 The dark eyes of the figure are positioned in a deliberate focal area. The strong contrast of values in the eyes draws the viewer's attention, so position them on an axis point of the composition (see page 38).

2 **Lighting:** The background communicates the light source. The most intense highlights will push close to a white value. The rim light areas (light that catches the outer edge of the figure) offer an opportunity to introduce some soft, warm tones that help to bring the figure to life. The background of this painting communicates the light source. Sample the brightest values from the background and apply them to the left side of the figure with a hard-edged brush. Use a softer, low-opacity brush to transition the highlight color into the mid-tones of the flesh. Use the same approach to introduce some bounce light on the right side of the figure, but select a red tone from the background.

3 **Rendering:**

Eyes: The eyes are the dominant focal point of the composition and are a break from the softness of materials in the rest of the painting. Create crisp, dramatic highlights on the eyes. Use a soft-edged, low-opacity brush to lay in subtle mid-tone reflection. Switch to a hard-edged, 100% opacity brush to execute the sharp highlights on the surface of the eye.

Skin: The skin is similar to that of an elderly human. A reference photograph will help to get the right amount of translucency (see above). A slight sense of visible veins on the cranium will help to give the skin an aged feel. The wrinkles are important as well—consider the structure of the face and how the figure's facial expressions would create wrinkles and lines over time.

Robe: Consider the underlying structures when rendering the robe. The folds in the fabric should originate from the base of the neck and flow down vertically to show that they are affected by gravity.

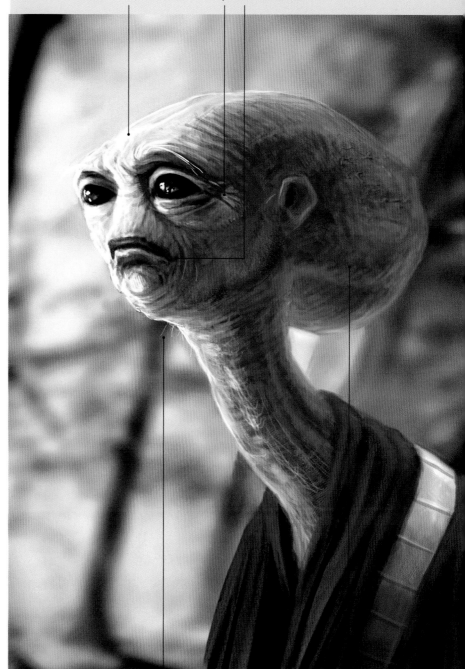

The elder's expression gives him a feeling of benevolent wisdom.

Aspects of the Tibetan Man study remain apparent in the final painting—this helps to give a tangible feel to the character.

Tiny hairs on the elder's chin catch strong highlights.

The strong red hue of the robe creates a bounce light on the right side of the elder's head and neck.

See pages 34–37 for more details on the digital process.

EXOTIC JUNGLE

Jungle hawk

Deep in the forests exist bright, beautiful birds of prey. These apex predators are so swift to catch their prey that they can forgo the need for camouflage.

Design development

1 Getting started: Do some thumbnail sketches to explore a variety of influences, such as the owls, toucans, vultures, and hornbills above. The hawk body type fits the design challenges best. One of the trickiest parts of this design is to make the bird feel fast enough to make the bright colors possible. The bird should look exotic and predatory, but at the same time capable of catching a meal.

CONCEPT DESIGN

The body type is inspired by birds of prey—mainly eagles and hawks. The coloring comes from bright Hawaiian roosters. The additions to the silhouette help to create a little more visual interest and give the design a unique and slightly alien feel. The background suggests the viewer is situated in the canopy of a dense forest.

2 Geometric breakdown: Do a sketch to explore the volumetric properties of the bird. Having a solid understanding of the underlying forms of the creature ensures that the final painting won't feel flat or stilted.

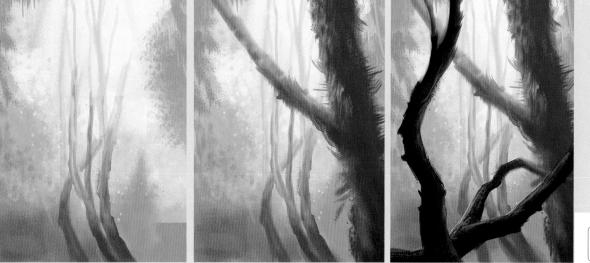

3 Blocking in: The surroundings are not the focus of this scene—they serve to draw attention to the bird. Use a large brush and use quick, decisive brushstrokes to create shapes that lead the viewer's eye toward the bird.

See pages 34–37 for more details on the digital process.

The luminous cyan tone of the bird's eye pops out without feeling too disjointed from the rest of the palette.

Spherical nodes on this tree give it an exotic alien feel.

The high chroma of the red on the bird's head creates a strong contrast with the dominant green hues of the painting. This helps to direct attention to the right area.

Branches and leaves guide the viewer's eye through the scene.

The bird's perch flows on the z-axis of the painting—this helps to give a sense of space and depth to the scene.

4 Rendering:

The background remains quite loose, so apply most of the detail to the bird.

Feet: Give special consideration to the placement and position of the feet. This is an important aspect of the painting; if the feet feel flat or unconvincing, the bird won't feel grounded in the environment.

Plumage: Reference is crucial when tackling the plumage of the bird. Feathers have very specific patterns of formation, which are essential in giving the bird the right amount of lift and control to fly. Certain areas can be exaggerated and altered, but wings should be very close to the wings of hawks and eagles. The additional feathers on the head should add interest to the silhouette, but still feel as though they would remain streamlined while the bird is in flight.

Leaves: Add a few leaves in the foreground. These help to populate the environment and also act as compositional devices that draw the eyes away from the edges of the canvas. It's important to create visual paths for the viewer's eye that lead through the canvas. If those paths stop dead in certain areas—particularly the edges of the canvas—it disrupts the flow of the composition. The leaves are like arrows, pointing away from areas where the viewer's eye is not intended to rest (see page 38).

Rendering tips: Keep the brush work loose in the environment, and tight on the bird to ensure that the bird remains the primary focus of the painting. Experiment with custom brushes in the background. When selecting/ creating a custom brush, give special attention to the edge quality of the brush and how it relates to the subject matter. Rough edges help to quickly articulate rough surfaces like tree bark. Render the bird exclusively with a small, round, hard-edged brush set to 100% opacity.

See pages 34–37 for more details on the digital process.

EXOTIC JUNGLE

Chariot

This sleek, one-person ship helps transport the occupants over the dense jungles and swamps of this vast planet.

Design development

1 Getting started: Make some sketches to explore different design possibilities. The below sketches show some ideas. The first sketch was far too blocky. The sketches progressively become more streamlined and refined. Try to eliminate any superfluous design elements without ending up with something so reduced that it becomes impractical. The final design has a very reduced shape, but still has a cockpit, engine, and stabilizing features, which give the appearance of a craft able to take flight.

CONCEPT DESIGN

To communicate the bond with the natural world held by the creatures in this jungle world, a representation of nature should be apparent in the design of their technology.
The desired abstraction should possess elegant lines and a light and delicate structure. A leaf is a good starting point, since it possesses the correct characteristics. Look for ways to reflect the line flow of a leaf into the structure of the craft.

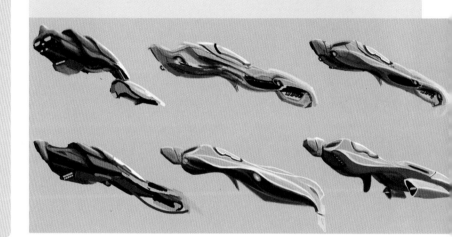

2 Blocking in: Block in a basic background showing the canopy of a forest, and then apply a Motion blur filter to it to give the ship a sense of speed. The motion of the craft should dictate the angle of the blur. The craft will remain completely in focus—this sort of focal shift gives a photographic element to the painting.

Implementing various levels of focus and blur helps to establish a contrast of detail and a sense of depth—this helps to guide the viewer's eye to the intended areas of a composition. Highly detailed areas will pop out and read with more presence when juxtaposed with soft, ambiguous, and undefined elements.

3 Colors: Color choice is an important consideration when attempting to create harmony between nature and technology. A strong contrast in hues would make the craft feel separate and out of sync with the rest of the world. A harmonized and somewhat limited color palette is therefore appropriate. Sticking to greens is a logical decision, as so much of this world is dominated by green plant life. A warm light source offers more variety to the palette and helps to create more interest in the scene. Monochromatic palettes can be effective, but often tend to lack the impact of a slightly broader range in hues. The swatch of colors below illustrates the desired range.

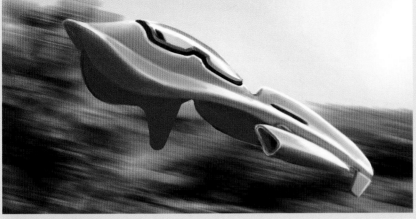

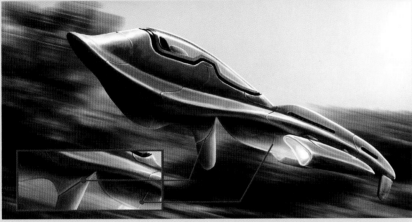

4 Rendering:

Before focusing on the specifics of the materials and the finer details of the ship's construction, try to define the overall volume of the chariot with a smooth matte finish (see left). This smooth surface will provide an easy surface on which to render finer detail.

Use a soft-edged brush to define the smooth gradients of the internal structures of the craft. Switch to a hard-edged brush to tighten up the outer edges of the craft.

A distinction must be made between the glass of the cockpit and the metal of the chassis. The cockpit will remain completely transparent. Tight highlights help to reinforce the lighting and define the surface. The metal is at a mid-range of reflectivity and specularity.

Use a small, 100% opacity hard-edged brush to define the construction seams. Begin by painting the seams with a dark value to convey the inset. Then create a new layer and switch to a highlight value (which can be sampled from the background) to create the sharp highlights on the edges of the seams. These lines need to perfectly mirror the inset lines, so make use of the undo function—keep repainting these lines until they are perfectly matched to the layer below. These highlights should fall slightly to the right of the inset.

The elder's head (see page 84) is visible in the canopy of the ship.

The colors of the environment are mirrored in the surface of the craft. This helps to harmonize the craft with the scene.

A bloom of cyan indicates the propulsion system of this craft.

The motion blur on the background gives an added sense of speed to the painting. Additionally, the softness of the background pulls focus to the sharpness of the ship.

Jungle panorama

Light, hi-tech aircraft race through stormy and brooding skies. The dense jungle that carpets the hills and plateaus looks impenetrable on ground level, making the aircraft a perfect mode of transport.

1 Getting started: Do a pencil sketch to establish the forms of the various plateaus. Understanding the volume of the structures makes the lighting less challenging when the time comes. This exercise also helps to clarify how the trees will sit atop these structures. A lack of attention to volume could make the trees appear flat and pasted onto the hillside.

CONCEPT DESIGN

This painting shows a vast jungle landscape. The stormy clouds break in the distance to reveal sunlight. Small openings in the cloud layer reveal strong shafts of light beaming down on the treetops.

The shapes of the sky and terrain are planned to create a path for the eye to move through and take in the detail of the scene. The ships move quickly in sharp contrast to the calm landscape. This painting communicates two distinct classes of inhabitants in this planet—those in touch with the natural world, and the technologically advanced elites.

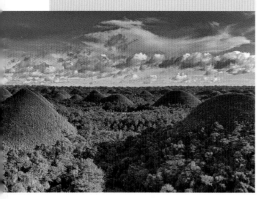

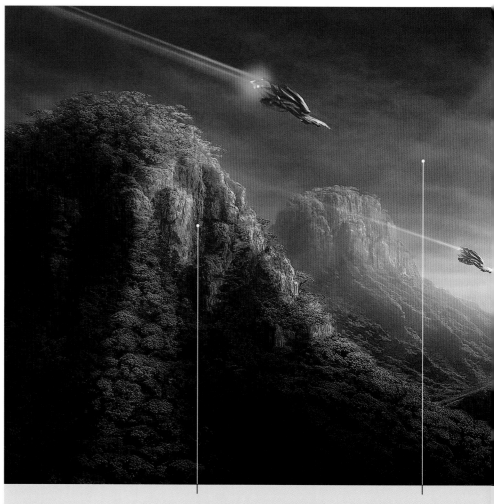

Patches of exposed rock help to break up the texture and color of the jungle.

Transparent shafts of light add drama and interest to the scene.

2 Value study: As with all large-scale landscapes, control of values is a critical aspect of creating the illusion of depth, which is vital to this scene. Keep the rules of atmospheric perspective in mind when plotting out the values.

The values should be darkest in the foreground, and increasingly lighter with each layer of depth. Determining the layers of depth is easy in this scene, since each one is divided up into one plateau formation.

3 Colors: This painting employs an analogous color scheme, meaning that the colors are adjacent to one another on the color wheel. When using an analogous color scheme, make one color more dominant. In this case, the greens are dominant and the blues are secondary. The bright cyan emissions from the aircraft act as accents. These accents are much higher chroma than the rest of the painting, which makes them pop out. Use this accent subtly so as to not overpower the soft atmosphere of the rest of the painting.

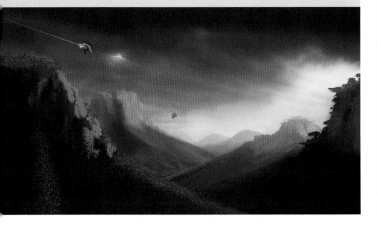

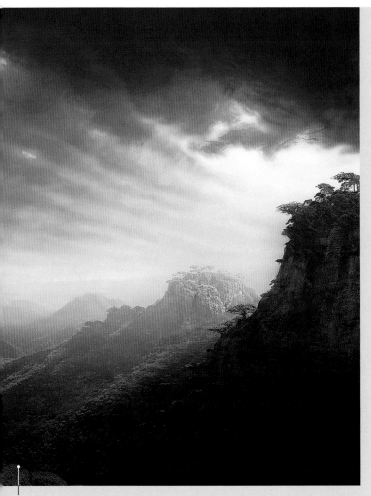

Sharp foreground textures contrasting with the soft background help to create a sense of depth and scale.

See pages 34–37 for more details on the digital process.

4 Rendering:

Ships: The design of the ships can be handled quite quickly—they are very distant from the viewer and therefore read as being quite small. Use the ship design from page 88 to inspire the design, or come up with one of your own. Block in the silhouette of one ship using the shadow value. Define the structure further by adding highlight values to the areas facing the light source. Use a full saturation cyan at full opacity to denote the exhaust of the craft. Then create a low-opacity stroke flowing from the exhaust to give the ship a trail. Make sure that this line fits the perspective of the scene. Now duplicate the layer with the ship and the trail and move it into the position shown for the second ship (center of the composition). Now use the Transform tool to shrink the ship. This will give the sense that it is farther forward than the ship on the left.

Trees: Build up a general leafy texture to spread throughout the jungle area and then define each individual tree with a distinct shadow side. Be sure to give extra attention to the trees on the edges of the hillsides. The silhouettes of these tree branches will add believability to this scene. Let the light source catch the treetops more intensely in certain areas to define the small ridges and valleys within the internal structure of each plateau. The Clone stamp brush can be very useful when repeating texture over and over in different areas. Add highlights to the high points of the plateaus facing the light using the Dodge tool.

Sky: Use a small soft brush to define the outer edges of the clouds. The key to painting these clouds is to design shapes that support the rest of the composition without feeling too contrived. This is a difficult balance to achieve, but the results are worth the effort since the sky adds a great deal to the overall mood and atmosphere of the painting.

Invaders
interpretations

Themes of invasion offer the artist a chance to visually develop a highly advanced, militarized alien race. War ships, warriors, and weapons become a dominant focus. Heavily damaged landscapes with rich smoky atmospheres fit well in this genre—destruction can make for interesting shapes and silhouettes.

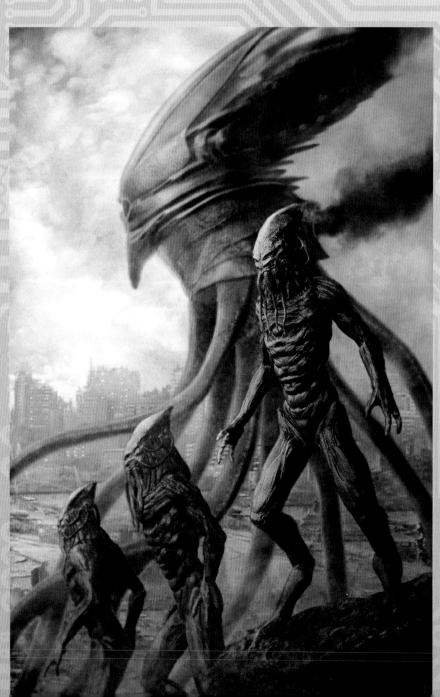

▲ **"Spaceship Crashsite" by Lorenz Hideyoshi Ruwwe**

This giant craft looms over the landscape. The use of color on the ship makes it feel alien in contrast to the desaturated world around it. Consider how these types of visual devices can be used to make an element feel out of place.

◀ **"Ebo District" by Riyand Cassiem**

These fearsome creatures march in a militarized fashion. Situating them on high ground overlooking the city gives them a sense of superiority. The city in the background is made to feel Earth-like and vulnerable.

▶ **"Flight" by Tom Godfrey**

Invaders need not be large and fearsome. Something as simple as an infected alien insect could bring a planet to its knees.

▼ "Ragnorocl 8" by Carlos Long
Fiery skies set a tone of destruction in this image. Smoke from the war-torn cityscape builds up a rich and interesting atmosphere.

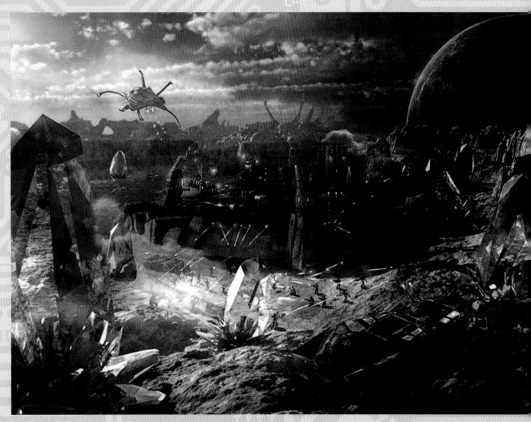

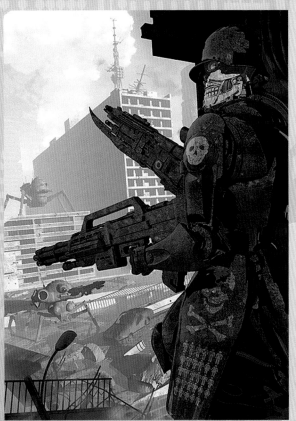

◄ "Forever Peace" by Franco Brambilla
A menacing soldier overlooks the city. Military equipment in the background helps to communicate a widespread attack on this familiar-looking environment.

Geoff Taylor's alien invaders roam from world to world, seeking conquest and resources. Their methods are insidious and reflect minds devoid of morals and compassion. They arrive as messiahs in an attempt to pacify and covertly destabilize the population. Once control has been attained, the second wave of the assault is launched—an all-out war effort designed to serve the whims of the empire. The following pages feature examples of Geoff's interpretation of this world. ▷

INVADERS

Battle suit

In this world, heavily armored foot soldiers patrol the invaded warzones.

CONCEPT DESIGN

The unusual anatomy of this species presents an interesting challenge when designing armor.
The suit must be created to accommodate a very unique range of motion. The body of the creature is somewhat spindly, therefore some additional bulk seems desirable. Be sure to consider the form under the armor and how it would move when bulking up the armor. Too much mass can impede the bending of various joints and make the armor more of a hindrance than an enhancement. Look to real-world examples of armor to

establish a framework for how it tends to interact with a body. Joints such as elbows, shoulders, and knees tend to require additional padding; however, be sure to add this padding in such a way that the joint can still bend.

Much like the armor, the weapon should suit the unique anatomy of the figure. This two-handled design works nicely with the four-armed structure of the creature. The below design (see above for close-up) gives a sense of stability and accuracy to the weapon.

1 Getting started: The pencil sketch expresses the anatomy of the figure under the armor (see page 43). The pose is loosely inspired by Leonardo Da Vinci's *Vitruvian Man*. Perform this sketch with a 2B pencil. Use a sharp-edged eraser to clean up the drawing and add final highlights. The highlights should indicate the crests of the various anatomical volumes.

2 Grayscale sketch: Do some sketches to define the basic look of the suit. With a complex design such as this, the finer points of the design can come in later stages.

3 **Value study:** Start with a basic silhouette. The pose should convey power and aggression, so look to create a strong stance with a good sense of weight and solidity (see right). A basic contact shadow helps to ground the figure and give more believability to the pose. A background isn't always necessary, but images without any sense of contact with a ground plane often appear to float.

Once the silhouette is resolved, add a range of values to define the various internal shapes of the suit. Color will be added with an overlay in step 4, so be sure to keep the value range wide, as overlay coloring tends not to work well when applied to images with a limited range in values. Pay careful consideration to each individual form at this stage, and make sure everything is clearly defined with a precise edge treatment (see far right).

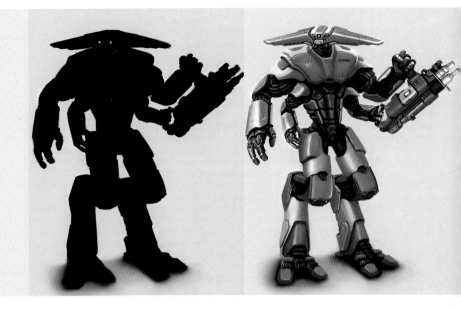

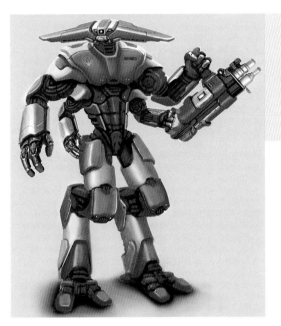

4 **Color:** Create a new layer and set the blending mode to "overlay." Overlay allows you to quickly experiment with various color schemes while preserving the detail and contrast of the underlying values. The various tones seen in the armor increase the visual legibility of the figure. Without the two-tone coloring of the armor, and the cool tint to the darker sections, the figure would feel flat.

5 **Rendering:** Small details such as vents, lights, and decals help to bring the design to life by adding an added sense of function and purpose. Contrast can be achieved through various levels of detail and intricacy. Use the finer detail in specific areas and allow some shapes to remain broader. Anatomical features with more complex and intricate ranges of motion (such as hands and feet) require more attention to detail, since they would need more moving parts.

Use a small, hard-edged brush to render the fine line work. The highlights on the armor are tight in spread but have a soft edge quality, so use a small, soft-edged brush to produce this effect. The light source is coming from the top left—keep this in mind when adding these details.

Small blue lights on the face and weapon draw attention to the more interesting portions of the design.

Tightly detailed areas such as the hands, face, and gun are balanced by areas of visual rest such as the chest plate, forearms, and thighs.

Subtle blue tones in the dark portions of the armor contrast with the overall warm palette.

See pages 34–37 for more details on the digital process.

<div style="writing-mode: vertical">INVADERS</div>

Gunship

In this science fiction scenario, these brutish gunships make short work of even the most developed of cities.

CONCEPT DESIGN

This craft is essentially a heavily reinforced flying cannon. The silhouette should have a solid, muscular feel devoid of fragility and weak points. One of the sturdiest looking vehicles on the planet today is a supertanker (see above). Although these ships aren't weaponized, the bulk of their form makes them a suitable piece of reference. Elements of the battle suit design (see page 94) are implemented in the design of this craft to help give a unified feel to the design of this culture. From a head-on view, the shape of this craft would closely mirror the helmet of the battle suit.

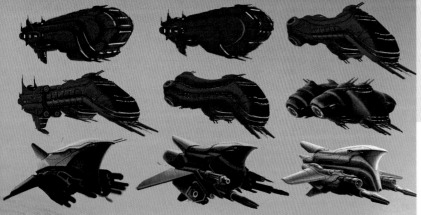

1 **Getting started:** Create a smoggy sunset background to set the right tone for a machine focused on destruction. Select an image of sky and clouds and use Image adjustments such as Color balance, Photo filter, and Hue and saturation to create the palette.

Do some thumbnail sketches to develop the design. The sketches at left show a slow development of the tanker concept becoming more and more visually communicative of air travel. The early designs tend to read more as transport vessels than gunships. The exaggeration of the weaponry helped to give the design the intended aggressive feel.

2 **Perspective:** Use a two-point perspective grid to establish a complex view of this ship (see page 46). As the level of detail increases, perspective becomes increasingly challenging. Make sure that every detail correlates with the grid, no matter how small.

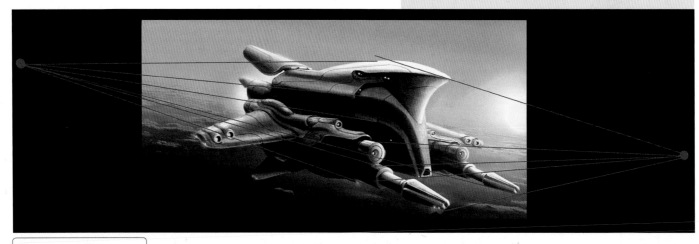

See pages 34–37 for more details on the digital process.

3 Blocking in: Create a new layer and begin to block in the ship. Use a hard-edged brush to create a crisp edge quality on the silhouette. Having the ship on a separate layer allows for added control in terms of rendering and composition. Start with the darkest value and begin to add progressively lighter values. Approach the painting in a series of passes, each time working through the value range from light to dark, and with each additional pass focus on increasingly finer levels of detail.

4 Texture: Texture helps to develop a backstory for an object. In this case, the ship should feel used and scuffed up from battle. Take a photograph of some scratched rusty metal and experiment with placing this layer on top of the ship with the Blending mode set to overlay. Be sure to clean up any portions of the photo that fall outside of the parameters of the ship. Some manipulation of the texture may be required to alleviate any visual flatness. Careful transformation of the texture helps the details to flow with the volumes of the craft as opposed to laying flat on top and degrading the overall impression of form (see page 37).

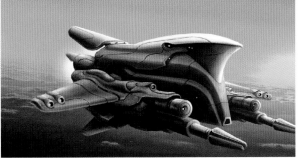

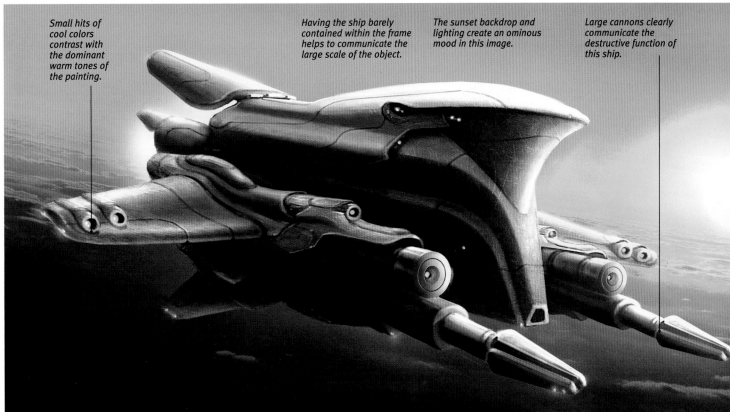

Small hits of cool colors contrast with the dominant warm tones of the painting.

Having the ship barely contained within the frame helps to communicate the large scale of the object.

The sunset backdrop and lighting create an ominous mood in this image.

Large cannons clearly communicate the destructive function of this ship.

INVADERS

Behemoth

As the invaders journey through the cosmos, they come across various life-forms that they deem useful. This gentle giant is used for its strength and put to work on the construction of temples.

The behemoth needs to feel immense, powerful, slow, and somewhat downtrodden. The story of this creature evokes sympathy in the viewer, so the design should help to amplify this feeling. This can be achieved through both appearance and pose.

The creature is based on a variety of Earth animals both living and extinct. Looking to prehistoric animals is a great way to come up with unusual creature concepts, since the audience tends to be unfamiliar with their appearance. Elements of rhinos, bison, chameleons, giant sloths, *Chalicotherium*, and elephants are combined to create this new species.

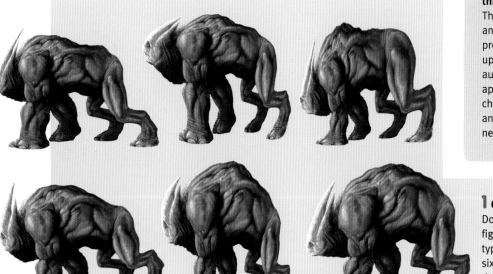

1 Getting started:
Do some sketches to show variations of the figures. In the sketches at left, different body types are explored, but in the end, number six best conveys the desired attributes of the creature.

2 Anatomy: The main challenge with the anatomy is deciding which muscle groups should bear the weight and stress of the pose. If all the muscles are tense, the figure looks unnatural, and if none of the muscles show tension, the pose will lack power and believability. The best way to determine which group should be shown in a tensed state is to consider which muscles are actively driving the figure, and which ones are receiving the bulk of the weight. A gesture sketch can be a helpful way to understand the energy of the pose without getting caught up in detail too early on (see page 42).

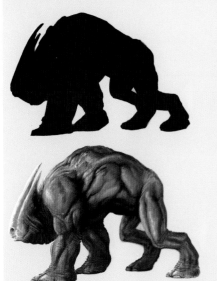

3 Blocking in: Start with the figure's silhouette and use the darkest value as a base. Block in the dominant masses of the figure with a lighter mid-tone value. With a light source determined (in front and above the figure), let the light catch the relevant portions of the structure.

These highlights will begin to give the figure a sense of volume. Define the volumetric properties of each muscle group before moving on to details such as wrinkles and skin detail.

4 Rendering: To accurately depict the various wrinkles in the body, consider how the skin is being stretched and pulled by the movement of the creature (see above right).

Add a basic ground plane with a basic attention to detail to give an added dimension of reality to the painting.

Give extra attention to the expression of the face, since the viewer's eye will be naturally drawn to this area.

Tip: The Liquefy filter (found in the Filter menu) can be used to make minor adjustments to the pose and proportion of this design. The Default brush tool in Liquefy mode is a very powerful tool, but if pushed too far, the result can become muddy and blurred. Experiment with this tool and see what kind of variations can be achieved.

The detail in the spinal column makes the figure look malnourished and mistreated.

See pages 34–37 for more details on the digital process.

The tension in certain muscle groups helps to convey movement in the pose.

Small eyes and a passive expression make this creature feel harmless in spite of its powerful stature.

The feet are slightly sunken into the ground plane—this communicates the immense weight of the figure.

Temple

This race spreads throughout the galaxy, colonizing various planets for resources. Given their advanced technology, they are easily mistaken for gods by unsuspecting populaces. This temple was constructed as a monument to the conquerors. The temples are laboriously etched out of the sides of mountains. A lone priest watches the sunset over the monument to his ruler.

CONCEPT DESIGN

Complex intersecting shapes create visual tension to convey a sense of unease, which presents a difficult design challenge. Achieving a sense of tension without losing the composition to visual chaos is tricky.

The solution lies in the use of parallel lines, and carefully placed repeated shapes. In spite of all the overlap and intersection in this composition it still feels relatively balanced. Repeated angles help to create an overall harmony in this otherwise tense composition. Although we see a great deal of square and rectangular features, triangles are dominant in the focal areas of this scene. The path the eye follows through the scene is

also triangular—the eye travels from the statue to the temple entrance to the priest, and then back to the statue. These shapes add to the visual harmony, but the jagged nature of the shape still helps to promote that sense of tension.

Use the landscape painting below to reference the shapes of the mountains. Resist the urge to generalize shapes. It's a common mistake to make all mountains look like simple triangles. The key is to break up the primitive geometric shape with fine detail comprising the edges of the structure.

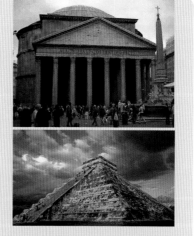

Architecture: The temple is inspired by Roman and Mayan architecture (see above). Combine the strong verticality of the Roman temples with the pyramidal structures of Mayan ziggurats. Vertical columns also play an important role in this painting. Establishing a rhythm of vertical shapes throughout the foreground, middle ground, and background helps to tie this complex composition together. They also create interesting negative shapes, and serve as framing devices within the overall composition.

1 Basic sketches:
Statue: Sketch out the statue to define its character. The figure's pose should have some suggestion of spirituality, while maintaining the overall malevolent feeling. Incorporate a sense of triangular shapes in its design to harmonize the statue with the architecture. Due to the symmetrical nature of the figure, you only need to paint one half of the image. When you have drawn one half of the figure, duplicate the layer. Hit Ctrl····⟩T to transform the new layer, then hit flip horizontal. Now move the mirrored section into position. Some clean up may need to be done at the point where the two layers meet.
Priest: The priests of ancient cultures often wore costumes to appear more god-like. The design of the priest should communicate his allegiance to the figure shown in the statue, so give the priest's costume some shapes and attributes that are reminiscent of the statue.

See pages 34–37 for more details on the digital process.

2 Line art: Do a simple line drawing to help determine the shapes found in the focal areas of the temple. On the far right is a quick study of the entrance of the temple. The diamond head motif serves this scene well, since it references the shapes seen in the statue's face nicely.

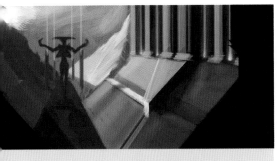

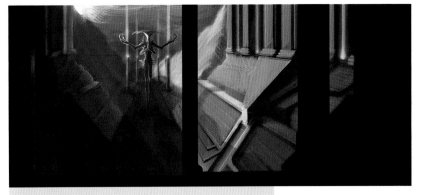

3 Value study: With the shape of the figure resolved, it is time to block in the composition with a grayscale value study. At this stage just focus on resolving the dominant masses. Take perspective into consideration, but hold off on creating a perspective grid until a little later. At this stage just draw freely, since it's easy enough to go back and adjust the perspective later. Doing so too early can cause the drawing to feel stiff and lifeless. Once the composition is effectively communicated, use the line tool to create a one-point perspective grid (see page 45). Clean up any lines in the painting that aren't congruent with the grid.

4 Color: Begin adding color by creating an overlay layer on top of the value study. Fill the entire layer with the dominant beige color. Create a new layer and leave the blending mode set to normal. Select a high-saturation green tone and block in the lights. The vertical shaft of lights can be painted by holding shift (this allows for straight vertical and horizontal lines). Create another layer and set it to multiply. Now select a dark, low-saturation red and add some warmth to the shadow areas.

5 Surface effects: The temple is carved out of a mountain. The mountain is raw and unrefined, whereas the temple is laboriously carved and smoothed. The statue is made of an onyx-type stone. The statue is one of the key focal areas in this painting, so giving it a slightly contrasting material helps draw attention to it.

Soft, blooming light sources contrast the sharp, tight details of the architecture.

A perspective grid is vital, since every detail needs to be congruent.

Try desaturating the painting in Photoshop from time to time to ensure that the values are distributed properly.

6 Rendering: Use photographic overlays of texture to help convey the grittiness of the rock. When transforming the textures, be sure to adhere to the perspective grid. Keep the darkest values in the foreground, and gradually lighten the values toward the background. Complex architecture calls for precise line work and edges. Holding shift and dragging the tablet pen creates horizontal and vertical lines. To make straight lines at any angle, start by making a single mark to define the origin point of the line, hold shift, and click the intended destination point for the line. If shape dynamics are turned off the line weight will be even, and if it's turned on the line will taper.

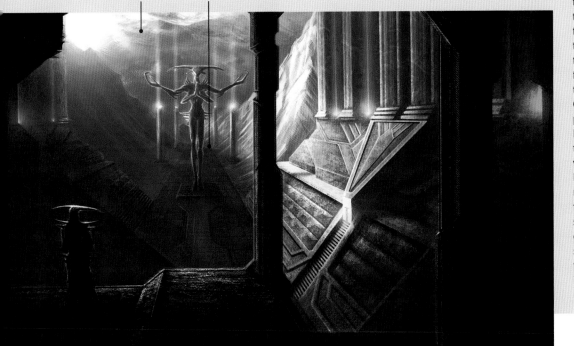

Desert
interpretations

The desert planet is a frequent sci-fi setting. The concept of a harsh inhospitable world is a great backdrop for storytelling. An interesting point of conjecture when envisioning other worlds is the unique challenges of survival faced by alien species. The unforgiving nature of a desert is a great setting in which to explore these themes.

▶ "Sunset" by Vincent Laïk

Brilliant colors from the sky bathe this landscape in alien hues. The roughness of the cracked earth contrasts nicely with the soft shapes of the cloudy sky.

◀ "Salvation" by Riyand Cassiem

This image effectively communicates the hardships of life in a wasteland. The image manages a good balance between an emotional impact and feeling "otherworldly."

Geoff Taylor's concept of a future desert world shows the plight of a human-like race plagued by a harsh and unforgiving environment. Climatic turmoil drives the technological progress of this society— the inventions exist as a result of necessity. Ingenuity for the sake of survival is the driving force behind this culture. The following pages feature examples of Geoff's interpretation of this world. ▷

◀ "Secret of the Abandoned Land" by Camille Kuo

This wide vista shows a fascinating desert environment. Strange gravitational forces enable giant masses of rock to float above the hidden jungle below. Small figures in the foreground celebrate the discovery of a lush oasis.

▲ "Temple" by Carlos Long

Interesting stone architecture blends in nicely with the desert backdrop. Not every world needs to be high-tech to feel alien.

▶ "Aliens" by Michael Knight

A strange cast of characters roams this desert landscape. A warm light source helps to define the form of these creatures.

DESERT PLANET

Desert buck

One of the few creatures capable of withstanding the harsh climate in this world, this buck roams the desert wasteland in an endless search for food and water.

Design development

1 Getting started: Begin with a series of thumbnail sketches to explore various possibilities. Consider a wide array of influences from the real world when designing the possible forms. Try to harmonize a visually interesting silhouette with a body type that seems suitable for this harsh, challenging climate. Paint these forms quickly with a hard-edged brush. Start with a basic gesture sketch to communicate the rough shape of each creature, then reduce the brush size and increase brush hardness to define the details of the outer silhouette. The final rendering will feature the animal being backlit, so your silhouette will be of the utmost importance.

CONCEPT DESIGN

Camels are remarkably well adapted to desert conditions. Drawing upon the overall body type and the prominent water-storing humps seems a logical solution for the creation of a desert animal.

Various creatures in the animal kingdom are combined together to create a unique design. Features inspired by steer, camel, and oryx are synthesized to arrive at the final result.

2 Basic sketch: Animal anatomy (particularly fictional animal anatomy) can be very challenging, since it is much more difficult to base a pose on observational drawing than it is with human subjects. Photo reference is helpful, but anatomical drawing is an equally important exercise (see page 42). Break the figure down into a series of primitive geometric shapes to define the mass and structure of the creature. Pay careful consideration to the position and articulation of the joints. Use a sharp 2B pencil to execute this sketch.

See pages 34–37 for more details on the digital process.

3 Rendering: This image will feature a simple environment. Structure the composition in four layers: Layer 1: Sky, Layer 2: Sand dunes, Layer 3: Creature, and Layer 4: Lighting effects. Expanding further upon this layer structure may be necessary, but try to maintain those four dominant components in your series of layer groups (the option to create a group is located in the Layer menu). Groups add organization to scenes as layer structure becomes more complicated.

Start with a dark value silhouette to define the shape of the creature. Use a warm rim light (see page 59) to define the finer points of the structure, such as the hips and knee joints. The rendering of the fur can be fairly laborious. Use a small, hard-edged brush—only render the mid-tone and highlight range of the fur, since the shadow areas can be left untouched. The brush work in the mid-tones will help to define the appearance of the shadows. Because the figure is backlit, think about how light would wrap around the outer edges of the form and highlight some anatomical features, while leaving some more obscured by a dominant core shadow.

The atmospheric elements (dust, clouds, etc.) can be handled with a large, soft-edged brush set to a low opacity.

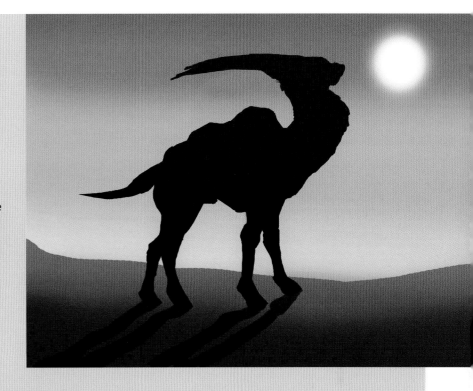

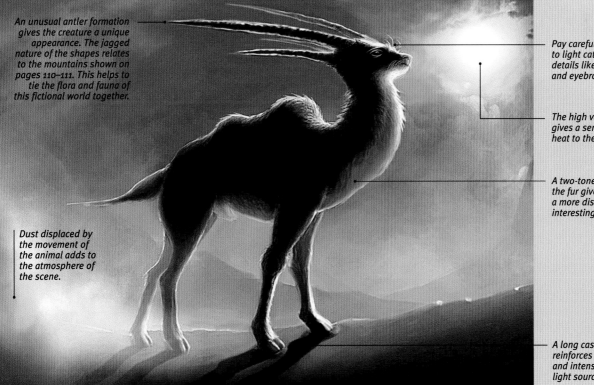

An unusual antler formation gives the creature a unique appearance. The jagged nature of the shapes relates to the mountains shown on pages 110–111. This helps to tie the flora and fauna of this fictional world together.

Dust displaced by the movement of the animal adds to the atmosphere of the scene.

Pay careful consideration to light catching fine details like whiskers and eyebrows.

The high value of the sun gives a sense of scorching heat to the scene.

A two-tone marking on the fur gives the creature a more distinct and interesting appearance.

A long cast shadow reinforces the position and intensity of the light source.

DESERT PLANET

Crab tank

The desert is reclaiming vast expanses of the landscape. A fast, ground-level vehicle well suited to the terrain is required.

CONCEPT DESIGN

The inspiration for this vehicle came from a drawing of a crab combined with the lines of a Lamborghini sports car. Although crabs are well suited to a sandy terrain, they don't signify speed, so combining the creature with the aesthetics of a sports car was a good solution to the design challenges.

1 Getting started: Begin with a rough assessment of the overall geometric structure of the tank, and a quick study of the background. A basic desert background is appropriate.

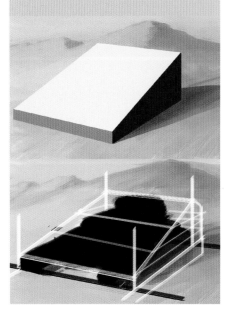

2 Line art: With a basic understanding of the overall shape and structure, proceed to a pencil sketch. This sketch defines the line work of the painting, without addressing lighting or value. Complex designs are best handled in stages.

Design development

Thinking of the various design stages of the tank is a good exercise, since this demonstrates an understanding of the mechanics of the vehicle.

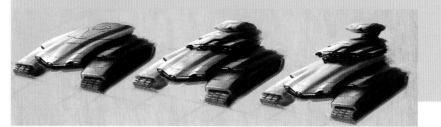

3 Value and lighting: Paint a value study of the entire scene. Use a mid-size brush set to a high opacity to execute this sketch quickly. The background can be achieved with a few large brushstrokes. Start by blocking in the mass of the dunes with the shadow value. Next add light by painting lighter brushstrokes on the left side of the dunes. For the tank, start with the shadow value and block in the silhouette of the vehicle. Next, switch to a mid-tone value to define the planes of the form that are lit. Add near-white highlights to the edges closest to the light source.

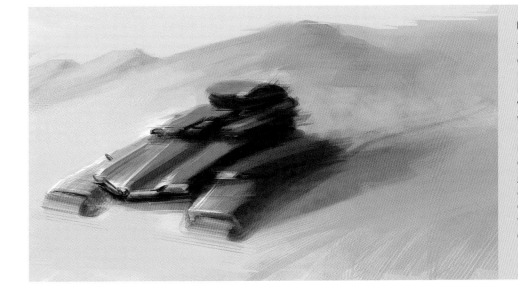

4 Color: This color block-in shows the transition from grayscale values to color. The red is derived from the design reference—a classic sports-car paint job helps to emphasize the speed of the vehicle. The reds also harmonize nicely with the hues of the desert.

Use a soft blue for the sky and much higher intensity blue for the lights and details of the tank. The blue sky helps to justify the presence of such strong blue accents. If the accents were too much of a departure from the rest of the palette, they may begin to feel too unnatural and out of place.

5 Surface effects: Add more intense highlights to help give a better sense of the materials. Use the Dodge tool with the range set to Highlights. Highlights are descriptive in terms of material—the shapes seen in the highlight area can suggest the appearance of the material in the mid-tone and shadow areas. The desired effect is sand on metal, so use a brush with a rough edge to create this effect.

6 Rendering: The sand displaced by the tank helps to develop a soft atmosphere. Use a large, soft brush set to a low opacity to develop these cloudy areas. Keep the background as soft as possible to allow the sharp angles of the tank to pop out and be the focus of the painting. Switch to a smaller brush with hard edges to render the details of the tank.

See pages 34–37 for more details on the digital process.

Small lights and details suggest that the vehicle is hi-tech and capable of a variety of functions.

The angle of the antennae helps to suggest speed.

The ruts in the sand behind the tank help to establish a simple visual narrative and offer depth to the scene.

Subtle details, such as the sand collecting on the tank treads, help to make the scene more believable.

The construction seams on the tank help to emphasize the various volumes. These seams are shallow grooves cutting into the surface of the vehicle. Use lighting to occasionally catch the edge of these seams.

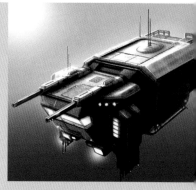

DESERT PLANET

Windy canyon

Large-scale construction efforts are made to control the harsh climate of this desert terrain. These large bracket structures aim to control the intense wind storms that plague huge portions of the planet.

CONCEPT DESIGN

The bracket structures are inspired by the work of graffiti artist Daim (see above). The complex interlocking shapes offer a good guide for the design of these intricate assets. The air traffic should feel utilitarian and geared toward construction. The strong cubic shape denotes stability over speed. The climate should indicate that the weather is stable in this area, so the appearance of a blue sky is justified. Finding a balance between aesthetics and believability is an important consideration when deciding upon a palette.

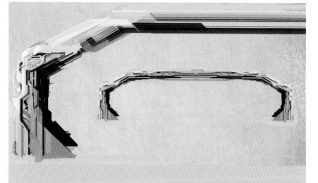

1 Getting started: Do some sketches to define the shape language of the brackets. A focus on fine detail helps to reinforce the large scale of these structures. Block in the initial shape with a large hard-edged brush set to full opacity. Then switch to a smaller brush to define the detail of the silhouette. With the silhouette well understood, begin to lay in the internal structures. The shapes should feel varied and complex, yet unified and cohesive. Look to repeat angles wherever possible. Try to limit the overall number of different angles to keep the design harmonized.

2 Value study: This value study breaks down the design for the air traffic. Start by drawing the vehicle in perspective with a series of solid black brushstrokes. Use a small hard-edged brush to elaborate upon the silhouette and add detail to the craft. Consider the functionality of the craft when adding elements. Blasters on the front help to clear rock. Bracket arms on the bottom are intended to clip into the scaffolding of the bracket structures to secure the vehicle to architecture. Details like railings and ladders communicate the utilitarian nature of the craft—workers are able to walk safely on the surface of the vehicle. Use an overhead light source to illuminate various

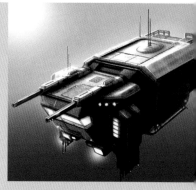

details on the craft. Switch to a lighter value of gray to define the portions of the craft in direct light. Once all of the details are rendered, use the Dodge tool to add dramatic highlights to the surfaces directly facing the light source.

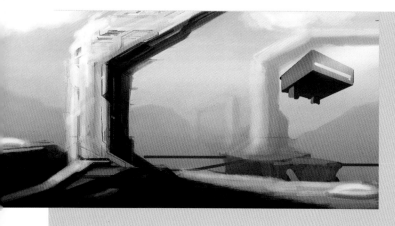

3 Color: Execute a rough color sketch to plan the overall atmosphere and composition of the painting. Focus on shape, color, and placement, without getting caught up in detail. Keep the rule of "general to specific" in mind when approaching this painting. A basic cube can be used to represent the vehicles at this stage of the painting. As the painting progresses, refer to the previous vehicle sketch. Only paint the vehicle once—the element can be duplicated and transformed to populate the scene.

Use sharp brushes to define the structural elements and soft brushes to communicate the atmosphere. The light source is at the top left—keep a consistent angle to the lighting to ensure the end result feels believable. Keep things loose and focus more on the overall feel of the painting. Keep each element on a separate layer to allow for quick changes to perspective with the Transform tool when it's time to clean up the painting.

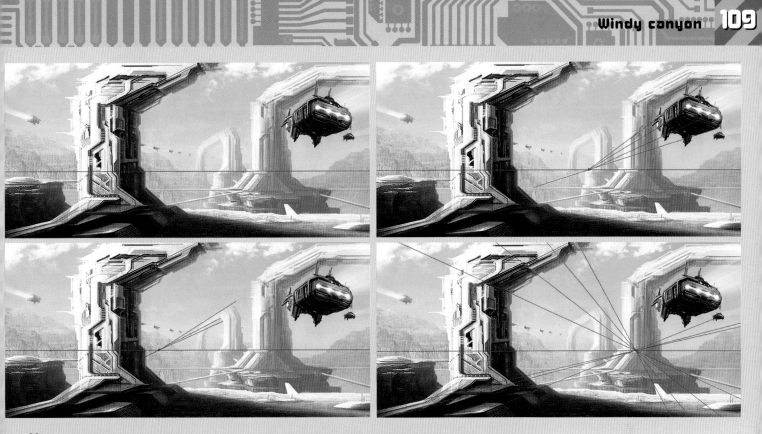

4 Rendering: This painting employs numerous vanishing points. When showing a large, complicated environment, it's unlikely that every structure would be built on a perfect perspective grid—this accounts for multiple vanishing points.

An infinite number of vanishing points can be added, just as long as they all fall on the horizon line. Make sure that every line on every structure is consistent with the horizon line of the painting.

See pages 34–37 for more details on the digital process.

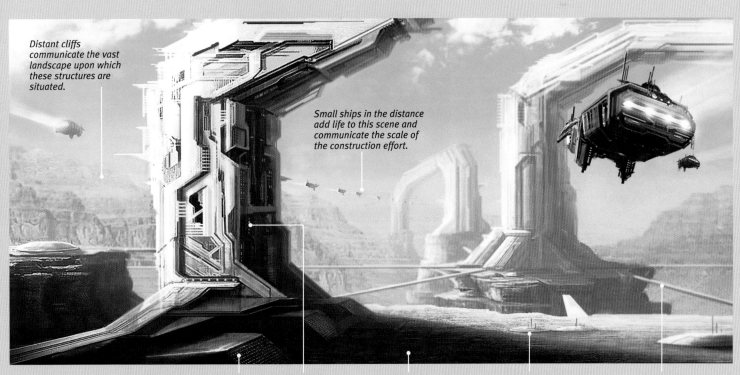

Distant cliffs communicate the vast landscape upon which these structures are situated.

Small ships in the distance add life to this scene and communicate the scale of the construction effort.

Tiny lights on the base of the bracket give an indication of scale to the architecture.

Tiny blue lights on the bracket structures harmonize with the hue of the sky.

Scattered hits of red on the ground plane show evidence of settlements at the base of the brackets.

Dome buildings are scattered throughout the landscape to add variety to the range of shapes seen in the architecture.

Roadways connect the various structures.

Jagged coast

This planet is hostile in both climate and landscape. Jagged geological formations protrude from the sandy coast. The sands meet the boiling seas, and steam rises from the point of contact.

CONCEPT DESIGN

This painting is all about shapes. The razor-sharp peaks need to feel bizarre and alien but plausible within their surroundings.
A faint row of lights show there are inhabitants high up in the peaks. They are high enough that they are protected from the scorching sandy winds of the

desert. They are also well hidden, which offers some security in this war-torn planet. The peaks push up through the deep sand of the desert, revealing sheer dark slate-like rock. Treacherous ridges serve as walking paths, connecting the different peaks.

1 Getting started: Make a pen sketch to establish the overall look of the peaks. Each one will have its own unique character—the sketch establishes the general style for all of them, and it also gives clues to how the peaks will be situated on the ground plane.

See pages 34–37 for more details on the digital process.

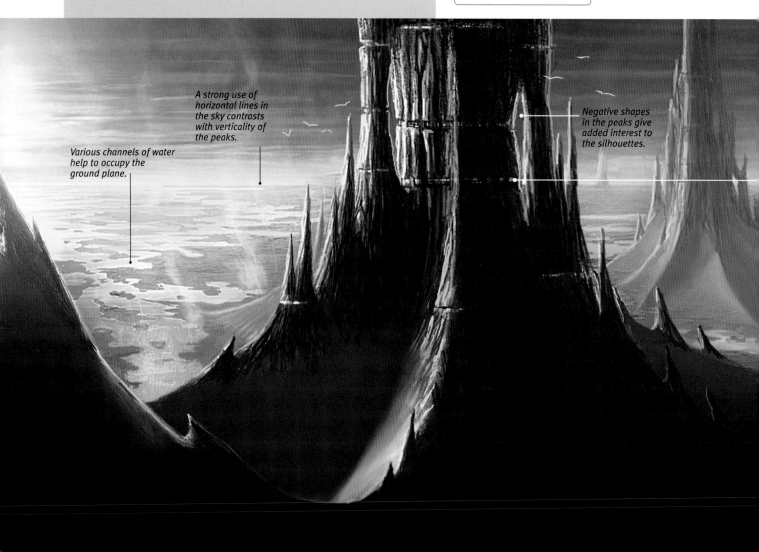

A strong use of horizontal lines in the sky contrasts with verticality of the peaks.

Various channels of water help to occupy the ground plane.

Negative shapes in the peaks give added interest to the silhouettes.

2 Line art: Scan this pencil sketch to begin blocking in the painting. Set the resolution of the scan to 300 dpi. This sketch will help to determine the placement of the various elements of this painting.

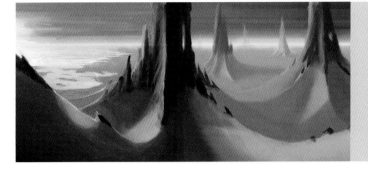

3 Value study: When doing the value study, keep in mind that the atmosphere is sandy, so objects should become more obscured by atmosphere as they recede into the distance. Start by filling in the line drawing with solid blocks of value. Use a mid-tone gray for the sky and a lighter mid-tone gray for the ground plane. Use the Dodge tool to communicate the value of the water. Express the peaks with a darker shadow value. Next paint the highlights onto the areas of the peaks facing the light source.

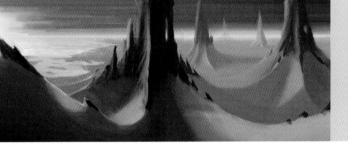

4 Colors: This environment is intended to feel otherworldly and somewhat menacing and treacherous. Begin the color pass by replacing the gray values with relative color values. Light earth tones for the sandy areas, darker earth tones for the peaks, and warm red for the sky. Overlay painting processes can also be applied to this painting, but learning multiple approaches is a valuable exercise.

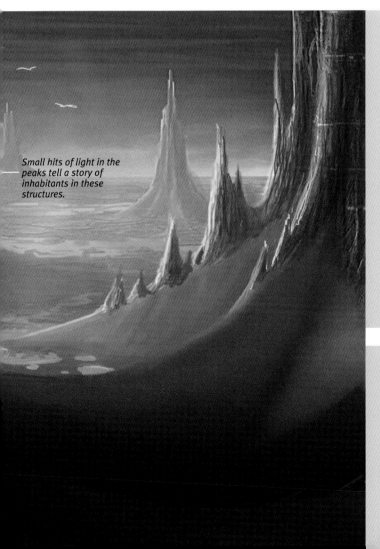

Small hits of light in the peaks tell a story of inhabitants in these structures.

5 Lighting: The angle of the sun is low—this will create long cast shadows running over the ridges of sand and onto the desert floor. A strong bloom of high values around the light source gives additional heat to the sun. Paint this bloom with a large brush set 20% opacity and 0% hardness. The cast shadows on the ridges not only give volume to the structures but also help to guide the eye through the scene so that the viewer reads the entire composition. Apply smooth shadows to the sand, since the surface quality is consistent. Paint these shadows with a brush set to 50% opacity and 50% hardness.

The rock faces are rough and faceted, therefore the highlights will be more erratic and broken up by cracks and shadows. The steam coming off the ocean where it meets the sand is an important descriptive element of this painting. Use a soft, low-opacity brush to achieve this effect.

The water is quite still, so it catches highlights like a sheet of glass. The proximity of the sun to the water is such that it blooms to nearly a pure white value.

6 Texture: The texture of the sand on the ridges is smooth and requires minimal treatment to the surface. The sand on the desert floor appears slightly cracked, so more texturing is needed. Switch to a smaller brush in this area to communicate the finer detail.

The surface of the rock is very detailed, particularly in the peak closest to the viewer. Paint this detail with a fine brush, or use a photographic overlay of a detailed rock texture. Make sure texture of the rock matches with the vertical lines of the peak.

PICTURE MAKING

This chapter begins with the examination of three vistas inspired by the content of the previous chapter. Experiment with your results from Chapter 3 to create elaborate scenes featuring a variety of the characters, vehicles, and environments. These images show three different combinations. Consider the possibility of mixing elements from the different worlds in one painting. Think about how these assets can be combined together to tell a multitude of different stories. The latter half of the chapter is an analysis of some fantastic science fiction art from several talented artists. These works explore a variety of themes and subject matter. Try to identify how the fundamentals from Chapter 2 are implemented in these paintings. In addition to developing a critical eye to analyze one's own work, it's also important to be able to determine what other artists are doing that makes their work so successful. Apply the techniques and theories applied in these paintings to improve the quality of future projects.

Dystopia vista

"POLICE CHASE"

Elements from the Dystopian Earth world of Chapter 3 (see pages 56–65) are combined to create this scene. An aerial police unit chases an outlaw biker through the high-altitude streets of this overdeveloped metropolis.

Familiar buildings and signs occupy this city, but the layout implies huge leaps forward in development. With the entirety of the ground level occupied, the city began to develop vertically. Giant highway structures tower over the city. This section shows a commercial center rich with advertisements and neon lights.

The nighttime setting coupled with the thick rainy atmosphere allows the colors of the neon lights to come alive. The lights of the vehicles bloom and catch the surrounding atmosphere. This type of atmosphere allows for localized pools of light, which create an interesting color range.

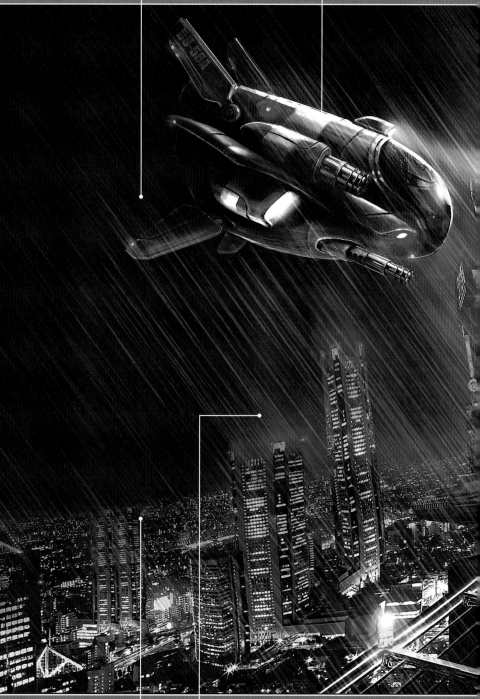

The angle of the rain helps to reinforce the action in the scene.

This police unit is specially designed to move effectively through the multileveled city (see page 64).

The distant horizon shows that the city stretches far and wide, communicating the overdeveloped nature of this world.

Vertical shafts of light shine from the rooftops of the city below.

No impression of the natural world is evident in this scene—nature is completely overpowered by the development of this megacity.

Japanese signs help to give a tangible context to this futuristic world.

Colorful graffiti murals harmonize with the vibrant lighting.

Guardrails line the sides of the street to highlight the edge of the structure and keep drivers from plummeting to the city below. The streets feel narrow and dangerous, adding to the tension of the scene.

Wet concrete reflects the color and light of the city to spread color throughout the composition.

A quick light vehicle is the biker's only hope to evade the heavily armed police cruiser. The strong, angled spotlight from the police cruiser adds visual tension to the scene and helps to convey the sense of conflict.

Jungle vista

"SWAMP TOWN"

Elements from the Exotic jungle section of Chapter 3 (see pages 80–91) are combined to create this scene. This image depicts a settlement in a swamp within the roots of a gigantic forest. The architecture harmonizes well with the surroundings, reflecting the ethos of the society.

Overhanging vines and lush foreground leaves situate the viewer in dense vegetation. These elements also frame the composition.

Giant vines wrap around the root structure of the massive tree. Smaller vines dangle from the underside of the root extending to the forest floor below.

A misty atmosphere catches the light emitted from the huts and the emissive marsh plants.

Simple huts rest upon the gnarled roots of the giant tree. These dwellings are made with basic natural materials—they blend into the organic environment, as opposed to overpowering it.

Tiny lights coming from the root of the tree give evidence of inhabitants living in the tree. The brightest light at the bottom shows a way into the tree dwellings.

Exotic red fungus grows on the foreground root structures.

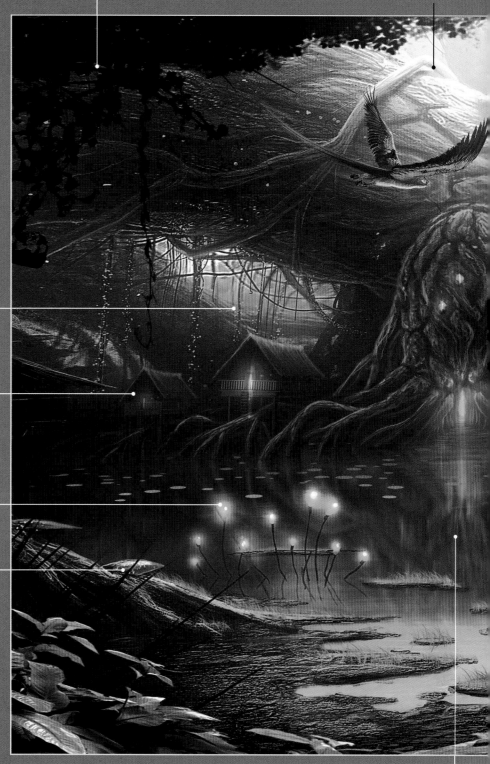

The clean reflection on the surface of the water shows the stillness and tranquility of the swamp.

Several chariots zip through the sky in the background (see page 88).

Large distant shapes indicate how expansive this enormous forest really is.

Large fungus growing from the giant tree acts as a landing pad for the chariots.

An elder (see page 84) standing on his front porch calls upon his jungle hawk (see page 86). The path of the bird reinforces the curved line of the root structure.

Lily pads and small sections of moss dot the surface of the water.

The isolated hits of red pop out from the dominant green palette of the painting.

Invaders vista

"INVASION"

Elements from the Invaders section of Chapter 3 (see pages 92–101) are combined to create this scene. A warrior scans the streets of an Earth-like planet looking for any remaining signs of life. The city in the background is laid to waste by patrolling gunships. The world is in ruin—defenseless to the military might of these extraterrestrial invaders.

Distant silhouettes of jagged buildings give a clue to the extent of the destruction caused by this assault.

An ominous fiery orange sky sets the tone of this nightmarish scene. The atmosphere is thick with smoke, which allows it to pick up the colors from the smoldering city below.

A burning car billows with smoke. The fire from the car emits a secondary light source, which illuminates the figure.

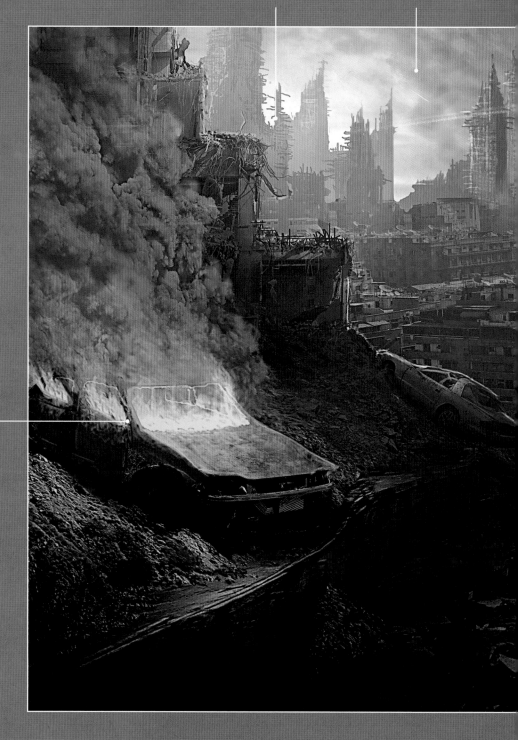

There is no evidence of human resistance in this scene—this communicates that the invaders greatly outmatch the inhabitants of this ravaged city.

Flashes and streaks of light coming from the gunships (see page 96) indicate that they are firing on the city below.

There is a distinct absence of human life in this painting—no lights are on in any of the buildings and very little of the city remains intact.

The buildings in the middle ground show evidence of extensive damage. Exposed rebar and framing help to show that the exterior facades of these buildings have been severely damaged.

Trash and debris litter the pathway under the feet of the warrior—this adds to the sense of chaos in the image.

The warrior's (see page 94) gun emits a thin plume of smoke, indicating the weapon has recently been fired. This element also helps to visually link the foreground to the background.

Debris from the surrounding city slides from the sides of the composition into the central pathway. This is evidence of massive disruption to the city.

Gallery

"METROPOLIS PT. 4" (below)
By Andree Wallin

The sunset atmosphere of this painting is very well established. The high saturation colors of the lights and sky play nicely with the dark silhouettes of the architecture. The silhouettes themselves are well designed and nicely arranged. Softer tones in the distant buildings and planets give this image a great sense of depth. The silhouetted figures in the foreground really bring this city to life. This image demonstrates a well understood use of three-point perspective. This use of perspective grounds the viewer in the scene, making them feel dwarfed by the massive skyscrapers. Repeating the bright orange hues of the sky on the tallest building on the right-hand side helps to draw more attention to an already well-defined focal area, and also helps to harmonize the palette.

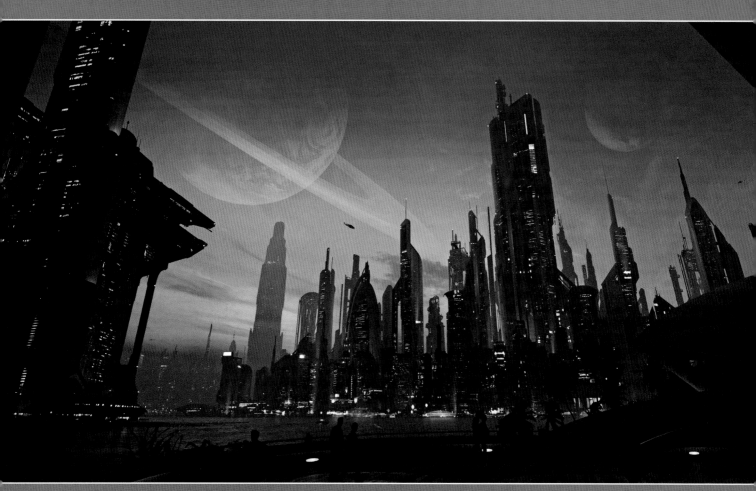

"STEAMPUNK VILLAGE" (top right)
By Robh Ruppel

The soft tones of this painting produce a calm atmosphere. The pastoral village on the far right creates an interesting visual contrast with the high-technology structures looming overhead. This image succeeds in establishing a strong sense of foreground, middle ground, and background. The intensity of color remains low without losing impact—this is due to the expert use of mid-tone colors. Look closely at this image and examine the wide variety of colors found in the mid-tone range. Small details, such as the plume of smoke coming out of the industrial complex on the far left, help to guide the viewer's eye through the scene. The large, spherical structure is very carefully rendered—the fine details such as lights help to establish the vast scale of the structure.

"FLOATING 2" (right)
By Robh Ruppel

This image has an excellent sense of scale. The fine details of the underside of the ship and the city below make the craft feel truly massive. The strong lighting and interesting cloud formations create a dramatic feel in this painting. The cool blues of the ship's exhaust pop out nicely from the warm yellows and oranges of the surrounding sky. The darker cool blues of the shadows of the cliffs vibrate nicely with the warm earth tones of the lit ground. Notice the attention to detail on the edge of the cliff—this added definition makes the environment increasingly believable. The slight tilt to the horizon line gives extra vitality to this composition.

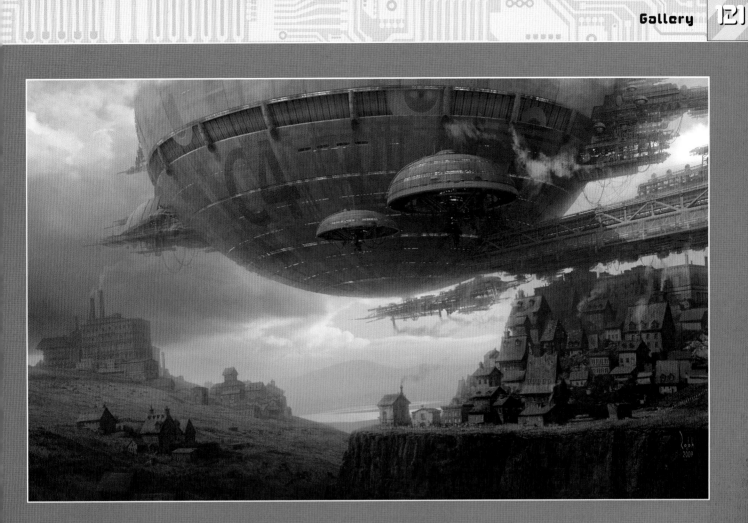

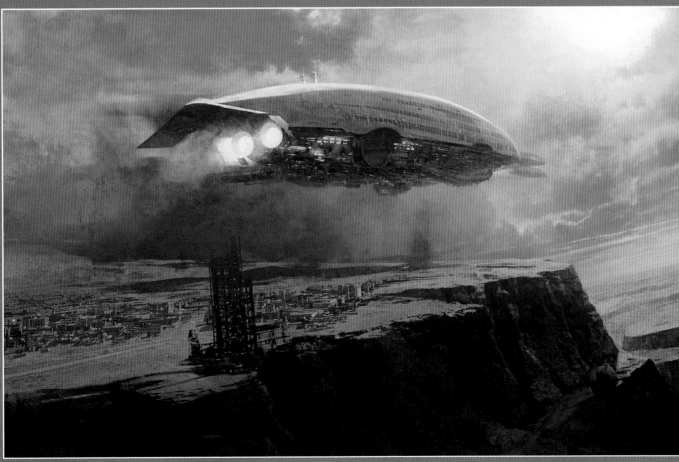

"MASCOT" (right)
By Camille Kuo

This image is a great example of updating a cultural reference to give it a sci-fi vibe. Aspects of the character and landscape design are from traditional Japanese culture. By elaborating on these elements the artist has created a fantastic design. The shapes and colors of the distant background feel like a Japanese woodcut print. The design of the character is reminiscent of a traditional geisha. By adding leather and metal to her costume, she feels updated without losing that cultural grounding. The panther is an excellent addition—it fits very quietly into the shadows but gives the character an added sense of ferocity. The panther's different-colored eyes is a small detail that draws the viewer even deeper into the image. The low-lying mist in the background separates the figure from the landscape nicely— it makes her silhouette much more legible. The pose is well handled and the body language feels natural. The tattoos are a great addition—while they're not traditional Japanese tattoos, they feel harmonized with the design of the character.

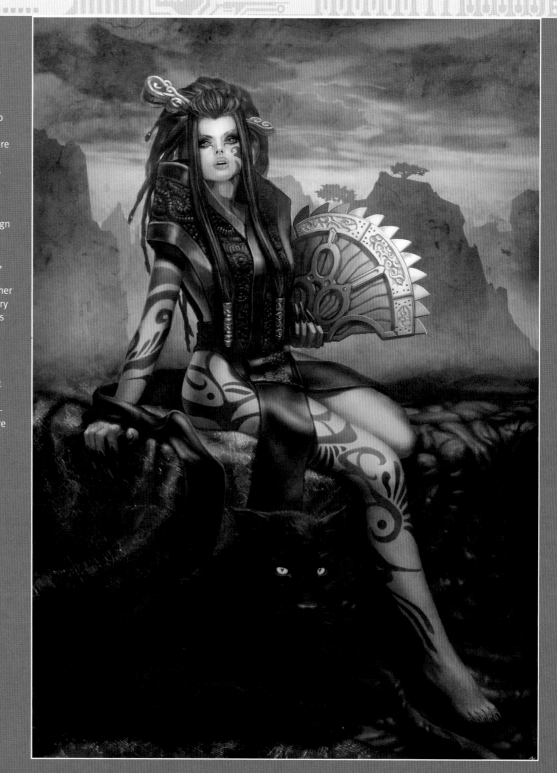

"WORSHIP" (right)
By Camille Kuo

This painting develops a rich sense of culture and narrative. The architecture and imagery feel reminiscent of Meso-American cultures without being too derivative. The sharp, highly rendered details of the stela balance nicely with the loose, confident brushstrokes of the foreground. Small specks of debris swirl through the air, adding little hits of color that help to draw interest to the entire composition. The lighting is well conceived—it highlights the figures and the details of the architecture, and also manages to create some interesting silhouettes in the shadow areas. The delicate silhouettes of the background pillars contrast nicely with the strong, cubic architecture of the foreground and middle ground. This painting demonstrates a strong use of one-point perspective. It's not always necessary to create a complex perspective grid—this painting succeeds in creating a great deal of interest with only one vanishing point. This is the type of painting that leaves the viewer wanting to know more about this world and the story of these characters.

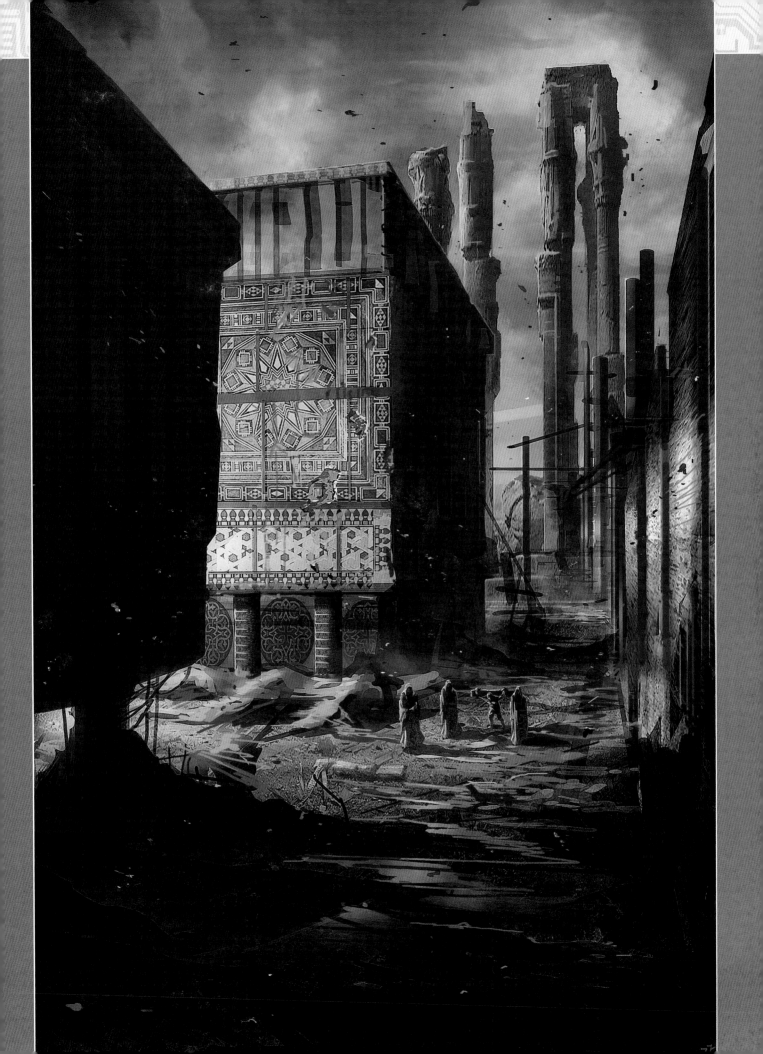

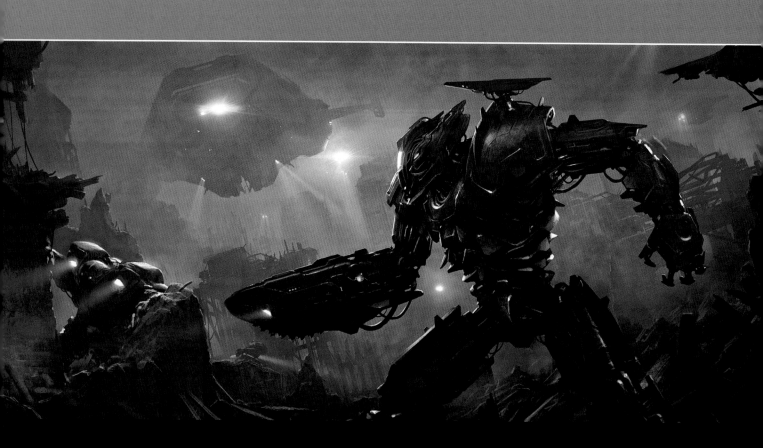

"SEARCHING" (above)
By Andree Wallin

This painting creates a great sense of tension—the title is very well conveyed through the mood of this piece. The searchlights of the ship and robot peer into the darkness—the menacing appearance of these machines truly makes the viewer sympathize for who or whatever is being searched for. The value range in this painting is well thought out. The soft mid-tones in the background allow the jagged foreground silhouettes to pop out nicely. The occasional hit of metallic highlight or cyan glow adds visual interest to this composition by drawing the viewer's attention to every section of the canvas. The pose of the focal robot creates strong negative shapes and dynamic lines of action, which again helps to lead the viewer through this work of art.

"TIME MACHINE" (top right)
By Camille Kuo

This painting is an excellent example of sci-fi invention. Although no one knows how to travel through time, this environment feels like the place where it could happen. The rafters and catwalks help to ground this environment in reality, while the complexity of the machines offers a very sophisticated leap forward into possible futuristic technologies. The circular shapes of the gyroscope create a strong contrast in shape to the hard angles of the catwalks and staircases. The overhead lighting catches the surfaces of the gyroscope to create a sharp contrast in values. This creates a well-defined focal point. The cool tones of the lighting pop out nicely from the warm copper tones of the machine on the left. The spherical shape of the turbine harmonizes with the shape of the gyroscope—nothing feels out of place in this image. The rows of light fixtures on the ceiling set up a good rhythm of repeated shapes and communicate the scale of the environment.

"SEWER" (right)
By Camille Kuo

This image succeeds in taking an environment that could potentially be lackluster and turning it into something intriguing and extremely visually pleasing. The grungy textures in this painting help to set the scene. The unearthly green glow of the sewage takes this image out of the realm of being "just a sewer" and presents the viewer with an interesting sci-fi setting. The green rim light on the foreground fence posts is very well handled. Letting the glow of the sewage spill onto some of the surfaces was a great artistic decision. The lighting coming from the tunnels gives an ominous feel to this scene, as if something very bad is about to happen. The translucent surface of the sewage is well communicated, and the repetition of doorways on the left side of the piece adds depth and rhythm. There is a great balance of straight vertical/horizontal lines and circular shapes. Making the foreground fence posts slightly off-kilter adds to the unease of this shot.

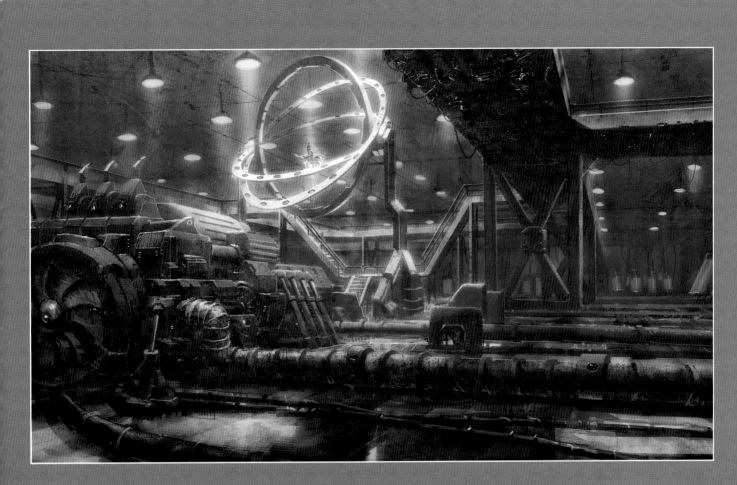

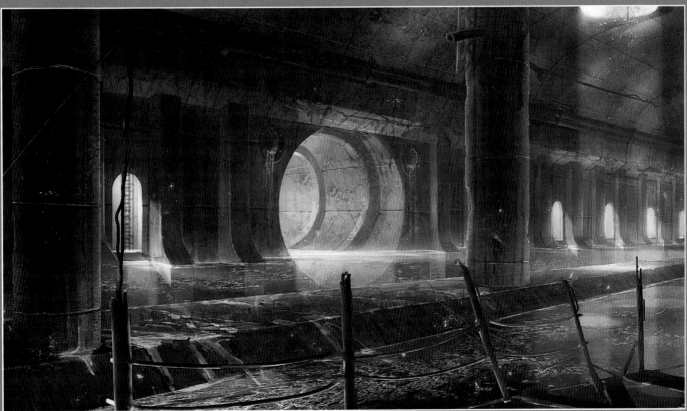

Index

Resources and credits

Resources

http://www.cgtextures.com/
http://www.conceptart.org/
http://cghub.com/
http://www.therydanworkshop.com/
http://www.mattepainting.org/
http://colorschemedesigner.com/
http://geofftaylorsketchbook.blogspot.com/

Publisher credits

Quarto would like to thank the following for supplying images for inclusion in this book:

Alamy p.8r
Kobal p.9, 10t/b, 11, 12tl/tr, p13br, 18r, 19, 21l
Corbis p.18
Rex Features p.20, 21r
© 2011 Microsoft p.22–23
©2011 Sony Computer Entertainment Europe p.22-23
Angel Alonso, http://angelitoon.deviantart.com, p.49, 66t
Franco Brambilla, http://francobrambilla.com, p.66b, 93br
Riyahd Cassiem, p92bl, 102t
ELREVIAE, http://elreviae.deviantart.com, p.56b
Tom Godfrey, www.tomgodfrey.net, p.67t, 81b, 93bl
Stephen Hickman, www.stephenhickman.com, p.4, 5, 57t
Uwe Jarling, www.jarling-arts.com, p.50
Michael D. Knight, p103br
Camille Kuo, http://camilkuo.cghub.com, p.3bl, 53tr/br, 102b
Vincent Laik, www.vincentlaik.com, p.103t
Carlos Long, http://web.me.com/carloslong/www.carlosonline.com, p.57b, 80b, 81t, 93t, 103br
Rob Ruppel, www.robhruppel.com, p.56t
Lorenz Hideyoshi Ruwwe, www.hideyoshi-ruwwe.net, p.38/39t, 67b, 92t
André Wallin, http://andreewallin.com, p.2bl, 52

All step-by-step and other images are the copyright of Quarto Publishing plc. While every effort has been made to credit contributors, Quarto would like to apologize should there have been any omissions or errors—and would be pleased to make the appropriate correction for future editions of the book.

Author credits

A big thanks to my family and friends for all the love and support! Thanks to all the great teachers I've had over the years—I couldn't have done this without you guys! Thank you so much to all the amazing artists who contributed to this book. Thanks Denise :) And thank you to the Quarto staff for all of the help along the way!